Water-Colour Painting

First published 1982

ISBN 0 7134 3978 5

Photoset in Monophoto Ehrhardt by
Servis Filmsetting Ltd, Manchester
and printed in Great Britain by
The Anchor Press Ltd
Tiptree, Essex
for the publishers
B T Batsford Ltd
4 Fitzhardinge Street
London W1H 0AH

James Fletcher-Watson
RI, RIBA

Water-Colour Painting

Landscapes & Townscapes

B T BATSFORD LTD LONDON

Contents

Preface

The art of painting in water-colour is the art of producing a transparent and spontaneous picture. A good water-colour should not take a long time to paint; it is the bad ones that take a long time! One of the great attractions of a good water-colour painting is its lasting freshness, even many years after it has been painted.

This book is all about painting in *pure* water-colour and not using white paint or body colour or pastes or other texturizing materials. I like to let the paper breathe through the paint and by the clearness of the washes obtain a luminous quality in the final result. This is only achieved by clear thinking and a sure technique based on a knowledge of drawing and a feeling for form.

We are going to deal with *landscape* painting in this book and I want to emphasize the importance of painting out in the open direct from nature. Water-colour painting is a very English art as the English climate lends itself so much to the medium: the mists and clouds and soft colouring of the varying landscape of the British Isles give endless scope for this very liquid form of painting. I am anxious that the tradition started by the great eighteenth-century water-colourists should be carried on today by the young up-and-coming painters.

This book sets out to help those who have only just started using water-colours and may not yet have left school; and the student already at art school. It should also prove helpful to those who only have time for painting at week-ends, and I hope it may perhaps be useful to the more experienced full-time artist who would like to see how someone else tackles a painting problem. After all, we are all students however old we are or however long we have been at the painting game. We should always be striving to paint better and to learn something new. I know I am always dissatisfied with my work and want to improve my painting and I delight in seeing another painter at work and observing his methods.

I said that water-colour painting is a very English art, but I do not mean it should only be painted by Englishmen in England; far from it. Water-colours can be painted in any country and climate and by anybody – the more the merrier. I enjoyed enormously painting in Arizona, with a hot sun drying the paint rapidly on the paper. There was no hanging about waiting for washes to dry; one could get on with the job more quickly than usual which I found most satisfying.

Water-colour is said to be difficult because you cannot cover up your mistakes as you can in oil painting. That is true, but if you are prepared to work hard and develop a *method* of painting you will find it is not nearly so difficult as you thought. I am going to describe some very simple methods which you cannot fail to follow and carry out, if you are really keen. Enthusiasm is half the battle with water-colours; it is a very exciting medium to work in once you start.

I shall be taking you through various processes from preliminary drawing and rough sketches to painting direct with the brush only, and completing a finished water-colour picture. Different techniques are discussed and illustrated and I deal with various subjects such as trees, mountains, skies, water and buildings and methods of painting these things are described in detail and illustrated.

My advice to the beginner is never give up or be depressed if you paint a bad picture; you will have learnt something and success is waiting for you just round the corner. Plenty of first-class water-colour painters make mistakes and have to try again. Water-colour is not easy, but I hope by reading this book you will find I can give you a helping hand.

The pure water-colour tradition

We inherit a great tradition of water-colour painters in Britain and the golden age was from the late eighteenth to the late nineteenth century when such men as Girtin, Turner, Cotman, Cox and De Wint produced water-colours the like of which had never been seen before. I think there is a case for us in the twentieth century to carry on the tradition of pure water-colour painting along side the several variations of the medium such as gouache which is similar to tempera (which was incidentally used by the old Italian masters to paint murals) and acrylic, a new medium which can be applied thinly or thickly like oils. Both these media are mixed with water and very beautiful effects can be obtained with them, but they do not give the translucent effect which results from pure water-colour and the technique for using them is entirely different. I have used gouache and acrylics myself and I like them, and there are other new media which are related to water-colour coming into use. But I am anxious that the pure water-colour technique should continue through the twentieth century and beyond, and this book is devoted to promoting that particular art.

Part of one's training as a water-colour painter is, I am sure, to know something about the great water-colourists of the past, and if possible to examine closely original paintings by them and see what colours they used and how they applied their paint. I would like therefore to say a little about the ancestry of water-colours and mention the names of the chief performers so that you can look at their work in illustrated books or better still in art galleries.

The ancestry of water-colours

Probably the earliest use of water-colour was when the monasteries of Europe produced illuminated manuscripts in the eleventh and twelfth centuries and later. The great German painter **Albrecht Dürer** used water-colour for landscape in the fifteenth century. In 1587 **John White** formed part of Sir Walter Raleigh's expedition to North America which founded the first English colony. White carried a box of water-colours and he produced a quantity of pictures of the country and the people. This is probably the earliest record of an English water-colour painter. The pictures were in simple pen and wash. In about 1635 **Van Dyke**, the great portrait painter, was using water-colour and body colour (white paint) to paint landscapes on grey paper.

In the seventeenth and eighteenth centuries there grew up a vogue for topographical draughtsmen and water-colour painters, and such men were often included in the retinue of young English noblemen going on 'the Grand Tour' to Europe and, in particular, to Italy. When they returned home they could show their friends pictures of where they had been. These draughtsmen were the forerunners of the family photographers of today.

Such topographical artists were also attached to armies and navies to record the scene. In 1743 **Thomas Sandby** was on the Duke of Cumberland's staff and he was at the battle of Dettingen.

Not until we come to **Paul Sandby** (1730–1809), younger brother of Thomas Sandby, do we arrive at the first English water-colour painter who really used the medium in its broader sense with a full range of colours. He was for 30 years drawing master at the Woolwich Military Academy, but he broke away from the pen and wash technique and eventually made real water-colour landscapes of a closely detailed nature. Both Thomas and Paul Sandby were founder members of the Royal Academy of Arts when it was formed in London in 1768.

We must not forget **Alexander Cozens**, (1717–1780) who came on the scene before the Sandbys. He was very much a drawing master and he taught at Christ's Hospital and at Eton. He advocated the 'new method' of painting tone values rather than pen outlines filled in with washes. He painted mainly in monochrome. His son **John Robert Cozens** (1752–1797) who became a pupil of his father, took a big step forward with his 'realist' technique. He was much given to mountain subjects and his colour schemes were usually pale blues and greens. Constable described him as 'the greatest genius that ever touched landscape'. He certainly forms an important link in the chain of developments.

Water-colours, as we can see, were now moving into the area of important pictures and were being exhibited at the Royal Academy; both the Cozenses exhibited there and so did three more painters of note – **Francis Towne** (1740–1816), **William Pars** (1742–1783) and **Francis Wheatley** (1747–1801). Towne was mostly a mountain painter and pen work was much in evidence. His colouring tended towards blue and was rather thin. Pars did beautiful brown and blue pictures, particularly in Greece. Wheatley was excellent at figure groups and introduced the full range of colours – reds, yellows and blues – into his rustic landscapes in an attractive way; his lakeland pictures are especially good.

There is one more name that must be remembered at this point – **Thomas Gainsborough** (1727–1788). Chronologically he should have been mentioned before Paul Sandby, but Gainsborough is a special case and he does not fit in as part of the gradual development of water-colour painters. He was first and foremost a portrait painter in oils, but he himself confessed that the portraits were done for a living and for real enjoyment he much preferred landscapes. His water-colour landscapes were something quite remarkably beautiful. Sometimes they were pencil or charcoal with colour washed over; at other times they were drawn with the brush and washes were added. The colouring was often various tones of brown on blue or grey paper. Trees and wooded scenes with figures judiciously placed were his favourite subjects and the compositions were masterly. They do not appear to have developed from the topographical painters but are Gainsborough's own invention, and very beautiful and moving they are. They hold a special place in the progress of water-colour painting.

Dr Thomas Monro (1759–1833)

Dr Monro was an amateur water-colour painter, but, more important, he was a connoisseur and collector of works of art. He arrived on the scene just when the golden age of water-colour painting was about to begin and he had a remarkably helpful influence upon water-colour development in the last quarter of the eighteenth century. His father was also a doctor and a collector of pictures and so Thomas Monro had a good artistic background. He spent as much time as he could spare away from his medical practice in drawing and painting, collecting pictures and meeting artists. His own style of painting was mainly charcoal and wash. He became wealthy and purchased works by Rembrandt, Canaletto and Claude and the early English water-colourists Paul Sandby, J R Cozens and others. He was particularly keen to encourage young water-colour painters and so he opened a small Academy in his own house in Adelphi Terrace overlooking the Thames. He provided desks for pupils, gave instruction and set them to work copying prints and paintings from his collection; sometimes he let them paint views of the Thames out-of-doors. He paid these boys, for that is all most of them were, half-a-crown for the work they did, and gave them supper. He kept their paintings! He had a great eye for good quality in paintings and spotted the bright students. He undoubtedly picked some winners as amongst his students in the 1790s and early 1800s were the star performers of the golden age – Thomas Girtin, J M W Turner, J S Cotman, David Cox and Peter De Wint.

I do not wish to exaggerate Monro's influence on his pupils. The ones I have mentioned and a good many others that came to him were young men of genius and would have fulfilled themselves in any case, but I think some credit can be given to Monro for bringing these men together. He introduced them to influential friends and helped launch

them on their careers as artists. And he must have helped them to learn from each other and improve their capabilities more quickly than would have otherwise happened. Girtin particularly had tremendous influence on Turner and Cotman during their early stages and they all three painted in quite a similar way in their first years. Let us look briefly at these great artists.

Thomas Girtin (1775–1802)

Girtin's work matured very quickly and he was much influenced by the painting of J R Cozens. His draughtsmanship and architectural subjects were marvellous and his water-colour of Peterborough Cathedral, west front, is a masterpiece; it can be seen in the Whitworth Art Gallery. He produced rich colouring in his mountain subjects and was one of the first artists to use light washes overlaid by darker washes without losing transparency. He would put in detail with the point of a small brush in a series of dots and dashes. His pictures are beautifully mellow, like a green-brown tapestry. Sadly, he died at the early age of 27.

J M W Turner (1775–1851)

Turner had the rare distinction of being a genius in painting oils *and* water-colours; and not only that, but he was probably the finest water-colour painter of all time. He soon emerged from his early topographical work and outdistanced all his contemporaries and took the water-colour medium further than anyone has before or since. His skies alone were sheer wizardry; storms and rain were marvellously portrayed, as were rainbows and mists, blue skies and white clouds and shafts of sunlight. He frequently painted looking into the sun, and trees and buildings were seen in silhouette.

Turner toured the British Isles many times painting castles and lakes, seascapes and landscapes of all descriptions. His pictures of Venice are ethereal and magical. His methods could be ruthless, scratching out paint with a finger-nail which he grew long for the purpose. He occasionally used body colour but not excessively. His control of wet washes was masterly.

He was a very close friend of **Girtin** throughout his short life, and when Thomas Girtin died Turner remarked 'If poor Tom had lived I would have starved!' At that time Turner had not developed to his full capacity as a water-colour painter and he had a further 50 years to live, fortunately for us.

Turner had a very wide colour range compared with Girtin, who kept to a limited palette. At first Turner's colours were mellow with greys and greens and browns like Girtin's, but later he was all reds, yellows and blues with dramatic effects even in his water-colours and much more so in his oils. He was a forerunner of the Impressionists. Hundreds of Turner's water-colours and rough sketches can be seen at the British Museum, London. I strongly recommend a visit, which will be most rewarding and inspiring.

J S Cotman (1782–1842)

Cotman was born in Norwich and became a painter with a very distinctive style much in advance of his time. He went to London early in his career and later returned to Norwich where he became the most important member of the Norwich School of Painters.

It was probably from **John Varley** (1778–1842) whom he met at Dr Monro's, that he learnt to apply broad washes of clear colour, conveying detail without actually drawing it. This technique became the hallmark of Cotman's work. He was a great simplifier of a subject and his paintings were often a series of slabs of colour fitting into a delightful pattern. His compositions were masterly. In this he was genuinely an innovator and as such, one of the most influential artists of his period. Poor Cotman never lived to see his painting appreciated.

In later life he introduced paste into his colour mixes to give a thickness and texture, but on the whole he was a purist. His best period was 1803–1805 when painting in Yorkshire, and of many beautiful water-colours 'Greta Bridge' is probably his masterpiece. One could say that no lovelier water-colours were ever painted by anyone, even Turner. Many of Cotman's pictures can be seen in the British Museum.

I will not leave Cotman without briefly

mentioning the Norwich School. It flourished from 1803 to about 1840 and, as I have said, Cotman was its leading light, but it had many water-colour painters whose work should be studied. **John Crome**, who virtually founded the Norwich School, painted beautiful trees and woods in water-colour, although he was mainly an oil painter.

John Thirtle painted river views and old houses and ruins rather in the Girtin manner. **Robert Leman** and **Thomas Lound** were more the followers of Cotman and David Cox and they produced beautiful, soft water-colours. Cotman's two sons, **Miles Edmund** and **John Joseph**, followed in their father's footsteps and used strong blues and yellows, but they were considerably below his standard.

Henry Bright was a great artist doing very free brushwork paintings; he also made wonderful drawings in pastel and charcoal with body colour on tinted paper. **John Middleton** was a superb technician in water-colour and his tree brushwork is beautiful and worthy of much study.

If you wish to enquire further into the Norwich School a visit to the Norwich Castle Museum will be well repaid. They have dozens of works by J S Cotman and a stroll round the galleries will make you feel you have had a water-colour lesson from the great master himself. Cotman goes down in history, with his new style of painting, as one who made a clear break with the traditions of his time.

David Cox (1783–1859)

Cox was first employed by a toy maker to paint miniature pictures. He then became a scene-painter for the theatre. These two influences show in his water-colour work which developed later. His favourite subject was the open moorland with a strong wind blowing. You can almost feel the wind when you look at some of his pictures. His cloudy skies were beautifully washed in, showing movement, and his figures were skilfully portrayed leaning against the wind with clothing blowing out.

He discovered that a coarse paper of a light brown colour suited his style best; sometimes bits of straw broke through the surface. He achieved wonderful results with this paper. In the twentieth century a firm started to make what they called David Cox paper; it was an oatmeal colour with rough absorbent texture and very exciting it was to use. Sadly it has now been discontinued and many present-day water-colour painters are missing it very much.

The quality of David Cox's work varies but in his best work there is a pureness of wash and simplicity of handling which makes one regard him with Turner and Constable as a forerunner of the Impressionists.

Peter De Wint (1784–1849)

Born in Staffordshire, he was of Dutch descent and at the age of 18 he went to London and was apprenticed to the same firm of engravers as Turner and Girtin. They were all occupied in hand-colouring prints. He met Varley who gave him instruction, and at Dr Monro's he was introduced to Girtin's work which had a lasting influence on his style.

De Wint was fondest of outdoor farm life for his subjects, and many of his pictures are of cornfields and people harvesting with wagons and horses at work. He was able to convey immense distance in his landscapes. His choice of colours was extremely pleasing. His green trees were rich with depth and sometimes had red showing in the shadows. His skies were often yellow and pink giving a late afternoon light, and the picture would have a serene glow of peace.

He is an example to us all to make brilliant clean water-colours and his work should certainly be studied. There are examples at the Victoria and Albert Museum. De Wint never signed his work as he said 'they are signed all over'. How true this is.

This concludes our survey of the five leading artists who attended Dr Monro's academy, but there is one special painter who as far as we know did not join the good doctor's classes; this was no less a person than John Constable.

John Constable (1776–1837)

Constable was one of the greatest masters of landscape painting in oils and because of this his water-colours are apt to be overlooked.

Born in Suffolk, he was an enthusiast of the rural scenery around his home of East Bergholt. He always studied the weather and skies were his special interest. 'The sky is the keynote, the standard of scale and the chief organ of sentiment – it governs everything' he said. His pictures are mainly of East Anglia but he painted in the Lake District and Hampstead where he lived for the latter part of his life.

He painted water-colours entirely for his own use to record subjects and use them for making oil paintings in the studio. He made many sky studies recording types of cloud formation. The Victoria and Albert Museum has whole rooms full of his paintings. He was one of the first painters really to copy nature as he saw it and use vivid greens on trees and grass. His water-colours are very spontaneous and sometimes dashed off with speed and this is what gives them their great charm. He certainly never developed a 'finished' water-colour technique and the paintings were never intended for exhibition or sale.

Consolidation

While the more recently mentioned water-colour painters were maturing and developing, important events started to happen in the art world. **The Royal Academy of Arts** was founded in 1768 and Sir Joshua Reynolds was its President. Water-colours could be accepted in the annual exhibitions but were not over encouraged as they were 'badly hung amidst pictures in oil and were surrounded by such inferior performances as were not deemed worthy of a place in the principal apartment'. So wrote **William Henry Pyne** (1769–1843) a good water-colour painter mainly of figure groups. At any rate there was now an opportunity for water-colours to be seen by the public and recognized as works of reasonable importance. Various small painting societies had been formed but nothing of great note, and the leading water-colour painters were agitating for more recognition.

At last in 1804 the **Society of Painters in Water-colours** was formed and W H Pyne was a founder member. This was a great step forward and their first exhibition in 1805 in Lower Brook Street was a tremendous success. Twelve thousand people paid admission to go to the exhibition and very many pictures were sold. The art of water-colour painting had at last been put on the map as an individual art in its own right. This exhibition sparked off an increase in amateur painters and the professionals found themselves with growing queues of pupils wanting to be taught. In 1881 Queen Victoria graciously decreed that the Society should call itself 'Royal'.

In 1824 the **Society of British Artists** was formed (later it became 'Royal') for painters in oil and in water-colour. In 1831 the **Institute of Painters in Water-colours** came into being (it also became 'Royal' in due course).

Other societies were formed in the nineteenth century and there was a general increase in the number of water-colour painters of a high order. Let us now catch up with the names of the most prominent of these men who were to consolidate the art which had reached such heights of perfection under Turner, Cotman, De Wint etc.

Neither **Thomas Rowlandson** (1756–1827) or **William Blake** (1757–1827) were landscape artists, so we will not dwell on them, but they both painted with great skill and should be mentioned.

Rowlandson was really a cartoonist. He saw the humorous side of everything that happened in the elegant age of the mid-eighteenth century, and his pen and ink and colour-wash pictures of people often had beautiful landscapes in the background. Blake was first and foremost a poet and philosopher; he dreamed dreams and saw visions, and his figure group pictures were often illustrations of biblical subjects and generally allegorical.

Samuel Prout (1783–1852) was a superb draughtsman and he is best known for his detailed water-colours of Gothic and Baroque buildings. Pen and ink was used but colour was strong and ink did not dominate too much. His figure groups were excellent.

Copley Fielding (1785–1855) was a most prolific painter. He was a pupil of Varley and his subjects were moors, lakes and mountains. At times he approached Turner with atmospheric effects. He was President of the R W S in 1831.

Clarkson Stanfield (1793–1867) was in

the Navy when young, and later became yet another scene painter. He is best known as a marine artist and did very capable work; he owes much to Bonington.

David Roberts (1796–1864) became famous largely because of the 250 lithographs that were made of his lovely paintings of the Holy Land and Egypt. The prints were hand-coloured and sold in large quantities and very beautiful they are. His draughtsmanship was supreme and his buildings and figure groups and even crowds were masterly. He could portray distance and a spacious scale with great assurance and his colouring was rich and effective. He was an R A and President of the RWS in 1830. Like so many excellent painters he started life as a scene painter. Louis Haghe was the brilliant lithographer of Roberts's pictures. He is rarely mentioned but deserves tremendous praise for his draughtsmanship.

Like Roberts **James Holland** (1799–1870) was an excellent draughtsman but was more fluid with his painting. His subjects were mostly architectural and his views of Venice are superb.

For **Richard Parkes Bonington** (1802–1828) there was triumph and tragedy: triumph because his water-colours were so superb and tragedy because he died at the extremely young age of 26. In his short life he advanced to an incredible standard of proficiency in water-colours, developing a sharp, clear style with a good colour sense, strong colour being applied at the key position in the composition. He painted for a while in England but most of the time in France, and he was particularly inspired by Venice. His treatment of buildings was extremely clever and effective, using the small brush to draw in detail. He adopted a dragged brush technique to create texture and he was soon copied in his style by his contemporaries. He has been an inspiration to water-colour painters all down the years to the present day. Many books have been written about Bonington's work and one cannot expect to cover his life in a brief note. To all aspiring young water-colour painters I would say: go and look at his pictures as soon as you get the chance. They can be seen at the Victoria and Albert Museum and many other galleries.

George Chambers (1803–1840) deserves a very high place amongst marine painters. He was the son of a Whitby common seaman and he went to sea at an early age. He always wanted to paint as a small boy and he became extremely expert at portraying water and waves and sailing craft.

Thomas Shotter Boys (1803–1874) was apprenticed to an engraver which explains his meticulous draughtsmanship. Most people know the beautiful London series of prints of his work. He was a master at street scenes and derived much from Bonington.

Samuel Palmer (1805–1881) was brought up in an atmosphere of English literature and he had a vivid imagination. His paintings were at first conventional and very beautiful. Later he became rather a visionary and his paintings became half nature and half fantasy and he mixed his medium, painting in oils and water-colour. He met Blake in 1824 and this gave his imaginary work more impetus. Like Blake he does not contribute very much to the mainstream of water-colour painting but his work is outstanding in that it is unique and different from anything else.

John Skinner Prout (1806–1876) was a nephew of Samuel Prout. He usually painted architectural subjects with his uncle's skill but with much more freedom and looseness; this makes his work extremely attractive. He owes much to William Callow.

William Callow (1812–1908) shared a studio in Paris with Shotter Boys and acquired his liking for street scenes. He travelled and sketched much in Europe and also in England and his architectural subjects were brilliantly executed with good figure grouping and composition. His colouring was delightful and his work is worthy of considerable study. He followed very much the style of Bonington.

Edward Lear (1812–1888) had a unique style using pencil, pen and washes of water-colour. Some of his more finished works are very telling indeed. He was a genius of many parts: a scholar of natural history and birds, a writer of nonsense books of rhyme, a skilled oil painter and an extremely good linear water-colourist. He gave lessons to Queen Victoria.

T M Richardson (1813–1890) painted magnificent distant views rather in the technique of Turner. He painted in Switzerland and Italy as well as England and Scotland. His work is beautifully executed with a wonderful

colour sense, especially in the blue distances. He has been rather overlooked by the general public and is worthy of considerable notice.

Hercules Brabazon Brabazon (1821–1906) was a country gentleman of means who was much travelled and painted water-colours not for sale but for pure enjoyment. He is referred to as an amateur painter but his pictures are really most professional. At the age of 71 he had his first one-man exhibition in London showing 66 water-colours. It was an immediate success and he became famous overnight. One sees the influence of Turner, De Wint and David Cox and his style is delightfully loose with colour being slapped on wet with touches of white paint to give highlights.

Thomas Collier (1840–1891) was painting in the 1860s to 1880s at the time when Victorian painting was at its height and the fashion was for highly finished and stiff work. Collier ignored this and went back to Girtin, De Wint and David Cox for his inspiration and he is therefore an important link in the mainstream of water-colour painting. His skies were particularly good, showing rain and cloud and wind and he was fond of open moorland subjects. His washes and brushwork were free and colouring was rich and translucent, most unlike that of his Victorian contemporaries.

John Singer Sargent (1856–1925) was an American born in Italy, trained in Florence and Paris, who settled in England for most of his life. He was the premier portrait painter of his day and he loved to paint in water-colours as a change from oil painting and to escape from the fashionable Edwardian world. He excelled greatly at water-colours and his Venice pictures are masterly, showing a liquid dashing technique of attractive wet washes and strong colours.

P Wilson Steer (1860–1942) is in some ways like Sargent in that he would paint straight off in wet water-colour without any pencil. He studied in Paris but lived in England. His style was Impressionist in its simplicity and with broad washes, never attempting anything too complicated. He knew his limitations, but that does not detract from his very successful pictures. He had a great following and was the doyen of the New

English Art Club which he helped to found.

Cecil Hunt (1873–1965), was a barrister who managed to be a successful water-colour painter as well. He was a member of the RWS and the RBA and specialized in mountain subjects. He painted mountains all over the world – Switzerland, Spain, Scotland – and he used gouache as well as water-colour and produced some extremely dramatic effects with strong dark colours. He captured the strength and dignity of mountains with simplified brush strokes.

Gerald Ackerman (1876–1960) was a painter in the true English Water-Colour School manner. He was a great painter of skies like Collier but I think Ackerman's skies were even more attractive. He lived in Norfolk and was constantly painting the marshes along the north coast and this locality is noted for its lovely skyscapes. He had a wonderful appreciation of light and tone values which were the key to his pictures.

We are getting to the end of the nineteenth century now and this survey of the English Water-Colour School is nearly done. I would just like to mention three more names for you to make a note of and look at their paintings when you get the chance.

Leonard Squirrel (1893–1979) was a skilful draughtsman and had a wonderful eye for colour. Born in Suffolk, his paintings are mainly of East Anglia but also of all over the British Isles. His usual method was to draw on the spot and paint in the studio. This allowed him to arrange his colour scheme harmoniously rather on the lines of Cotman.

John Nash (1893–1977) also had leanings towards Cotman in his blocks of tree foliage and bare tree trunks giving shape and pattern to the pictures. He painted in light colours, often yellows and browns and had a very individual style.

Charles Knight (1901) born just into the twentieth century, is another follower of Cotman but also of De Wint. He is a spontaneous outdoor painter who uses little pencil and draws with the brush. He loves trees and farm buildings and his landscapes have great strength and sharpness of colour. He uses many varieties of paper and technique.

I think I have mentioned about 50 painters in

this opening chapter on the water-colour tradition. I realize it is a long list, but it could have been longer still; there are many painters who have been left out. Some of the painters many of you will know already. The main object has been to awaken your interest in the great tradition of water-colour painting that we all of us inherit, be we beginners or experienced painters. The main thread of pure water-colour painting has been preserved through two and a half centuries from Paul Sandby in 1730 to the present day. We must go on painting water-colours, studying the early painters and learning from them and their enthusiasms and then painting the landscape in our *own way* and being equally enthusiastic to get down on paper what we see and are thrilled by. We don't want to be copyists, we want to be innovators if we can. There are many excellent water-colourists painting today all over the world – let us join with them in a great endeavour to excel at all costs in a medium which is difficult but such a beautiful art if we can but master it.

TWO

Materials and equipment

There is something very exciting about the idea of equipping oneself with water-colour painting materials and visiting a good art shop for the purpose. There is a danger of obtaining the wrong type of materials, dating perhaps from the days when a fond relation gave one a paint-box with all the wrong bright greens and reds in it and certainly the wrong type of brush.

I would like to give a few suggestions which you may find helpful:

Drawing equipment

1 Lead pencils – HB, B, 2B, 3B, 6B

2 Carbon pencil, 2B

3 Black conté pencil No. 2

4 Carpenter's pencil chisel point, 6B

5 Conté charcoal pencil – soft

6 Box of charcoal – willow sticks

7 Conté black chalk, square section 5 cm (2 in.) long

8 Fixative spray liquid for 'fixing' drawings and preventing smudging

9 Pocket knife with two blades

10 Sharp cutting knife with separate blades by Stanley or Edding. Very useful for cutting thick paper and cardboard and for scratching out parts of a water-colour

11 India rubber – good quality such as Faber
Note – this rather long list need not all be purchased at once. The important items are Nos 1, 6, 8, 9 and 11.

12 Penholder and selection of nibs. Try George Hughes Spoon Point and William Mitchell Italic, various thicknesses – some-thing that moves fast over rough paper with not too sharp a point. I often use an old fountain pen.

13 Felt pens – various thicknesses. Edding make them lightfast and waterproof; the latter is essential if to be used with water-colour.

14 Indian ink in Black and Sepia; this is waterproof.

Figure 1 shows various pencils, pens including a felt pen, a stick of charcoal and an india rubber. For holding my pens and pencils I use a tin box that is provided by pencil makers for holding a dozen new pencils. I have at least two in use to take sketching with me if I am travelling far from home. Any other cardboard box will do, but it is a good idea to always have a box ready with pencils etc in it.

15 Sketch books – use sketch books with hard backs and a spiral wire hinge so that pages turn right over. This makes it a lot easier for drawing. Sizes 12.5 cm × 17.5 cm (5 in. × 7 in.) are very handy for the pocket. Other good sizes are 17.5 cm × 25.5 cm (7 in. × 10 in.) and 25.5 cm × 35.5 cm (10 in. × 14 in.). The paper can be cartridge or thicker water-colour paper. Exact sizes vary with makers.

Painting equipment

Paint box Figure 2 shows the best type of black japanned box to get and I would advise nothing smaller than 20 cm × 7.5 cm (8 in. × 3 in.) when closed. This box holds 12 compartments for 'whole' pans of colour. It will take double that quantity or 'half' pans but the larger 'whole' pans are more practical and you will not require more than 12 colours as I shall show later.

You can buy colour pans pre-filled by the makers or you can get empty pans and fill

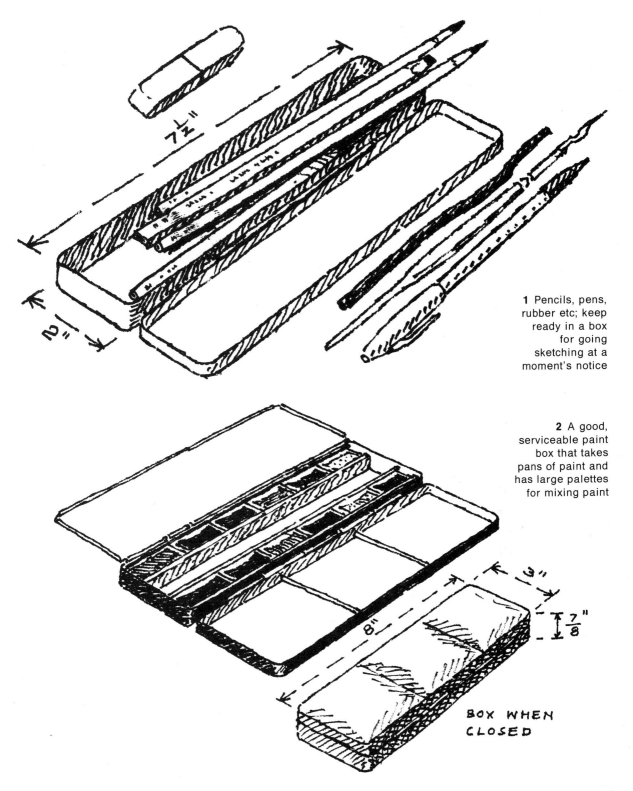

$7\frac{1}{2}''$

$1\frac{1}{2}''$

1 Pencils, pens, rubber etc; keep ready in a box for going sketching at a moment's notice

2 A good, serviceable paint box that takes pans of paint and has large palettes for mixing paint

$3''$

$\frac{7}{8}''$

$8''$

BOX WHEN CLOSED

them yourself from tubes of colour. I always prefer the latter course as your colours are then more moist and ready for use. I usually top up the pans before going out to paint.

The box has three dished palettes for mixing colours in one lid, and the other lid is a flat mixing palette. If you can get an even larger box do so as this will give you bigger mixing areas. In the studio you can supplement mixing areas with extra china palettes or a white saucer or two.

Colours I give below my choice of actual water-colours which I have found over the years suits my kind of painting and which I use in all the pictures illustrated in this book:

 (i) Cadmium Lemon
 (ii) Cadmium Yellow
 (iii) Raw Sienna
 (iv) Burnt Sienna
 (v) Burnt Umber
 (vi) Light Red

 (vii) Indian Red
(viii) Rose Madder
 (ix) Cobalt Blue
 (x) French Ultramarine
 (xi) Prussian Blue
 (xii) Paynes Grey

These are all what the makers call 'durable' and not likely to fade. They make some colours which are called 'fugitive' meaning 'likely to fade' and I would advise against these. The fugitive range includes such colours as Chrome Yellow, Carmine, Mauve and Vandyke Brown.

After some years of practice and experiment you may choose different colours to those on my list and it is quite natural that you should do this. My list is only a guide which does not have to be followed. But I would advise not having more than 12 colours. I discuss these colours in some detail in Chapter Four.

When you are staying away on a sketching

3 Water jar and brushes and methods of packing when going sketching

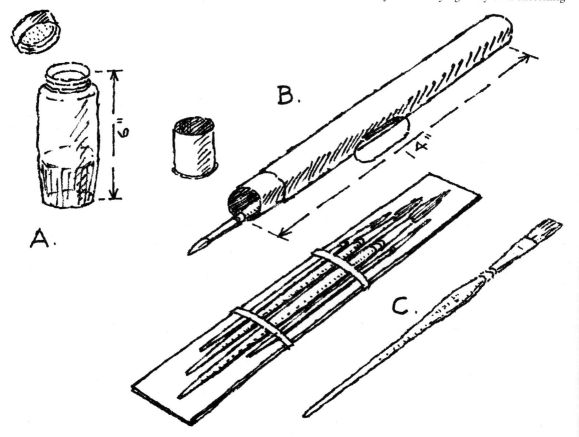

trip don't forget to take a box full of tubes of paint with which to replenish your paint box.

Brushes These items of equipment are the most important of all. You can manage with cheap pencils, poor colours and inferior paper but if your brush will not paint as you want it to then your efforts will end in failure.

You must have a brush that springs back to its original shape and has a good point to it. The best brush is made of red sable and this is expensive. There is a second quality sable which is quite good. Then there are ox hair and squirrel hair which tend not to keep their shape. It is better to have only three brushes of best sable than ten brushes of squirrel, so try to afford the best if you can. They must be looked after carefully. After use wash them out well in clean water, shake out and draw the hair into position with the lips. Then place the brushes on a table or cloth with a slight slope downwards towards the hairs. This allows them to dry out and the roots of the hairs will not rot or mildew. If put upright into a glass jar they will suffer in this way.

There is one other type of brush made of nylon. This is much cheaper than the sable and does keep its shape but does not hold water quite so well. It is worth having one or two for second best.

The sizes of sable brushes that I recommend are: Nos 0, 1, 3, 5, 7, 9 and 12. As a luxury I do have a No. 16 but they are very expensive in sable and you *can* do without it. To start with you could manage with a minimum of four brushes, Nos 1, 5, 9 and 12.

There are three other brushes I like to have, the first being a squirrel hair brush No. 8; this is a large floppy brush when full of water and is useful for skies and sometimes for initial washes or for simply wetting the paper. Secondly a small flat section hog hair oil painter's brush is useful for lifting off colour from the paper, such as white cloud over a mountain or other items which I mention in later chapters. These two are not expensive brushes. Thirdly I find a 'flat' sable brush 12 mm ($\frac{1}{2}$ in.) wide is most useful for painting thin blades of grass in foregrounds and for other things mentioned later. This costs about the same as No. 9 ordinary round sable and it is illustrated in figure 3 (C). This illustration

also shows a way of dealing with your brushes when you go out painting. Cut a really stiff piece of cardboard about 7.5 cm (3 in.) wide and in length a little longer than your longest brush. Lay the brushes on the cardboard and use a few rubber bands to hold them in place. You may require a second piece of cardboard if you have about seven brushes.

Figure 3(B) shows an alternative way of holding brushes. You can buy a metal case with a lid; it is tube shaped and holds a great many brushes of any length. I have had one for many years and it has given good service. But one word of warning: do not let the hair end of the brushes slide up to the top and press against the lid or else they will become bent. Always pack the case slightly sloping with the wooden end downwards; this is most important. Your brushes are the *most valuable* part of your equipment.

Painting water The glass jar in figure 3 (A) is an old coffee jar with a watertight screw top, ideal for carrying painting water as it does not spill. Any other similar jar will do but do have it large enough; it should be at least 15 cm (6 in.) high and about 7.5 cm (3 in.) in diameter. I usually take two jars with me full of water. You may want some clean water at the end of a painting for some special item or you might wish to do a second picture with no stream handy to give a fresh fill of water.

Paper

Water-colour paper A water-colour *can* be painted on any thick white drawing paper but it is best to use the paper specially made for water-colour use. This has a degree of absorbent quality about it, and different papers are given different surfaces to suit the type of painting you are going to do.

Textures Papers are made with three types of surface: (a) 'Hot pressed' which is smooth; (b) 'Not' which is medium-rough and (c) 'Rough' which has a very distinct tooth to it. The 'Not' is very popular amongst artists and I prefer it myself, but I often use 'Rough' for broad open landscape subjects.

Thickness It is important not to use a paper that is too thin as this will cockle or buckle when wet. The thickness is described by weight in the trade and a fairly average weight of paper is 140 lb. (The way this is calculated is that a ream, ie 500 sheets, of paper 55.8 cm × 76.2 cm (22 in. × 30 in.) weighs 140 lb).

I use 140 lb paper for small pictures, say 20 cm × 30 cm (8 in. × 12 in.) although even for these I feel happier with 200 lb paper. For the larger picture, about 30 cm × 46 cm (12 in. × 18 in.), I prefer 300 lb and this is as thick as cardboard and does not buckle at all, even with heavy water-colour washes.

Buying paper Most makers of paper supply it in sheets 22 in. × 30 in., called an Imperial sheet. It is much more economical to buy sheets of water-colour paper this size rather than in large sketch books of say 35.5 cm × 51 cm (14 in. × 20 in.) as you pay a lot for the binding.

If you cut an Imperial sheet in half it becomes 38 cm × 76.2 cm (15 in. × 22 in.) and this is a very convenient size on which to paint a picture. Another good size to work on is to cut the half sheet in half again giving you 28 cm × 38 cm (11 in. × 15 in.). This is a suitable size for a smaller picture.

Hand-made and machine-made papers All water-colour papers were at one time hand-made from rags. This method still gives the best quality paper but because of the high cost today, firms now produce machine-made papers as well:

1 T H Saunders: mould-made from rags, about 200 lb weight.

2 Bockingford: mould-made from cellulose fibre about 200 lb weight.

These papers are not too expensive and I sometimes use them. I think I have a slight preference for Saunders.

I suggest the following hand-made rag papers:

3 Barcham Green RWS paper 140 lb and possibly 200 lb. Good paper. Made in 'Not' and 'Rough' surface.

4 Barcham Green Pasteless Board paper. Made in 'Not' and 'Rough' surface and in 200 lb and 300 lb. I like the latter very much but it is expensive.

5 Barcham Green Turner Grey: 'Not' surface and about 140 lb weight. Very suitable for pen and wash work.

6 Two Rivers toned paper: colours are white

4 A serviceable folding sketching stool and chair

or sand or grey. 'Not' or 'Rough' surface. 140 lb or 200 lb. Rather good paper.

7 Arches French paper: 'Not' or 'Rough' surface. 90 lb, 140 lb and 300 lb. This is a very slightly cream paper and it is the one I like best, especially the thick 300 lb paper, but it is, I am afraid, expensive.

All the above papers from No. 1 to 7 are sold in sheets 55.8 cm × 76.2 cm (22 in. × 30 in.) and can be obtained from any really good art shop. A shop will probably have several other makes of paper to show you and it is a good idea to buy a variety and do experimental paintings on them and find out which you like best.

In Chapter 13 on Framing and Exhibiting I give more details about cutting up paper and suggested sizes for your actual painting.

One more word about paper: if you cannot afford the 300 lb thick papers, then you can mount your paper on hardboard or a drawing board to prevent it cockling when wet. The method of mounting is as follows: first damp the paper all over thoroughly with a sponge. Wait until the paper is really wavy and cockled: this may take five or ten minutes. Then lay it on your board and stick down all four edges with masking tape or brown gummed paper.

Your paper, when absolutely dry in about 20 minutes, will go completely flat and will stay stretched in this way while you paint on it. At the end of painting you cut the paper free with a knife.

An alternative to sticking down the paper is to use drawing pins and pin the paper to your board at about 5 cm (2 in.) intervals.

A stool or a chair Many painters stand up to paint their pictures and use an easel. I sometimes stand, but more often I prefer to sit and have my board on my knees.

I use a metal folding stool as shown in figure 4A. This is not the most comfortable stool in the world but it has the advantage of being able to be folded up absolutely flat and packed into a fairly small carrying bag.

If I haven't far to walk I much prefer to carry a folding chair as shown in figure 4B. This folds flat and can be carried under the arm with your painting paper and board. Its big advantage is that it is a low seat near the ground and enables one to have one's paint box and water jar etc *on* the ground within easy reach. An old raincoat or rug can be spread on the ground to make a flat place for the paint box, free of long grass or stones etc. This is only necessary if you cannot find a reasonably flat, tidy place to sit.

I sometimes find that the car is in a convenient place from which to make one's picture and I can use the back of it as an easel. The board rests almost horizontally which is what I prefer for water-colour work. If the car cannot be got to a good position I have an old oil painter's easel which will set to the horizontal position and has a convenient extension drawer on which I can rest my paint box and water jar. There are many types of easel on the market and an art shop will usually allow you to experiment with them before purchasing.

Carrying bag In figure 5 I show a simple carrying bag which you can buy almost anywhere. It has a shoulder strap and handles and its size, 43 cm × 28 cm × 15 cm (17 in. × 11 in. × 6 in.), is quite small but large enough to hold *all* one's painting equipment including the folding stool but not, of course, your longer sheets of paper.

5 A good type of carrying bag for all your painting equipment

6″

17″

19

When you are going away for a week or so on a sketching trip you will want to take a lot of the items I have mentioned, but when it is just a day out sketching then the list can be cut down considerably. You do not want to have too much of a heavy load when you are walking about looking for a good subject or view point.

I will just mention a couple more items. A small sponge is invaluable for damping the paper, or wiping out or cleaning your paint box. And blotting paper is very useful when painting skies (see Chapter Nine).

Painting a simple picture with only three colours

I have taken as a subject a view of a Cotswold stone barn standing in fields with a distant view beyond (see colour plate 1 facing page 96).

I am going to use three colours only, Rose Madder, Cadmium Lemon and Prussian Blue. These are 'primary' colours; any reds, yellows and blues are called primary colours. I will explain later about 'secondary' colours and 'tertiary' colours.

I settle myself on my sketching stool or chair in the field and take a 28 cm × 38 cm (11 in. × 15 in.) piece of Arches paper 140 lb weight 'Not' surface and get to work with an HB pencil (Stage 1). I decide to place the barn ground line about one-third the way up the picture leaving the sky occupying two-thirds. This is always a very happy proportion in landscape but of course can be made to vary considerably according to the subject.

The size of this actual *picture* is approximately 20 cm × 30 cm (8 in. × 12 in.). This is a good fairly small size to start on and makes it easy to handle washes of colour. See colour plate 1, facing page 96, Stage 1.

The barn is drawn in first a little to the left of centre; it is never a good thing to have your main feature exactly central. I leave room for the large foreground tree on the left, but do not draw this until I have put in the trees behind the barn and the various receding trees and fields on the right. These are not drawn too strongly as they will be painted with fainter colours, being more distant. As you become more experienced you can do less and less preliminary drawing and the pencil work can be fainter.

Even before you draw anything at all it is a good idea to pretend your forefinger is a pencil and draw the positions of the main objects with your finger on the blank sheet of paper so that you can gauge how big to make them and

see that they will fit into the size of picture you have in mind. This is a very useful idea, and I nearly always use the forefinger trick when I am starting a picture.

We have now finished the preliminary drawing work and can start painting.

I put my paint box on the ground close to my right side because I am right-handed. (Reverse this if you are left-handed). The water jar is placed close above the paint box and the brushes immediately to the right of it or below it. All is made handy for quick action. Once you start painting you want everything as conveniently to hand as possible.

I am suggesting using three colours only in this exercise so as to avoid all the complications of too much colour mixing and we can cover the main principles of water-colour painting quite adequately by proceeding in this simple way.

First I am going to paint the sky as this is the lightest part of the picture. You should always work from light to dark in watercolours and paint the very darkest items last of all. In oil painting you can paint your darks as soon as you like and paint light colours on top of them, but never try to do this with water colours or you will lose the transparency and charm of the medium.

It is a cloudy day with a west wind and clouds are moving quite fast from left to right and the sun is coming from the left. I mix up a light grey by mixing all three colours together using a No. 12 brush. You will find by adding a little of one and a little of another that gradually you arrive at a pleasant warm grey.

I do not wet the paper first but apply grey washes to the left-hand and right-hand sides bringing them down towards the horizon. I add some clear water to the edges allowing the grey to run.

Then with the central sky area still dry I

dilute some pure Prussian Blue, not too strong a mix, and apply it where shown. I keep a short jagged edge to the white cloud and allow the blue to run into the wet grey areas to right and left. I paint a separate blue area on the further left into the still damp grey wash; this creates a grey cloud with *blurred* edges.

I then mix a darker grey with the same three colours, making it stiffer and stronger by using less water, and I paint the dark cloud in front of the white cloud as shown. This gives a sharp effect on the dry white paper but runs off to the right into the still damp first grey wash.

Then comes a slightly more pink-grey wash for the lower clouds near the horizon washed over the trees and roof of barn, but leaving the walls of the barn dead white.

Next I mix a green-grey with the same three colours and wash this over the fields in the lower part of the picture taking care not to let it run into the sky wash which is almost dry. This completes Stage 1 as shown in colour plate 1A, facing page 96.

Just a word about skies before we go on. With a windy, fast-moving sky one cannot hope to copy an exact cloud formation which constantly repeats itself: in this case a white cloud coming up behind a dark grey one with irregular areas of blue sky around it. You will find on a sunny day that the clouds near the horizon are often pinkish or yellowish.

The white and dark grey clouds are purposely placed to the right of centre of the painting to give a happily balanced picture; this is all part of the 'composition' which I shall be explaining at more length later.

When everything is quite dry I proceed with Stage 2 (colour plate 1B, facing page 96). I mix a warm grey for the barn roof; this mix is mostly Rose Madder and Prussian Blue with only a touch of Cadmium Lemon. The lower barn extension on the left has a slate roof which is a purple-blue colour using Rose Madder and Prussian Blue.

Then I paint the distant field on the right a light green using the Cadmium Lemon and the Prussian. The field in front of the barn is yellow-brown stubble and I mix all three colours for this. The foreground field of grass is given an overall wash of light dull green using mainly the yellow and blue and just a touch of Rose Madder.

I have been using a small brush No. 3 for the roofs and a No. 7 and 9 for the fields.

Next I mix a light blue grey using Prussian and a touch of Rose Madder to put in the distant smudges of hill to right and left of the picture. These must be allowed to dry out completely as we do not want any colours to 'run' on them.

You will notice that I am only using the *lighter tone* colours so far, as we must always keep our dark colours till last.

Water-colour painting is all about *tone values*, the actual colours are of secondary importance. Look at your view from time to time through half closed eyes and you will separate the darks from the lights more easily.

We now start using darker colours and I mix a medium tone of green. A very rich green is produced with Cadmium Lemon and Prussian and this will want toning down a little with Rose Madder. With this I paint in the blocks of trees immediately behind the barn taking care to leave the clear shape of the barn; then the trees to the right, gradually lightening the colour as the trees go into the distance, and using more water and more blue for the farthest off. The distant trees on the left are also painted in with grey-blue colour.

When all is dry I mix a warm, grey colour for the various shadows on the barn: the shadow cast from the projecting building on the left and its wall in shadow and the shadows on the right of the big projecting gable and the lean-to. There is also a shadow line under the eaves of the main roof and the gable eaves. I have been using a No. 3 brush for the trees behind the barn etc and I now take a No. 1 brush and mix an almost black colour using all three colours and a stiff mix, ie very little water. I want this to do some brush drawing and I draw in the ground line of the hedge to the right of the barn and a ground line of the nearer hedge in line with the big left-hand tree. These lines are fairly thick, broken and uneven, not continuous or straight. Further thinner lines are drawn along the bottom of the barn buildings, taking care to break these also, and a few similar lines to the distant fields.

Then, with a No. 3 brush I paint in the hedges using a dark brownish mix varying to green and almost red in some places. I take the

small No. 1 brush again for various bits of timber fencing. The dark green shrub-like tree on the extreme right is painted in at the same time as the hedges.

The picture is now beginning to take shape and it is time to paint the big ash tree in the left foreground. The trunk and branches are drawn fairly clearly in pencil so I can start by painting the foliage. I use a No. 3 brush heavily loaded with a strong green mix and plenty of water. These three colours we are using make wonderful greens as you will soon find when you try mixes for yourself.

I hold the brush sideways and sweep the brush from right to left, pushing it and dragging the colour quickly over the textured paper; the result is rough edges and irregular shapes which can be fairly well controlled to give the tree shapes you want. At the same time, using the same colour, I indicate ivy on the tree trunk. I then apply a rather darker green to some of the right-hand side foliage; this is the shadow side of the tree and gives life and variety to it. Now the trunk and branches are painted with the No. 1 brush using a stiff dark brown mixture.

Next I mix a dark green and with the No. 3 brush I overpaint the tree behind the barn at the right-hand end; and the bush near the ground even darker using mostly Prussian with a touch of yellow and red. This brings emphasis to the centre of the picture and sharpens up the light on the barn.

It is time now to put in the cloud shadows on the fields; the stubble near the barn receives a wash of brownish colour and the foreground green field quite a strong yellow-green wash with an indication of rough grass in the bottom right-hand corner. I use a No. 5 and a No. 7 brush for this work. You will note that some of the foreground green wash is quite pale; I refer to the part farthest away; this gives distance but is also pale because cloud shadows do vary in intensity considerably, a thin cloud giving a very light shadow and a solid thick cloud giving quite a dark shadow. A ground shadow from a building can be much darker still of course.

The picture is now nearly complete and just wants the final punch of darks in the big dark doorway of the barn and the smaller doorways. Our three colours will make a very

good dark brown if mixed properly and stiffly. Use a small brush for this work (a No. 3 is about right) and do not bring the colour all down to ground level but stop short, leaving small light areas indicating farm implements or tufts of straw or an object on the ground catching the light. The little slit windows high up on the barn are indicated with the No. 1 brush. And finally a broken wash of warm yellow is placed over the left-hand part of the high barn wall; this throws accent onto the projecting door gable which is left pure white.

So our picture is completed and I think you will agree there is a considerable variety of colour, and it is a harmonious picture because we have used the same three colours for mixing the sky as for the ground. There is a three-dimensional feeling, that is to say you can feel the distance going away from you; this is due to the faintness and blueness of the more distant trees and hills and the stronger warmer colours of the nearer features. Note the touch of red in the green cloud shadow; this is a favourite trick of De Wint and you often get a little area of brown soil showing through grass.

Note also the composition of the picture, that is to say the balance of it. The barn is slightly left of centre and the foreground tree gives extra weight towards the left. But the white cloud is to the right and also the dark cloud in front of it, and the darker green foreground shadow with the rough grass catches the eye and gives a subconscious pull to the right. We therefore end up with a happily balanced picture.

I often turn my picture upside down when I have finished it and this reveals the tone values in a surprising way. You can tell more clearly what requires strengthening and what colour can do with toning down. When you are back in the studio you can look at your picture through a mirror and this can reveal mistakes in a similar way. Another trick is to look at your actual subject upside down standing with your legs apart and your head down looking between your legs. It is remarkable how very blue the distance can look and how strong and in focus the foreground objects become. It is well worth trying this idea especially when your subject is a distant landscape.

I hope you will try and paint several

pictures using only three colours, not always these three but another three; but they must always be red, yellow and blue in order to give you a full range of colour mixes. This exercise will, I think, persuade you that you do require very many colours and the list of 12 colours I have given in Chapter Two will be ample.

As you proceed with your painting experience you will no doubt experiment with other colours not mentioned by me and change your selection accordingly. For instance I do not use any of the made-up greens provided by the colour makers as I prefer to mix my own, but a number of experienced painters like to use Viridian or Emerald Green straight out of the tube and tone these down with other colours to give the required result. I don't personally find this necessary, but it is all a matter of taste and your own particular colour sense. Some artists like to use Black but again I find I can obtain dark enough colours by mixing, and I can do without it.

I said at the beginning of the chapter that I would tell you about secondary and tertiary colours. The primary colours are red, yellow and blue. The *secondary* colours are purple, orange and green and they are obtained by mixing red and blue for purple, red and yellow for orange and yellow and blue for green. The *tertiary* colours are produced by mixing together your secondary colours in pairs and you obtain a series of subtle colours such as browns, greys and blacks and variations of green etc. In the next chapter I give some ideas for more extensive colour mixing.

Colour mixing

Assuming that you have now painted several pictures with three colours only and have got thoroughly conversant with mixing these colours quickly, you can have a go at using the full range of 12 as mentioned in Chapter Two. I am sure you will now feel these are more than enough to choose from and that it is not necessary to crowd your paint box with more than 12.

I will go through each colour in turn giving a few ideas about colour mixing.

1 *Cadmium Lemon*. This is a lovely light yellow; it is a strong colour and excellent for making greens. When mixed with Prussian Blue it gives a vivid green and when with French Ultramarine a slightly duller green. Mix it with Cobalt and a lighter green is produced.

You don't often require these greens for fields or trees without toning them down with a little red. Try using Light Red, Indian Red or Rose Madder. Indian Red produces a very dark green such as may be required in deep shadow foliage.

When mixed with Light Red a warm yellow is produced and when with Rose Madder a good orange results.

2 *Cadmium Yellow*. This is a deeper yellow and a *very* strong colour. When mixed with the blues and reds mentioned at item 1 you will get the same sort of greens but ones which are much stronger and not required so often.

When it is mixed with Prussian and Rose Madder in a stiff mix (i.e. a lot of colour and not too much water) you get a dark brown-green colour rather useful for the branches and shadow lines under the eaves of buildings or when drawing parts of a landscape with a small brush.

It gives a strong orange when mixed with Rose Madder.

3 *Raw Sienna*. A very useful colour for many purposes. Mix it with Light Red for a pleasant warm dull yellow for a stubble field or a plaster wall on a building. Add a little Cobalt Blue to these two and you obtain a dull yellow, very useful for a background wash over a whole picture that may require a first overall tone.

Mixed with Prussian you get a good grass green but do not use too much Prussian.

It is a good yellow for sandy beaches but may require a little Burnt Umber added for darker stretches. It is useful for bringing yellow into skies.

4 *Burnt Sienna*. When mixed with Cobalt it gives a delightful warm brown useful for mellow brick walls or autumn trees or dark reeds on a marsh.

It makes a splendid dark green when mixed with Prussian. This is useful for summer trees that are turning dark or for moss on a Yorkshire moor. It can be used neat or with a little Raw Sienna added to indicate bracken in autumn.

5 *Burnt Umber*. A very useful colour for innumerable purposes. A light wash of this colour or with a touch of Cobalt is useful for a first background over buildings or roads. The same wash is good for beaches that often are not as yellow as you think.

It is excellent mixed with Prussian for dark trees or ivy or branches.

It is useful for cart tracks when mixed with Cobalt more strongly than first mentioned and also for the earthy edges of a road with grass verges. It gives a good sepia colour when mixed with Ultramarine and even darker, almost black when more Ultramarine is added. This can be useful for dark door openings and windows.

For grey clouds in skies it is very good when mixed with Ultramarine about half and

half with plenty of water. This gives a pleasant warm grey and can be varied in strength according to the clouds.

6 *Light Red*. This is a most useful dull brick red colour and when mixed with Cobalt gives a pleasing warm grey very appropriate for distant hills and also for shadows on walls or roads.

When mixed with Cobalt and Raw Sienna together you obtain a useful neutral colour suitable for shadows on yellow or brown walls or for distant trees.

Mixed with Ultramarine you get a much stronger warm grey-blue most suitable for background trees or hills that are not too distant. This is a useful colour in mountain scenery.

A very pleasant grey is produced when mixed with Prussian.

7 *Indian Red*. This is an attractive rich dark red and can be used as 'local colour', ie for a woman's coat or the colour of a red door. It can also be used as mentioned under Light Red (6) and will give a rather purple colour when mixed with Ultramarine which can be useful for shadows on distant mountains.

It was mentioned at item 1 (Cadmium Lemon) and 2 (Cadmium Yellow) for toning down or darkening greens, especially the latter.

It is also useful for mixing with browns and yellows for roof colouring where red tiles of differing shades occur.

8 *Rose Madder*. This is slightly pinker than the well-known Crimson Lake and is an extremely useful colour when used with re-straint. It can produce what I call a cheap purple effect when used with blue, which is to be avoided at all costs.

Used in mixing greens as mentioned at items 1 and 2 is delightful. It is helpful in mixing with shadow colours and gives a transparency which is attractive. When added to Cadmium Lemon it gives a pleasant warm yellow and added to Light Red gives a good increase in strength to a red roof.

It is a colour to be used in small doses but quite often.

9 *Cobalt Blue*. We now come to the range of blues. These have been mentioned in the other colour mixes but we haven't said much about skies. Cobalt blue is one of the artist's most well-known and well liked colours. It would seem the obvious colour to use for an English blue sky, but strange as it may seem it usually requires toning down with a little Burnt Umber or Burnt Sienna or for a warmer blue a little Light Red. A blue sky is very seldom a really bright blue in England.

Cobalt is particularly good for mixing greys as mentioned at 6, mixing it with Light Red.

10 *French Ultramarine*. This very strong blue can be used in skies at a high point only in the sky and toned down with grey. It is most useful in a cloudy grey sky where small peeps of blue show through the clouds. The sky is fainter blue towards the horizon as I shall mention again in Chapter Nine.

It is useful for greens and for mixing dark colours generally as already mentioned in previous colour mixes.

11 *Prussian Blue*. This is an even stronger colour than Ultramarine and must be used a little carefully. It is a greenish blue and useful in the lower part of a cloudy sky where blue is showing through but plenty of water should be mixed with it in this instance.

It is excellent for mixing greens using yellow or Burnt Sienna or Burnt Umber as previously mentioned. Very pleasant greys can be obtained as was shown in Chapter 3, when it was one of our three colours.

12 *Payne's Grey*. Nothing has so far been said about this colour and its use is fairly limited, but none the less it can play a useful part at times.

There are days in Britain when the blue sky takes on a less blue look and Payne's Grey can be just the colour when watered down. Probably there are thin wisps of grey cloud or mist about which gives this grey-blue to the sky.

It can be run into the sky area when the white paper has been previously wetted and the effect can be very pleasing; but more of this under the heading of skies later.

Payne's Grey, when mixed with Cadmium Lemon or Cadmium Yellow, gives a good dark dull green. Mixed with Light Red it gives an interesting dark brown. It can be a useful colour for mountain scenery on a dull day when the hills are rich with dark colours and can sometimes be almost neat Payne's Grey under heavy cloud shadows.

I should mention here that Payne's Grey by Winsor & Newton is the one I prefer and

is slightly bluer than the one by Rowney which is blacker. Different colours by different makers do vary very slightly and you get to know the ones you like best.

All the colours mentioned above are what is known as 'durable colours', meaning permanent and not liable to fade when a picture is subjected to strong daylight for long periods.

As I have mentioned before, some colours are called 'fugitive' which means that they do fade. Chrome Yellow comes in this fading catagory and so do Carmine and Vandyke Brown which I strongly advise you not to use.

What I would like you to do when you have read this chapter is to settle down in your studio, or the room where you paint, and try out all the colour mixes I have mentioned here. Take some sheets of cheap cartridge and systematically work through all the mixes, adding some of your own. This may take a whole morning but it will be time well spent. Be sure to mix the colours on a clean palette every time and every now and then wipe the palettes clean with a wet sponge. There is nothing worse than using a dirty paint box, it can lead to getting 'muddy' colour mixes. Always aim at producing clean, clear colour mixes and never mix more than three colours together to produce the colour you want – there are exceptions but very few.

A painter friend of mine recently went to a De Wint exhibition and was given a list of the water-colours used by De Wint; they are as follows: 1 Indian Red; 2 Vermillion; 3 Purple Lake; 4 Yellow Ochre; 5 Gamboge; 6 Brown Pink; 7 Burnt Sienna; 8 Sepia; 9 Prussian Blue; 10 Indigo. It seems a very well balanced list to me and I am intrigued by No. 6, Brown Pink, which I have never heard of. It may be the same as the present day Brown Madder which is a very pleasant colour. It is interesting to note that a great master like De Wint only used ten colours.

FIVE

Painting with ten colours

Choosing a subject

'What shall I paint today?', is a question often asked and the choice you make is dependent on so many things. The sort of day it is will often settle the question. If it is hot and sunny with blue skies it could certainly be a suitable day to paint a village or town where you will get strong shadows cast on one side of a street or building. If it is a blustery day with grey clouds blowing across, areas of blue sky and glimpses of sun coming through, it would be good for a rural scene of fields and trees or a moorland subject where cloud shadows play a part. But it largely depends on where you are living or staying at the time.

I will take for my example a holiday I spent recently with my family in southern France in the Dordogne area. We had been exploring down some of the country lanes; these little third class roads don't always have signposts and as they abound in this part of France it is very easy to get completely lost. But the adventure is worth it as you never know what gem you might otherwise miss. On this particular day we did find a gem in the form of the small village of Masquières. There was a

6 Dovecot, Masquières, France

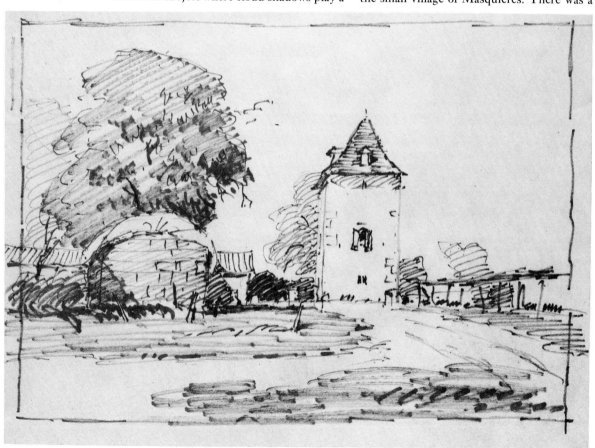

little square with trees and houses all round the church at one side, but best of all there was a superb old seventeenth-century farm house and outbuildings very near the road. I could see at a glance that there were several subjects to be painted here and I was accordingly dumped on the road with my picnic and sketching kit and the family drove off to other pursuits promising to be back in five hours' time.

It was an excellent day with a few white clouds and strong sunshine giving lovely shadows. One of the things to watch for in choosing a subject is to note where the sun is and where it will be in, say, one and a half hours' time when you may be reaching the point of putting in the shadows.

Colour plate 2, facing page 97, shows the Masquières farm dovecote seen from the main road to the south. It was morning and the sun was gradually working its way round to the left of the picture. It was 10.30 am when I actually started and I felt that the shadows on the tower shaped dovecote would improve and so would the shadows from the straw stack and big tree on the left. This would give me a bit of time to get going before the shadows were at their best.

Composition

The first thing which comes to mind when one is chosing a view is *composition* and this is half the fun of painting: getting things in the right place and arranging your picture so that it satisfies the eye. You are not tied like the camera to facts; you can move objects very slightly or enlarge them a little so as to have what your eye tells you is satisfactory and pleasing. You can also change the colours slightly or darken the darks or lighten the lights fractionally – this is all part of composition.

Figure 6 shows a rough, felt-pen sketch of the dovecote at Masquières which I made quickly before starting the proper picture, to see if it was going to be a good composition. On the strength of this I decided to cut out some of the sky and let the big tree go out of the picture and to close in the view on the left-hand side. This rough sketch is 17.5 cm × 25.5 cm (7 in. × 10 in.) and only took about eight min-

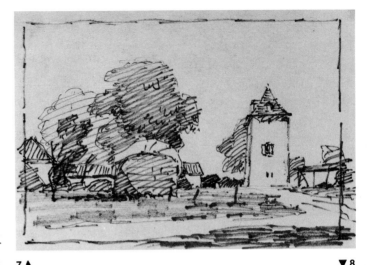

7 ▲

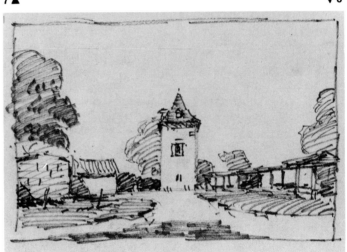

▼ 8

utes of my valuable time. It was well worth it as it enabled me to get on with the main picture more quickly.

Since painting this picture I have made two more rough felt-pen sketches (7 and 8). I have done these to illustrate still further the important question of composition.

Figure 7 shows the dovecote on the extreme right, more farm buildings visible to the left and the big tree almost central. This is an unhappy balance, I think, as the tree and straw stack are too near the centre of the picture which is in too important a position. The most important feature is the dovecote and this is too much on one side. The eye tells one that this picture is restless and unsatisfactory however well it might be painted.

In figure 8 I have pushed the dovecote

29

towards the left, into the *middle* of the picture in fact. This is wrong as the picture has become equally balanced with the big tree on the extreme left and another tree on the extreme right. Also we have lost much of the interest in the dovecote as you can no longer see the left-hand side of it which catches the sunlight so attractively (see the finished watercolour, colour plate 2, facing page 97). The farm track is straight up the middle of the picture, which is not so pleasing as it would be at one side.

As you become more experienced with your painting you will be able to see quite quickly which is the best view point. It is worth walking slowly this way and that, watching how the different features of a subject move into a position which most satisfies you.

Painting a picture with ten colours

I will now go through the process of painting the picture shown in colour plate 2, using the following ten colours: Cadmium Lemon, Raw Sienna, Burnt Sienna, Burnt Umber, Light Red, Indian Red, Rose Madder, Cobalt Blue, French Ultramarine, Prussian Blue.

I sat on the grass verge immediately on the other side of the road and was not disturbed by traffic at all except for one farm tractor. This shows the seclusion of this part of France even in August.

I was using the French paper *Arches* 'Not' surface, 300 lb weight. This weight is a thick paper and does not require mounting or stretching as it does not buckle at all with heavy washes of water colour. I use it a great deal for this type of subject although it is rather expensive.

With the paper resting loose on a sheet of hardboard on my knee, I commenced drawing using an HB pencil. I very lightly touched in the position of the straw stack and big tree and the dovecote and open shed. Actually the very first line I drew was the ground line of the dovecote. This was about one-third up the paper and would allow for the height of the dovecote and the road below.

I then drew the dovecote rather carefully, getting the roof slope right and the dormers and windows properly placed and a few stone

quoins at the corners of the building. It is a good thing to draw in a stone or two of a wall as this gives the correct scale.

The open shed on the right came next, not too carefully drawn as it was a rickety affair with old twisted posts.

The straw stack and big tree were only very lightly drawn and the small barn behind. The shape of the tree behind and to the left of the dovecote was shown in a light outline. The grass verges were also outlined quite lightly. This was enough pencil work and it only took about 15 minutes.

I was ready to paint the sky which I decided to keep in a very low key so as not to distract from the dovecote.

I mixed Cobalt and Light Red, making a light grey with plenty of water, and using a No. 12 brush fully charged I washed in some grey cloud shapes that were to be seen over much of the sky. When this was half dry I painted some very weak Cobalt at the right-hand top corner, letting it run slightly into the grey. Centrally I used a slightly stiffer mix of Cobalt and where I had purposely left a dry white area I could give a sharp edge to the white cloud over the dovecote roof. I ran some plain water into the left-hand side of this blue wash to allow it to run. I then darkened the grey cloud immediately below the central blue sky.

This was all that was necessary for the sky which I then allowed to dry out completely.

Next I wanted to apply a big all-over wash to most of the picture as a background tone: what an artist friend of mine calls 'getting the soup on'! It isn't always necessary but it sometimes helps in deciding on one's tone values. I mixed Burnt Umber and Cobalt with quite a lot of water so that it became a pale grey brown wash with the No. 12 brush again. This was run all over the big tree and stack, and the dovecote roof and walls with the exception of the left-hand wall catching the sunlight: this was left white and was never painted at all. The wash also went over the tree to left of the dovecote and the open shed and small barn and the foreground grass and roads. This wash remained the final road colour. This had to dry out before I could proceed.

I then painted with a No. 7 brush the creamy, stone dovecote wall with a mixture of Raw Sienna and Light Red, also the small

barn walls behind the stack. The straw stack received a wash of Raw Sienna and a little Burnt Umber and the dovecote roof was painted with Light Red, Raw Sienna and a touch of Cobalt.

The low barn to the left was a pinkish colour and was given a light mixture of Indian Red and Raw Sienna. The tarpaulin on the stack received a light wash of Cobalt with a touch of Light Red.

We were now ready for a darker colour to be applied, namely the large tree on the left. I mixed a fairly strong brownish-green for this old chestnut tree which was beginning to go slightly autumnal although it was only late August and I used Burnt Sienna and Prussian Blue. When the wash was nearly dry I made a stiffer, stronger mix of the same colour and applied it to the right-hand shadow side of the tree and drew in with the brush a few leafy shapes to the left. Care was taken to get a good, dark, sharp edge to the top of the tarpaulin as this needed to stand out.

I next used a smaller brush, a No. 5, for the tree showing behind the left side of the dovecote. This was a most valuable tree from a technical point of view as it allowed me to show up the dovecote strongly, especially that little bit of the left side which needed to look bright as it caught the sun. This tree was then painted with a mixture of our old friend from Chapter Three, Cadmium Lemon, and Prussian and Rose Madder, giving that delightful green-grey, with a touch of the Rose Madder showing through the green. Then the small tree to the right of the dovecote was painted with Burnt Sienna, Prussian and Rose Madder and the tree further to the right with the same colour as the larger tree on left of dovecote.

Next came the foreground grass for which I used Cadmium Lemon, Prussian and Light Red, giving a warm yellowish-green. The open shed to the right was painted in with bold strokes of Ultramarine and Burnt Umber using the same No. 5 brush.

I felt like a little break now to take stock of how the picture was going. I stood up and stretched and gazed at it from six feet away. It was coming on well but of course lacked strength as I had not yet put in much dark colour, apart from the big tree, since I was working to the infallible rule for water-colour of putting in the darks last.

I suddenly realized how hungry I was and hastily devoured my picnic lunch. It is always a good thing to take your eyes off a picture for a while; then you come back to it refreshed and ready to go on with renewed enthusiasm.

It was now time to paint in one of the darkest parts of the picture, the more distant low line of trees seen between the dovecote and the small barn to the left. These trees were from time to time covered by cloud shadows which gave them a dark blue grey colour. So I gave them a mixture of Ultramarine and Light Red.

The shadow under the eaves of the dovecote was next put in with a mixture of Cobalt, Light Red and Raw Sienna, and similarly the shadow on the small barn to the right of the straw stack. The same colour was used on the straw stack itself, picking out the individual straw bales and the slanting shadow on the left-hand side of the stack cast by a tree out of the picture. Note the darker touches in the joints of the bales indicating holes etc where they were unevenly stacked. Incidentally while I was painting a small boy came round and buried his hand into one of these holes low down by the ground and pulled out three hens' eggs. He knew just where the farmyard hens had their special places for laying!

An important little shadow was painted to the right of the dormer on the dovecote roof using Indian Red, Cobalt and a little Raw Sienna.

A big tree just behind me was casting a shadow on the road and this together with the shadow on the farm track were painted with a mixture of Cobalt, Cadmium Lemon and Indian Red. This makes an excellent warm grey. I made sure there was enough yellow to go with the light, biscuit-coloured road. I added in a touch of Rose Madder to the foreground shadow while it was still wet, to darken this slightly. I would mention at this point that shadows are always the same colour as the object on which they are casting their shadow. On green grass there will be a darker green shadow, on a buff coloured road the shadow will be a darker buff with an indication

of blue in it. Many artists make all their shadows too blue and this can give a rather cheap effect.

I next put in the green shadows on the grass using a stiffer mixture of the original grass colour.

I now stood up and looked at the picture at a distance to see how the tone values were looking. I even turned the picture upside down; this is a very useful trick as I have said before to assess and evaluate the picture generally.

The shed on the right was not quite right and the underside of the roof required a little darkening, and also the stacks of old boxes. I gave these some purple touches using Ultramarine and Rose Madder.

The straw stack was too light and I darkened up some of the bales with a little Raw Sienna, and Light Red and Burnt Umber.

The roof of the dovecote was a little bit dull in colour so I painted touches of Rose Madder mixed with Raw Sienna which brought a little life into it. I did not paint this colour on the bottom of the roof where there is a flatter slope, as this catches the light and indicates the turning up of the roof. This is an interesting architectural feature of many of the steep roofs in France.

I had not yet painted in the two hens wandering on the farm track. One was painted with Burnt Sienna and the other with Cobalt and Burnt Sienna. Their small shadows were also put in.

Finally, I was not happy with the big tree and I 'lifted' some colour off , using clean water and a small hogs hair oil painter's brush to indicate individual leaf groups on the right-hand side. It broke up the dark mass of green which was looking too heavy. I also drew in some foliage shapes with a thick-nibbed pen using Burnt Umber and Ultramarine, giving a sepia colour. This treatment gave a little texture to the tree which I felt it lacked. The picture was now finished.

Some of my readers may think these touches on the tree are getting away from the pure water-colour technique, but, after all, Turner used any method that came to hand in the moment of painting, in order to obtain the result he wanted. He often scratched out paint with his finger nail when it was partly dry to give the effect of rough water. He was also known to put a picture into a bath of water to soften it down and he certainly sponged out passages of colour when required.

I feel our object in painting with water-colours should be to obtain a fresh and un-laboured looking picture, where colours look as if they were put on the paper with easy brush strokes and then left alone. But we *can* still use one or two methods for finishing off such as pen work or 'lifting', as long as we do not overdo it.

Preliminary drawing and perspective

'A good drawing never made a bad painting'. This is a very true saying and most of the great water-colour painters of the past were master draughtsmen. Turner, Constable, Cotman, Prout, Bonington, David Roberts, Callow and so on, all had good ground work of pencil underneath their water-colours. This does not mean to say that it was always detailed drawing: sometimes it was very slight and sometimes almost no pencil work at all, all the drawing being done with the brush. So I certainly don't want anyone to do elaborate drawings every time they do a painting. It is simply that a drawing *knowledge* and experience is almost essential. A knowledge of perspective, of buildings, of trees, of figures and animals, of rocks for foregrounds and so on is of immense value and will have a most beneficial effect on your water-colour work. What is wrong with many pictures one sees today, both by students and by mature artists, is the lack of drawing knowledge behind the painting.

Perhaps I have used rather daunting words for the person who is just starting on a painting career in water-colours and I hasten

9 Burford High Street. 30 cm × 21.5 cm (12 in. × 8½ in.)

to add that this drawing business is *not* going to be too difficult and the more you do the more intriguing you will find it.

We have seen a simple preliminary drawing for a simple subject (colour plate 1A, facing page 96) showing the Cotswold barn. I will now take a rather more detailed architectural subject to illustrate a case when some detailed preliminary drawing is essential before painting commences. The illustration in figure 12 shows Burford High Street looking down the hill. Figures 9, 10 and 11 show the process of making this picture step by step, starting with the drawing only at figure 9, Stage One.

I took a little time, choosing my view point for this picture and I eventually manoeuvred myself so that I had the war memorial in the foreground a little to the right of the picture and not coinciding too closely with the church spire in the distance. I wanted to include enough houses on the left of the picture to give a counterbalance to the mass of buildings on the right of the street. There are a lot of *horizontal* lines in this picture, mainly

the eaves of the houses on the right and the lines of the footpaths and it was useful to have the contrasting *vertical* lines of the stone war memorial and the two wooden posts in the foreground. This is our old friend 'composition' again, mentioned in the last chapter. Half way down the street on the right there is a projecting house at a street corner with an archway in the lower storey. In the finished picture it shows up white. This house is the key to the composition as it breaks the monotony of the houses which are all joined together and then there is this sudden break which gives an interest just where it is wanted. I purposely made the best of this house; it had a colour washed white gable wall and I emphasized this.

So much for composition, now to the task of drawing. I used a 'Not' surface paper which has enough smoothness for drawing but a little texture suitable for painting. Using an HB pencil I first lightly marked in the roof line of the houses on the right and the approximate footpath line, then I did the same for the

houses on the left. I did not draw the foreground memorial at this stage. I next did a little *measuring*. This is a well known idea that you may know about but I will describe it for the benefit of those who don't. You need a long pencil, piece of wood or ruler for this — anything straight will do.

Hold the pencil in and out of your first, second and third fingers of your right hand and hold your arm straight out in front of you with the pencil in a horizontal position. With your left eye closed and your thumb sliding along the pencil you will find that you can easily measure distances between various objects in the subject you want to draw. Measure for instance the height of the tallest building on the right ie the second one from the right, holding your pencil in an upright position for this. Measure it from the top of the roof to where its wall meets the footpath, moving your thumb as necessary. Then, keeping your thumb firmly in position and your arm straight out, turn the pencil to a horizontal position and measure from the right-hand

corner of this building across the view until you reach the house on the left, ie the building with the sun blind and the two figures. You will find that the length of the pencil goes about two and one-third times into the distance. You can then make a firm vertical line indicating this left-hand house.

Now try another measurement using the pencil in the same way. Mark with your thumb again the horizontal distance between the left-hand house with the sun blind and the corner of the white house with the arch that I mentioned earlier. Then see how many times this will go into the distance from the left-hand house with the blind to the corner of the right-hand house that we referred to for the first measurement. It goes just about five times so you can mark the corner of the white house on your paper.

We are now beginning to get the proportions of the picture accurately marked up.

I then drew in the group of buildings on the left of the picture and also the footpath. Then I started on the furthest houses at the bottom

11

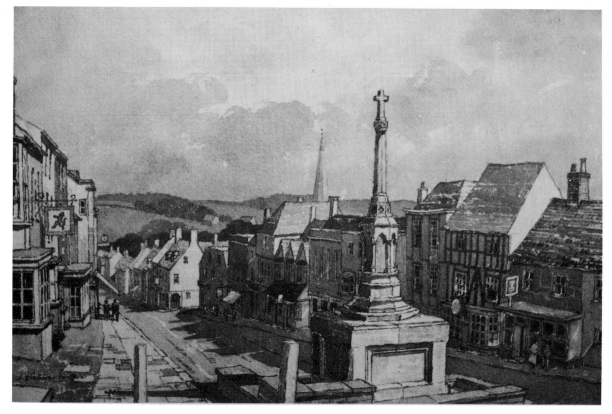

of the street, noting the height of their roofs against the houses on the left. They come about half way up.

I gradually worked up the street drawing in the houses with their roofs and the footpath until I got to the top or right-hand side of the picture. All this drawing was done fairly lightly so that it could be rubbed out and altered if necessary.

I made a few more check measurements as I went along to keep the positioning of houses reasonably correct.

As you get used to this type of drawing you will find you can do it with less and less measuring; your trained eye will do it for you.

Perspective

Now I must mention perspective before we go any further, because with a very little knowledge of this subject you can make life much easier for yourself when drawing a row of houses, especially when they are on a downhill slope. There is something called a *vanishing point* which is always situated on the horizon

and I must interrupt the painting of this picture of Burford to explain this matter. Look at figures 13 and 14. Figure 13 shows one of the Burford houses near the top of the hill drawn separately and diagrammatically. The top of the roof is a little above the horizon line at eye level, that is to say from where I am sitting sketching this roof top is only just above my eye. Now look at the eave line at the bottom of the roof; you will see this is sloping upwards and this line and the top of the roof run towards a vanishing point on the horizon or eye-level line, as shown by a dotted line. Now look at the bottom of the house where it rests on the footpath. This line ought to slope upwards towards the vanishing point but because the house is on a hill the line does not run towards the main vanishing point but runs towards another vanishing point lower down.

Now we will look at figure 14 and we will move the eye level down and pretend you and the houses are standing on level ground and assuming that your eye is about 1.5 m (5 ft) above ground ie a little below the top of the

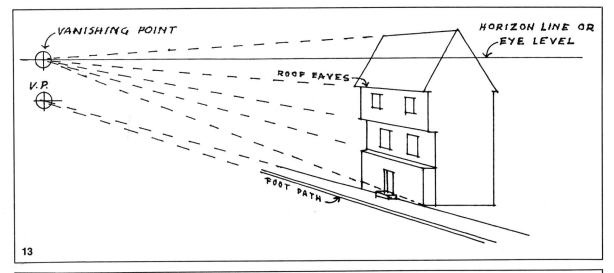

Figure caption content:
VANISHING POINT
V.P.
HORIZON LINE OR EYE LEVEL
ROOF EAVES
FOOT PATH
13

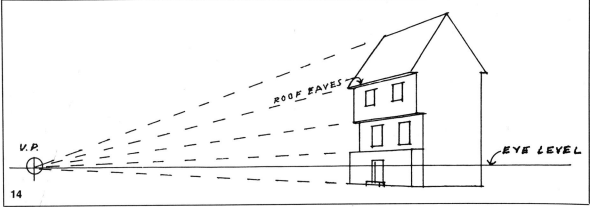

V.P.
ROOF EAVES
EYE LEVEL
14

front door. You will see that the top of the roof is now sloping quite steeply down to the new vanishing point and all the other lines are going downwards instead of upwards as in figure 13. The only line which goes upwards is the ground line of the house.

Looking back now at figure 9 of the Burford picture the eye level is about at the top of the hanging sign of The Red Lion on the left and the actual vanishing point on this line is about over the two figures in the left-hand footpath. Most of the buildings have their eave and window lines etc running towards this point but some of them do not quite do this owing to the irregularities of old buildings with uneven roof lines. Look at the bay windows on the left-hand buildings and you will see the top of their flat roofs and their perspective lines are running upwards to the

vanishing point just mentioned. This indicates clearly that the street is running downhill.

When you are drawing a street scene it always helps to have an approximate vanishing point position in mind so that you can roughly check that the various features of your buildings, roofs, window heads etc are being drawn in the right direction. You need not be over-careful about this otherwise your drawing will become too mechanical and fussy. I have said enough about perspective for the moment but I will say a little more about it at the end of this chapter.

Now to return to the Burford picture, figure 9 – Stage One. It is time to draw in the foreground memorial and I can note its position: how it cuts across the buildings on the right side of the street and where its base

comes in relation to the footpaths. I also note the height of the cross which is just level with the top of the extreme left-hand building. The two white posts in the immediate foreground are drawn in next. It now only remains to draw in lightly the background hills and trees and spire of the church getting its height correct in relation to the top of the war memorial.

I have now got the skeleton drawing fairly correct and I fill in windows and doors and hanging signs and I also put in various figures of people. One takes great care to get their heights right against the buildings near which they are standing. Don't draw them so big that they can't go through doorways; this is always a pitfall.

I am nearly ready for the painting, but not quite. I feel that a lot of interesting detail is going to be lost when paint is applied and so I decide to ink in the main lines of the closer buildings. I use a fairly thick nib and fill it with a dark brown water-colour mixture using a brush for filling.

All the houses on the left of the street are inked in, not the window bars but just the roof lines and window sills and ground lines, also the footpath. The houses on the right side are inked in, going down as far as the white house with the arch. Only the salient features are indicated, not window bars etc. The houses in the lower part of the street are left in pencil only as I want them to be fairly faint and fade away into the distance.

The foreground memorial is inked in rather firmly. I do not ink in the church spire as this has to be unobtrusive.

You will be surprised to find when the picture is finally finished (12) how the pen work is almost lost to sight and certainly does not obtrude itself.

There is rather a pleasant sky of light cloud and large areas of blue and I quickly get out my painting things and float this in. I run a mixture of Raw Sienna and Light Red over the lower half of the sky and when this is almost dry I paint the grey clouds using Ultramarine and Burnt Umber. I then paint in the blue areas using a rather faint wash of Prussian Blue and let this run into the grey cloud on the right and give it some clear water on the left so that it fades into the clouds below. I leave some crisp white clouds in the central area

where the paper has not been wetted – see fig 10, Stage Two, which shows the sky treatment.

I now decide to go back to the studio to finish painting this picture. There are too many people and cars getting in the way and obstructing many of the buildings and I shall really be able to paint much better away from the subject. I make a few notes on special colours such as one of the houses being Georgian red brick and the roof of the second house down on the right having a blue-grey slate roof instead of the Cotswold grey stone like all the others. The bay windows on the left are white or buff coloured plaster. The main mass of buildings have warm grey walls and roofs similar to most Cotswold villages and it is not difficult to memorize these.

One important thing I did before finishing the drawing was lightly to pencil in the positions of shadows on road and buildings when the sun was casting them in a desirable direction. The sun was on the right or east, almost at right angles to the street and this was a happy position from the painting point of view.

Back in the studio I am ready to paint with the scene clear in my mind, having been staring at it for the past two hours. See figure 10 – Stage Two.

First I mix a yellow-grey with Raw Sienna, Cobalt and Light Red and wash this over the background hills and the shadow side of the buildings on the right and over the road shadows. I leave unpainted some of the windows and sunblinds and shop signs, items which are catching direct light or reflected light. Then I paint the rooves of the top two buildings – one grey-blue and the other a stone brown-grey. And then when this is all dry the background trees and woods are painted a green-grey and for the most distant wood a grey-blue. This finishes Stage Two.

Stage Three, figure 11, is simply a matter of finishing off completely the right-hand side of the street. I paint further washes on the roofs and walls of these buildings using variations of the same three colours already mentioned, Raw Sienna, Cobalt and Light Red, but stronger mixes and predominantly red for the red brick building half way down. Burnt Umber and Cobalt is used for the half

timbered house and Burnt Umber and Ultramarine for the dark browns and greys for the windows. As the houses go into the distance a bluish-grey is painted over the walls, and a similar blue-grey for the shadows in the road, and the road itself is given a light wash of brown-grey.

A light yellow-grey is used for the shadows on the spire and a darker green-grey for the distant woods, and this completes Stage Three.

We not turn to Stage Four – figure 12. I am not giving a very detailed account of the painting work on this picture because the chapter is mainly about *preliminary drawing* and *perspective*, but we will finish the colouring as follows.

I complete the left-hand buildings next using again Raw Sienna, Cobalt and Light Red producing grey-yellows and grey-blues for the various wall surfaces and shadows under eaves and mouldings and Burnt Umber and Ultramarine for the dark window panes and the open windows. Always open a window or two in an architectural subject as it gives interest and depth.

The war memorial has so far not been touched. This has to be made to stand out well as it catches the sunlight. I paint the strong shadows on its left sides with a stiff mix of Raw Sienna, Cobalt and Light Red and when dry I touch in the sunny side with the same mixture but rather yellower, dragging the small No. 5 brush so as to catch the tooth of the paper and give a textured effect to the stone work. The shadow falling across the footpath is painted fairly strongly using Raw Sienna, Cobalt and

Indian Red. Light grey is painted to give shadow to the two white posts.

The picture is now nearly finished and the various figure groups are touched in. Looking at the picture through half closed eyes and a mount round it, I can see one or two places that required strengthening to pull the picture together. It is often a good idea to use a mount during the last stages of a picture; it helps to show up any weak area that should be dealt with.

This picture could have been treated in a more free and loose manner by not doing the pen work or so much drawing. This would result in a more impressionist picture, but I wanted, in this instance, to bring out the architectural detail and the character of Burford.

Linear and aerial perspective

I would like now to come back to perspective which I don't think I have dealt with quite fully enough. There are two types of perspective in painting:

Linear perspective which we have already partly dealt with on pages 36–7 is concerned with the mathematical or geometrical science.

Aerial perspective which is to do with the degree of strength we give to tone and colour according to the distance objects are away from the eye.

Starting with *linear* perspective, I will first refer to figure 15 which is an example of *angular perspective*. This shows a diagramatic view of a water mill and you are looking at the building at an angle so that one corner is

15 Angular perspective

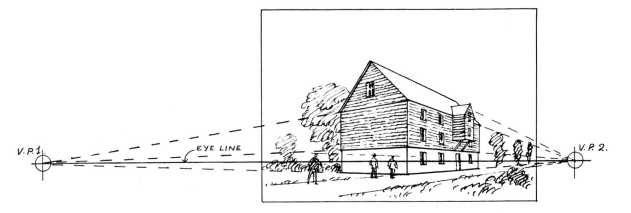

nearer to you than any other part of the building. This angle of the building means that it will have *two* vanishing points, one at each end of the eye line (or horizon). If you are sitting down to sketch, the eye line will be about 1.1 m (3 ft 6 in.) above the ground line, assuming the ground is level. The right-hand side of the building has all the lines of roof and eaves and weather boarding running to Vanishing Point 2 and the left side has all lines running to Vanishing Point 1.

The positions of the vanishing points of course vary according to the angle at which you are looking at the building. You can sometimes mark one of the vanishing points actually on your paper but in this case both vanishing points are outside your sheet of sketching paper. I have indicated three figures to the left and three trees to the right of the mill; in both cases the top of the figures and the trees run to Vanishing Point 2.

Once you have grasped the principle of perspective your eye alone will tell you at what angle to draw your lines.

There is another form of linear perspective called *parallel perspective*. This is a variation of

angular perspective in that the buildings or objects you are looking at are not at an irregular angle to you but are square on or at right angles to you. If you stood in the centre of an Oxford College quadrangle exactly facing one side, you would see that the roof line and eaves and windows of this side were all running parallel to your arms if you held them out each side of you. No vanishing point would appear to be required until you looked at the left and right side of the quadrangle and then you would see that the roofs and windows etc of these walls very much had a vanishing point but *only one*. If you were standing *exactly* in the centre of the quadrangle the vanishing point would be exactly in the centre of the building you were looking at. If you were standing a little to the right the vanishing point would be likewise to the right and so on. In parallel perspective there is only *one vanishing point* and this is always exactly opposite the observer. Now look at figure 16 which shows a rough sketch of a quadrangle in an old foreign town. The vanishing point is a little to the left of centre in the archway. The lines of the building on either side vanish to this point, so

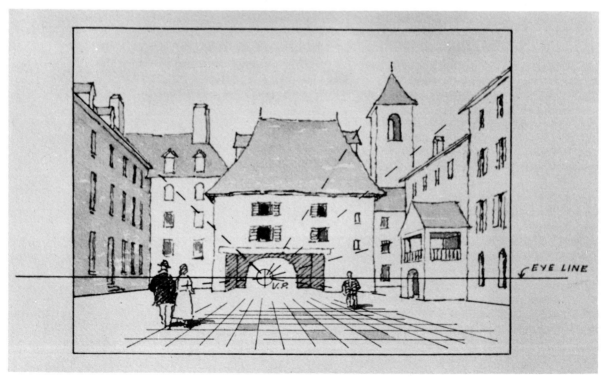

there is no need for a second vanishing point. The rectangular paving stones also vanish to this one point. Any face of any building which is facing you has its lines of roof and eaves etc parallel to you and the edges of the paving stones facing you are also parallel.

The eye line which fixes the height of the vanishing point is shown a little below head height but if you were sketching from an upper window the vanishing point would rise accordingly.

Knowledge of this parallel perspective is very useful to have and very easy to apply. If you are drawing the interior of a room it is extremely helpful to mark a vanishing point position and check up on the perspective lines of floor and ceiling and tables and chairs just as a guide; there is no need to start ruling lines or be too exact about it.

Figure 17 shows an example of parallel perspective in the interior of an old church. This church of St Simon and St Jude, Norwich, was undergoing repairs and alterations and all the pews had been taken out, so you could see the fine proportion of the building very well and I felt it would make an interesting subject. The vanishing point is somewhere about the middle of the dust sheet on the left covering a memorial. All floor lines and roof lines run to this point. But all the wall faces or other objects actually facing you have parallel lines running from left to right whatever heights they are.

Don't forget of course that if a box or chair was standing at an odd angle to you in a parallel perspective picture, it would be in angular perspective again and have the vanishing points fixed on the same eye line. Incidentally the Burford picture, figure 12, is basically parallel perspective but the war memorial in the foreground is not exactly at right angles to the street and is therefore just in angular perspective and has two vanishing points.

In most old streets the houses are not by any means square to each other and therefore to be strictly accurate they should have differing sets of vanishing points, but with practice your eye will be able to make the necessary corrections to roof slopes etc.

It would take more than one chapter to tell all there is to know about perspective (there is the perspective of reflections for instance) but

I am sure I have said enough to guide you along the right road so that you can experiment and learn as you go.

Aerial perspective is a very important part of landscape painting and a knowledge of its principles helps us to give a three-dimensional feeling to our pictures. If you turn to colour plate 3, facing page 97 'Farm Road, Great Langdale, Cumbria', you will see a good illustration of aerial perspective. Objects get fainter and less distinct the further away from you they go. They become lighter in tone and the more 'local' colours become neutralized. For example the autumn-green grass fields in the foreground are a stronger colour than those further away. The small distant trees are much fainter and greyer than the trees closer to you which are quite a strong green.

The farm road twisting along is getting narrower as it goes away and this of course is linear perspective. The distant trees get smaller and this is also linear perspective and so with a combination of linear and aerial perspective we can obtain the maximum effect in distance which is exactly what this picture is all about, trying to give a feeling of a view that goes on and on into the far distance.

The closer foothills to right and left of the picture are the dark reddish-brown colour which you get with rock and bracken in the autumn. As the mountains recede their colour turns to grey-blue and purple, quite strong in tone to start with and then getting lighter in tone as they get further away. The very furthest mountain partly shrouded in cloud and mist, is very faint indeed and it looks a long way off.

The colour *red* is noted for being a foreground colour and *blue* for being a background colour so where the opportunity occurs you can bring a little red mixture into your foreground objects – rocks and logs of wood, and bring blue into your distant objects – trees mountains or buildings.

Another example of aerial perspective with buildings is colour plate 5, facing page 120, showing a street in Florence. The buildings in the distance are blue-grey compared with the nearer buildings which are a warm yellow-brown.

This chapter on drawing and perspective is an important one and as you progress with

17 Church of St Simon and St Jude, Norwich. 38 cm × 30 cm (15 in. × 12 in.)

your painting capability I hope you will give thought to these matters that I have mentioned. Drawing and perspective become easier the more you practise and eventually it all becomes second nature. Although I say drawing is important it must not be allowed to intrude into a water-colour painting. It is only for guidance and the more you can do without it the better, especially in an open landscape of wild country. You do not want to destroy the freshness of a water-colour by having too much pencil work showing. You have to use discretion about how much drawing is required and this depends entirely on the subject of the picture.

Trees

I am coming now to the question of painting trees, before we go any further, as they do form a very important part of the landscape painter's work. If you can paint a good tree you can paint a good landscape picture, even if you are not so good at buildings, skies and so on.

If we think of the old masters for a moment, we can see that we follow a great tradition of tree painting. It goes right back to Claude Lorrain, the great French painter of the seventeenth century, and Rembrandt the Dutchman in the same century, who used trees in their landscapes in a very dominating way, often as the most important part in the composition. At that time it was the fashion to paint mellow brown pictures and very beautiful they looked: nobody would ever have dreamt of painting a bright green tree.

Later on in the eighteenth century came Richard Wilson and Gainsborough, painting the most wonderful pictures with trees forming the main theme. Some of Gainsborough's brown pen drawings of trees on grey paper with washes of water-colour are the most inspiring pictures to look at. He had his own particular style of tree and the species of tree was not always recognizable – it could be oak, ash etc – but this did not matter. These two painters were still painting *brown* trees.

It was not until Turner and Constable came along in the late eighteenth and early nineteenth centuries that brown trees were given up and rich greens were used. Constable was passionate about rendering the exact truth in nature and we have only to look at his famous picture in the Victoria and Albert Museum of Salisbury Cathedral from the Bishop's garden, to see a realistic rendering of great green elm trees.

Cotman, a few years after Constable, painted trees in all colours: autumn trees in light greens, yellows and browns; copper beeches in rich reds as in his Greta Bridge picture; and sometimes a winter tree without leaves, in a rough sketch.

Corot, the French painter of the nineteenth century, painted almost nothing but trees and became famous for his leaning trees, making the most romantic pictures.

The work of all these painters and many others can be seen in our various picture galleries and in illustrated books, and I hope readers will find opportunities to see such pictures if they do not already know them. Even if you know some of them I always find another look does no harm and acts as a refresher and inspiration.

The anatomy of trees

People have often remarked to me 'Oh, I find trees so difficult to paint'. Well, if you feel like that, let me see if I can help you. To begin with we should start by *drawing* trees in winter when the leaves are off. Look at figure 18; this is a simple study of a single oak tree in a hedgerow. By making this drawing of a tree in winter we can study its anatomy and the way the trunk and branches grow. Whilst you are about it choose an interesting tree with perhaps a bit of a lean on it and a division of the main trunk into two trunks fairly low down. Corot, as I have said, was fond of leaning trees; they look much more attractive and romantic than straight up and down trees.

For this drawing of the oak tree I used a 4B pencil and smooth cartridge paper in a sketch book 25.5 × 35.5 cm (10 in. × 14 in.).

The technique is first to use the pencil very lightly, roughly marking in the whole outline of the tree. Then, with quite a firm line, start drawing the main trunk from the *bottom* upwards, gradually tapering to the smaller

main branches, carrying on right to the top where the branch is only a single line. Get all the *main* branches drawn in first and then come back to the intermediate smaller branches and gradually fill in all of them, not forgetting to taper them all the time as you go higher.

The same principle applies exactly when you are painting. Turn to figure 26, page 53, which shows the painting of two tall willow trees in the snow. A small brush is used, starting at the base of the trunk, dragging the colour upwards and changing to a smaller brush for the higher, thinner branches.

Turning back to figure 18, a little cross hatch shading is used at the top of the tree to indicate very small masses of twigs. There is also some shading on the thicker branches and the main trunk to show modelling and shadow. A few touches with a 6B pencil quickly indicate the line of the wood and hedge and some distant trees and the drawing is complete.

From this sketch we have learnt the characteristics of the oak tree. The branches do not flow easily, they go in jerks turning sharply at

18 Oak tree in winter

Oak Tree
Dec 1978

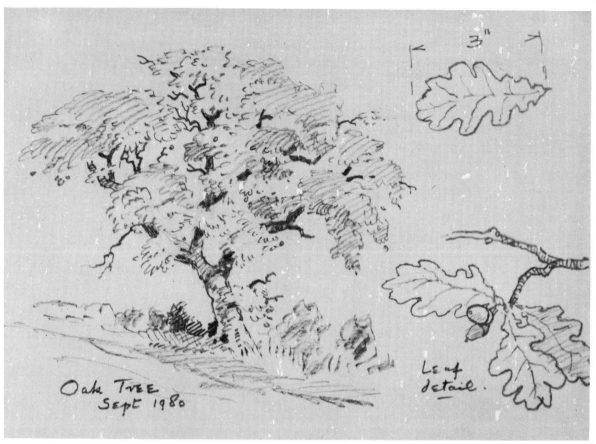

19 Oak tree in summer

right-angles to each other. This is typical of all oak trees and it is a thing which once drawn will never be forgotten.

Now let us draw the oak tree in summer. Figure 19 shows the very same tree two years later with all its leaves on. The time was autumn actually, but the leaves hadn't started to fall. This tree was in a road near where I live in Gloucestershire, so it was not difficult to find it again.

The branches do not show very much under the fairly heavy foliage but where they do show they are in the correct place because of our previous knowledge of how they join onto the main trunk. I start the drawing by roughing in lightly the outline of the tree, then begin again with the main trunk at the base and work upwards. I have to keep stopping the trunk or branches to draw in the leafy foliage until at last the topmost foliage is finished. Be careful to make the branches taper to really thin ones near the top or outside edges of the

tree as we did for the bare tree.

I give an enlarged detail of an oak leaf in figure 19 just to complete one's knowledge of the oak tree. What a lovely shape of leaf it is and surely the most unique of all British trees! There may well be occasions in your painting career when a foreground tree branch comes into a picture and a knowledge of leaf shape is necessary.

Once you have drawn a few examples of bare trees in winter you will find the summer drawing or painting of trees comes more easily and convincingly. You can trace approximately how the branches follow on from the main trunks.

Figure 20 is another sketch book drawing of an ash tree in its winter bareness. I have included this to show the contrast with the oak. The ash branches flow smoothly in graceful curves and the very ends of the branches have a tendency to curl up. This is most characteristic of the ash.

46

Figure 21 shows the same ash tree clothed in its full summer foliage. The same technique applies to the drawings as for the oak tree.

Over the years I have built up quite a library of tree drawings in different sketch books and I do very strongly recommend you to do the same. If you always have a sketch book with you, you can often take half an hour or an hour after a picnic with the family for example, to make a useful tree detail as I did of a scots pine recently (22). This is a lovely tree to include in a picture, especially a group of them. The dark grey-green leaves (or pine needles) can give a wonderful strength of dark colour in open moorland or mountain scenery.

The other trees I particularly recommend you to draw are the *horse chestnut* with its big flat leaves giving splendid shadows; the *beech* with its smooth bark – a beautiful tree in winter and spring; the *willow* to be found along river banks and often pollarded so as not to grow too big and overshadow a small river. An old pollarded willow will often take on a leaning and twisted shape and be a most artistic object to include in a picture. They can also grow to a considerable height if left

20 Ash tree in winter

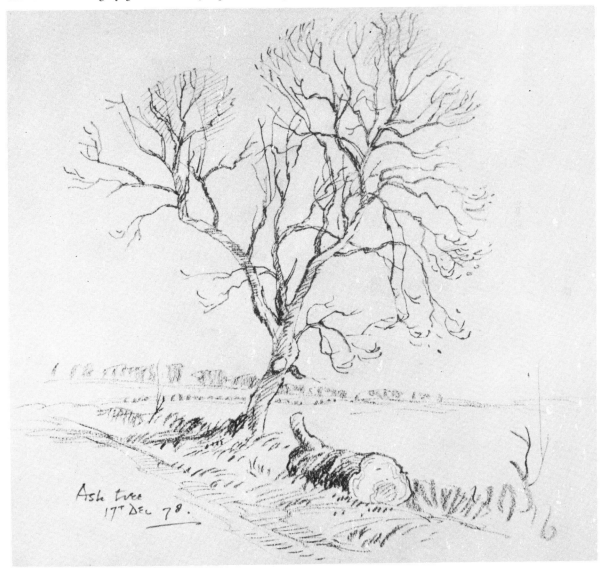

Ash tree
17ᵗ Dec 78.

21 Ash tree in summer

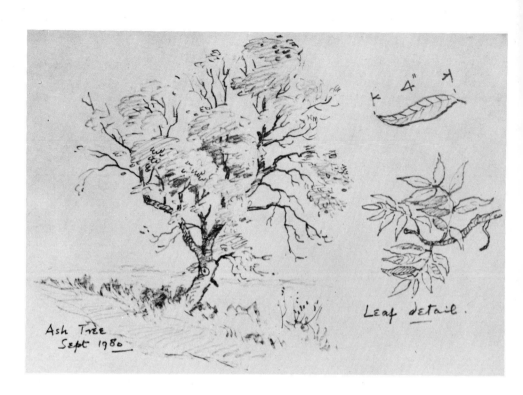

Ash Tree
Sept 1980

Leaf detail.

22 Scots pine

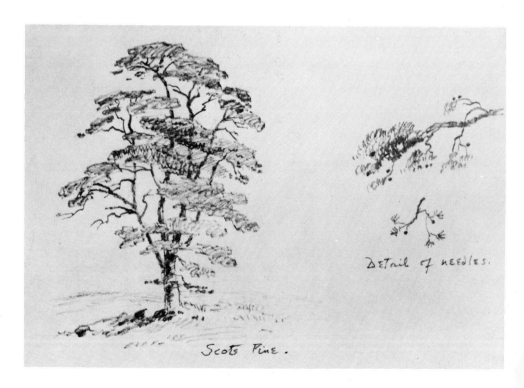

Scots Pine.

Detail of needles.

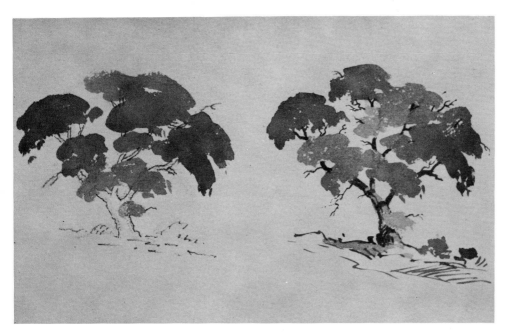

untouched as is shown in figure 26 of the two willows in the snow. The *sycamore* is a very fine, stately tree when fully grown and is a beautiful sketchable shape; lastly the dear old *elm* which is so sadly passing from the English scene owing to Dutch Elm disease.

When it comes to painting a group of trees you will find your knowledge of the individual tree types stands you in very good stead.

Let us now try *painting* the oak tree shown in figure 19. First we draw very lightly the outline of the tree and branches (23). Then mix a fair quantity of light grey-green colour and with a No. 9 brush paint in the main areas of foliage. I have shown, for the sake of clearness, the pencil work for trunk and branches rather darker than they should be. Only very light drawing is really required.

When everything is dry, mix a light grey-brown and paint the main trunk with a No. 5 brush and allow to dry (24). Then use a darker, rather stiff mix of grey-brown and with a No. 3 brush paint in all the branches and the dark shadows on the trunk and you will have the basis of a finished tree.

Some areas of foliage will be in dark shadow and will require over-painting, but I have not done this as I wanted to keep this illustration very simple.

When painting the foliage in figure 23 I sometimes used the colour-loaded brush *sideways* and smudged the paint across the paper; this helped to get irregular shapes. You should practise this technique on some rough paper and you will find it very useful sometimes to apply colour with the *side* of the brush.

A tree composition

Let us now paint a picture where trees form the main part of the composition – see colour plate 4, facing page 120. This shows a Cotswold country road near Little Barrington. I will go through the stages of painting this picture.

It was a late September day in the early afternoon and I was driving slowly along this unfrequented road when I suddenly saw the subject. I pulled up at once and took a long, hard look. It was a sunny cloudy day and tree shadows across the road were perfect. The bend in the road was interesting and the disposition of trees seemed just right. This is the moment when one sometimes thinks it might be better a little further on just round the corner. But experience teaches one to grab a view as soon as it is seen and not waste valuable time looking further. When painting out of doors one is so often in a hurry to catch the lighting effect and can't afford to waste a

minute. I felt the light was just right for the subject.

I pulled the car partly onto the grass verge and decided to stand up to paint, putting my board on the back of the car where it is conveniently flat. By using a rug on the back of the car I can make a suitable place for paint box and water pot. I always prefer to have both hands free and not hold my paint box in the left hand while painting. I often want to tilt the board this way and that and it is useful to have the left hand free.

I selected a piece of white paper with rough surface and with an HB pencil I quickly drew in the road and trees keeping a light line, not too strong. I first put in the horizon at about one-third the height of the picture, then the road and finally the main tree groups.

Then I got quickly onto the sky. There was a slight breeze and the clouds were moving fairly quickly and were pleasing shapes. I selected the position for the blue sky area in my mind and first painted the grey clouds with a mixture of Burnt Umber and French Ultramarine. But even before this I damped the paper using a large brush and clean water, keeping clear of the blue sky area and leaving that dry. I used a No. 14 brush for the grey washes. As I said in Chapter 2, a No. 12 brush will do but if you can afford it a No. 14 or even No. 16 for some sky work is even better. I swept the grey washes down to just below the horizon and over all the trees as if they were not there.

While this was drying I mixed Cobalt Blue with a touch of Light Red to take off the sharpness and painted the blue sky leaving a well broken line along the cloud edges by using the brush sideways and dragging it quickly over the rough paper. The blue ran into the grey cloud at the left side which was still wet; this was done intentionally.

I then mixed a large quantity of Burnt Umber and Cobalt with plenty of water to give a warm brown-grey colour and washed this over the whole of the lower part of the picture including the road. It was suitable for the final colour of the road and gave a useful general tone to everything else.

When the whole picture was quite dry I mixed Cadmium Lemon, Prussian Blue and Rose Madder to give a dull, light green wash over the whole of the long grass area on the left and the grass verges along each side of the road, but giving a little more Cadmium Lemon to the mixture for the latter as they were fairly bright green. I also touched in the line of green grass in the centre of the road. This completed what one might call Stage One of the picture.

When all was quite dry again I mixed Cadmium Yellow and Prussian Blue and Rose Madder, (a different yellow from the last mix you will notice as this gives a stronger colour) and painted the high hedge on the right of the road. There were several different greens in this hedge and I introduced some Burnt Sienna at one point, letting the different parts of the hedge nearly dry out before introducing a varying green. As the hedge went into the distance I floated in Cobalt Blue to the green and in the far distance it became a thin area of pure Cobalt, going away to the left with a distant blue tree.

It was important to keep a sharp edge where the hedge met the light green grass verge. The sun was overhead but slightly to the right and there was a small line of dark green shadow at the point of meeting of hedge and verge; this was strengthened up later.

The next area to receive a wash was the long grass to the left of the road. This was given the same green mixture as the hedge but varying it with more Rose Madder and when nearly dry some strong Burnt Sienna plants were painted in the foreground.

It was time now to paint in the trees and I mixed Cadmium Yellow and Cobalt and Indian Red for the middle distance tree left of centre. This was washed in to a light tone at first and then darker areas when it was drying off, all with a No. 7 brush. Finally the trunk and branches were indicated with Burnt Umber mixed with Ultramarine Blue and a No. 3 brush.

The tree to the right in middle distance was then painted using the same green and painting the foliage before putting in any of the branches. This is a particularly nice shape of ash tree with dual trunks divided low down.

Then came the group of several trees to the extreme right for which I used Cadmium Yellow, Prussian and Rose Madder, and where the lower leaves were turning autumn

brown some Burnt Sienna was introduced. I used a No. 9 brush for this work and then painted in the branches with a No. 5 and No. 3 brush using a stiff mix of Burnt Umber and Ultramarine.

Finally the big ash trees on the extreme left were tackled partly with the No. 14 brush and partly No. 9 for the smaller foliage areas. The autumn colours were beginning on these trees and I used various mixes of greens, browns and yellows. The colours used were Cadmium Lemon, Prussian and Rose Madder but for some of the foliage almost pure Burnt Sienna. The trunks and branches were more grey than brown and so I used Cobalt and Light Red with a No. 3 and No. 5 brush. Note that some of the branches have no leaves on at all, indicating that they are dead. Later in the autumn it could mean the wind had brought the leaves off. Never miss an opportunity of showing a bare branch or two as they so often add to the interest of a tree. I have heard people say they don't want to show dead branches but this is where they are wrong as such branches can add tremendous character and dignity to a tree.

The second stage of the picture was now complete and it only remained to put in the shadows and a few dark touches.

Shadows from trees and clouds had been falling across the road and I mixed a warm grey with Cobalt and Light Red and with a No. 7 brush washed in the two foreground road shadows carrying them onto the grass verge as well; also a distant shadow on the bend of the road from the big ash tree. It is important with these sort of shadows to allow the road to show through in places where the sun shines through gaps in the tree foliage. A quick stroke with the brush well loaded with paint across the paper from left to right or from right to left, whichever is appropriate, will give the right effect on rough paper. This is something to be practised on rough sheets of paper as it will be useful to obtain a spontaneous effect both for ground shadows and in painting cloudy skies.

I then applied some dark green shadows under the trees to the left foreground and some upright strokes to indicate the long grass texture. The narrow ditch was also indicated with some dark brown-green on the left of the left-hand verge; this helped to emphasize the shape of the road.

Now that the road shadows were dry I overpainted the shadow on the grass verges both sides with green; I had coloured these grey to start with and they needed a much darker tone. I also overpainted parts of the grass in the centre of the road where it came in shadow.

One of the last things to do was to touch up the edges of the road with dark brown, Burnt Umber mixed with Ultramarine using a No. 3 brush. These little touches were very important as they indicated breaks in the road where earth showed beneath the grass, and picked out the shape of the road. I also touched in a brown cart track in the foreground which helped the perspective. You have got to be careful not to overdo this when painting roads.

Finally the far fields on the left were painted in light green and light brown and the hedges and distant trees were picked out in green-grey using Cobalt, Light Red and a little Cadmium Lemon.

I walked away from the picture to rest my eyes for a short time and came back to it to give it a critical look. The tree in the left foreground seemed to lack strength and I gave it some darker green washes near the top. This helped to balance the composition and the picture seemed finished; it was time to leave well alone. One is sometimes tempted to go on painting interesting little features one can see in nature like tufts of grass, but with half closed eyes one realizes that these small details are hardly visible and it would be making a painting fussy to put them in. We must always remember that we are looking at a subject that may be 15 or 20 metres (50 or 60 feet) wide in the foreground in reality and on paper it is only 46 cm (18 in.) wide and therefore the subject must be simplified and unnecessary detail left out.

In painting this picture I have endeavoured to demonstrate some of the ideas we learnt in the earlier part of this chapter where we discussed the anatomy of individual trees, and to show how trees can be set into a landscape with a road, hedges and distance combining the art of perspective both *linear* and *aerial* as discussed in Chapter Six.

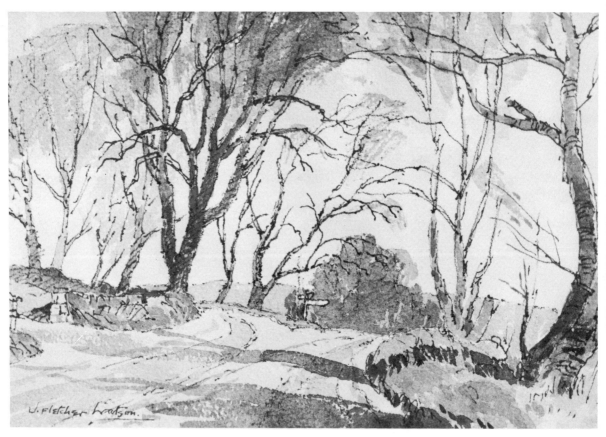

25 Cotswold
road near
Bourton on the
Water.
20 cm × 30 cm
(8 in. × 12 in.)

Winter tree subjects

Trees in winter can make delightful subjects and figure 25 shows a small sketch 20 cm × 30 cm (8 in. × 12 in.) of another Cotswold road near Bourton-on-the-Water. The road divides at a sign post and various groups of ash trees make an interesting subject. This drawing was made with a felt-tipped pen and then painted on the spot from inside the car. The colouring was predominately brown using Burnt Umber and Cobalt Blue for the near trees and the wood behind the signpost and Prussian Blue and Cadmium Lemon and Rose Madder for the yellowish winter grass. It was a fine January day and a pale Cobalt was washed over the sky. Foreground shadows were Cobalt and Light Red as also was the distant hill. Six colours were used in all.

Another example of winter trees which I have already referred to is figure 26, showing two tall willow trees in the snow beside the river Windrush. This picture, which is 30 cm × 46 cm (12 in. × 18 in.), was painted on the spot on a sunny day with blue sky, and the colouring of water and trees was a great delight. It was fairly cold in spite of the sun and I wore an overcoat and also a big shepherd's mackintosh which reaches down to my ankles. I keep it specially for these occasions and it keeps one extremely warm. I was sitting down to paint and I had had quite a tramp to reach this spot which I had had my eye on for some months past and it was tempting to see what it would look like in the snow.

I used rough surface Arches paper and lightly drew in the big willows and distant trees with an HB pencil, but on the whole there was no detail drawing done. I quickly laid in the sky wash of Cobalt Blue and a little Light Red to give a grey touch to it. In winter in England, as I have said before the sky is never really a bright blue or very seldom. One can use Paynes Grey as an alternative. I held

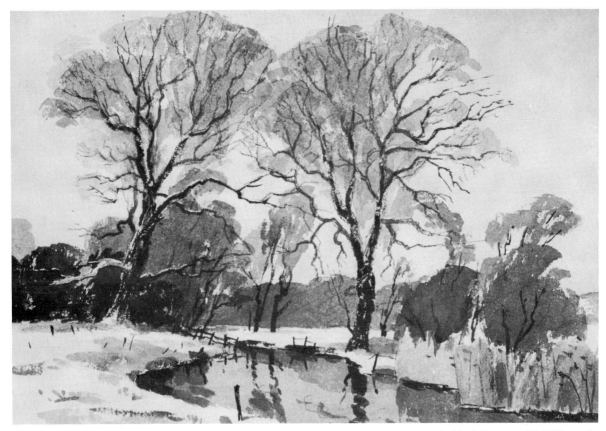

the picture upside down and graded the wash from very light at the horizon to darker blue at the high part of the sky adding a stronger mix as required.

While the sky was drying I took the opportunity to stamp round in the snow and keep warm. I then washed in the river with the same blue, grading it in reverse.

Next I tackled the two big trees because I wanted to establish them with white snow touches on trunks and branches before painting in the dark background trees and hedges which would have blocked out the white paper. I used a dark brown mixture for these trees and a No. 7 and No. 3 brush, working from the bottom upwards and tapering the branches as I went. The upper part of the tree was given a wash of light brown to indicate the areas of thick twigs.

While the two big trees were drying I painted the reeds on the right of the water with a warm yellow-pink colour. After this was dry I could paint in all the background woods and

low trees and the extra dark hedge behind the left-hand tree, taking care not to obliterate white snow on tree trunks and branches. The colouring for the distant wood was Light Red and Ultramarine and for the other trees Burnt Umber and Ultramarine in varying strengths as required.

I will not say anything about the snow on the ground as snow is dealt with in Chapter Eleven.

'Snow in the Windrush Valley' (27) is an example of *distant* landscape with trees and woods in winter. Here we have trees in the foreground, the middle distance and the far distance. This picture is 30 cm × 46 cm (12 in. × 18 in.) again and was painted direct from my studio window so I had all the advantages of warm comfort in which to paint.

A very minimal amount of light pencil guide lines were sketched in first on the white paper which was medium rough. Then the middle distance was painted in with a small No. 3 brush, drawing with the brush as if it

26 Willows in snow. 30 cm × 47 cm (12 in. × 18½ in.)

53

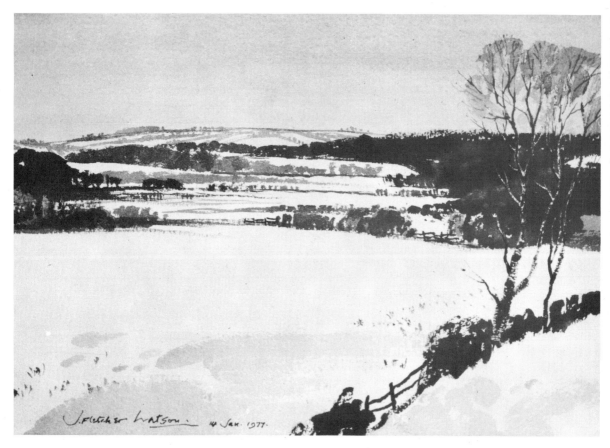

27 Snow in the Windrush Valley. View from the author's studio window.
30 cm × 47 cm (12 in. × 18½ in.)

were a pencil, marking in the horizontal lines of hedges and ditches and the base lines of the woods further away. I was using a mixture of Burnt Umber and French Ultramarine for this work. With the same colour I used a No. 5 brush to block in the main tree masses, using the brush sideways quite a lot of the time, and using a stiff mix and quick brush strokes, allowing the paper to breathe through, showing the snow covered fields. The colour was varied in intensity. Bits of post and rail fence were put in here and there with the point of the small brush.

As the woods receded into the distance they were painted a blue-brown colour using Cobalt and Burnt Umber with Cobalt predominating. The far distant trees on the hill were grey-blue using the small brush and a mixture of Cobalt and Light Red. On the horizon they became almost pure blue.

When everything was quite dry I painted the sky with a wash of Cobalt, Light Red and a

little Raw Sienna; this gave a warm grey colour and contrasted well with the white snow.

The snow on the far hill was given a *very* light wash of grey as it was not so pure white as the nearer snow.

I could now paint in the foreground hedge with a strong stiff mix of Payne's Grey and Burnt Umber; this gives a splendid rich dark brown. (By a *stiff* mix I mean lots of paint and very little water). I took care to leave a jagged snow-line at the bottom of the hedge and used the dragged brush method to allow white snow to show through the top of the hedge. Then the two tall trees on the right were painted using another stiff mix of Prussian Blue and Burnt Umber, giving a greenish-brown. I used a No. 5 brush for these trunks, dragging it quickly upwards to give a broken line which indicated snow lodging on the bark. I ran the brush up to the top of the trees, tapering the trunks, and as they passed over the dark wood behind they did not show up at all. It was

necessary to use a sharp knife and scratch out the trunks and branches in places to indicate snow and to mark the positions of the trees. The No. 5 brush was used for the tops of the trees, using a wet wash of the same colour to indicate the topmost twigs and branches. The brush was used sideways with quick downward strokes.

Finally, some simple washes on the foreground snow were applied with a weak mixture of Cobalt and Light Red and a few yellow grasses were dotted in.

Trees with buildings

Once you have acquired a certain amount of success in painting a tree you will get immense fun from painting a picture of buildings and trees together. Take for example the illustration of Shotesham Mill, Norfolk (28). Here is a case where we have a very light coloured building, almost white, contrasting in a most dramatic way with dark trees and shadows. This contrasting of tone values was one of the great features of the water-colour paintings of John Sell Cotman. His Greta Bridge picture in the British Museum is a superb example, showing dark trees painted against a light coloured stone bridge. Cotman hunted out

such subjects and we can do the same today; they always make a winning composition.

I used a white semi-rough paper as I wanted to get the maximum impact of the white weather-board walls of the old mill building. The trees of various sizes are vital to the composition and the heavy mass of chestnuts on the right form a useful counterpoise to the smaller, more distant trees on the left. The small tree immediately to the left of the building is in complete shadow and is painted in silhouette in a dark grey-green using Cadmium Yellow, Prussian Blue and Indian Red.

The top of a tree can be seen peeping over the roof of the right-hand slope; this tree is dark green and very useful in showing up the light woodwork. The big chestnut trees were painted with a mixture of Cadmium Lemon, Ultramarine and a very little Rose Madder for the darker of the two trees. Drawing leaf shapes with the brush gave depth and texture. A dark green was used at the base of the trees where the undergrowth was in deep shadow.

The lean-to shed to the right of the central gable was a key item and was the darkest shade in the picture; the colour was a warm dark brown from Payne's Grey and Indian Red.

28 Shotesham Mill, Norfolk. 24 cm × 43 cm (9½ in. × 17 in.)

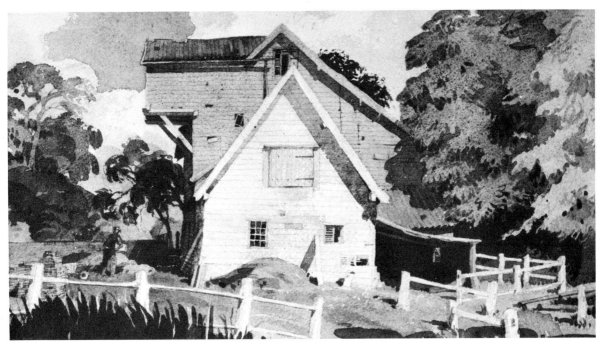

29 Barn with trees, Gloucestershire. 30 cm × 47 cm (12 in. × 18½ in.)

The roof of the gantry and the roof above the lean-to were a pleasant pink-red pantile and acted as an excellent foil to the strong greens of the trees in this picture.

Another rural example of trees with buildings is shown in figure 29, Barn with trees, Gloucestershire. The small stone barn is happily balanced by the group of trees to the right and they cast an interesting shadow over part of the barn.

A different example altogether is the picture of The High, Oxford, shown in Chapter Eight, (60); this shows a single massive old sycamore tree leaning out from between buildings. This tree *makes* the view and it forms a lovely green contrast amidst the wealth

and volume of ancient grey stone of the Oxford colleges.

One more picture is worth a glance because it demonstrates a different use of the tree – old tombs in Windrush churchyard (30). This study of tombstones shows them overshadowed by an ancient yew. The tree was partly drawn with a pen in brown ink, and penwork was used in other parts of the picture also. The tree is extremely helpful in including the right-hand tomb so that the group of tombs is seen as a whole. The colour scheme of this picture is browns, dull greens and yellows. The tree in this case is of secondary importance to the main subject which is the stone tombs.

Buildings, villages, towns

It is important that a landscape painter should become competent at drawing buildings because a very large proportion of landscape subjects have a building or buildings in them. It may be a lonely Yorkshire Moor with a single cottage in the distance, or a view of a small village with a cluster of houses, or it may be a complete townscape. But whatever it is, the building that is badly portrayed can let down the standard and quality of the picture and spoil an otherwise good effect.

We have all seen badly drawn buildings, be they cottage, mansion or church, with slightly wrong perspective or a lack of solidity as if the building is not really resting on the ground; or some architectural feature is not suggested convincingly and gives an amateurish look to the picture.

30 Old tombs in Windrush churchyard. 30 cm × 43 cm (12 in. × 17 in.)

31 Little
Farringdon Mill,
Gloucestershire.
20.5 cm × 31 cm
(8¼ in. × 12¼ in.)

A very good idea is to practise sketch book drawing of buildings whenever possible, either in pencil or pen. A handy size of sketch book is 20 cm × 15 cm (8 in. × 6 in.) which most art shops stock, but an even smaller size is still quite adequate. Such a book will just fit into a man's coat pocket or a woman's handbag. It is a good habit always to have a sketch book with you.

To many people the sketching of buildings does not come too easily and I am afraid that much practice is the only way. But it is great fun building up a library of sketches of different types of building, and putting the shadows carefully in when possible can teach one a great deal. The shadows, for instance, of a chimney stack or dormer window on a sloping roof so often bring a building to life and are so often painted incorrectly on a finished picture. Sometimes you have to finish a picture at home because of bad weather or failing light, and to be able to refer to sketch books with shadow details is a godsend.

Individual buildings

I recently painted a picture of Little Farringdon Water Mill, Gloucestershire (31), and the shadows were about right when I was ready to start. In view of a slightly threatening cloudy sky I decided to do a quick felt pen sketch first, mainly to register the shadow positions on buildings and foreground but also to decide on the composition (32). This pen sketch only took about ten minutes and when finished I felt I could safely get on with the main painting knowing that I had got my shadows recorded and if the sun went in it didn't really matter.

Figure 32 shows more of the cottage on the right and the house on the left than I have shown in the finished picture. The rough sketch helped me to decide that these side buildings were better running out of the picture as this would concentrate the eye more on the focal point which was the projecting mill gantry of white weather-boarding. I drew a rough rectangular line on the pen sketch to

indicate where I wanted the picture's limits to be.

I next drew with a B pencil on 'Not' paper the whole subject to a size of approximately 20 cm × 30 cm (8 in. × 12 in.) lightly sketching in buildings, trees and road etc.

I did not paint the sky first (see figure 31) because the subject was fairly busy with architecture and I felt that the cloudy sky should be played down and kept very simple so as not to detract from the buildings. I knew it would be easier to judge the sky treatment at the conclusion of the painting.

I first laid on a warm wash of yellow-grey over trees, water and road and buildings except the very light gable wall of the house on the middle left and the white gantry. The stonework was the typical Gloucestershire warm yellow-grey and I wanted this basic colour over everything to start with.

Next I put in roofs of a darker brown-grey and the garden wall on the left. Other walls were toned down slightly and I was then ready to paint the various background trees. These varied from light yellow-green to dark green-brown, especially the big tree immediately behind the mill gantry. They helped to show up the white woodwork of the gantry and the struts supporting it. The grass verges of the road were then painted in using a light green colour and also the bank on the right of the river. Next the main washes of the water reflections were painted in, but not the darker touches.

We were now ready for the windows and shadows under roof eaves and dormer windows etc, and my rough sketch came in useful as the shadows had moved considerably for the worse in the last hour and a half and were not very clear as clouds kept blotting out the sun. I felt it was time to stop painting on the spot and return to the studio.

It was tea time and how one enjoys that cup of tea after concentrating on painting! After this break I could assess the picture and put a mount over it to see how it was going. This picture was a small one, being one of the stock sizes I work to. This means you can always have mounts and picture frames ready when a picture is finished.

32 Little Farringdon Mill: preliminary sketch

59

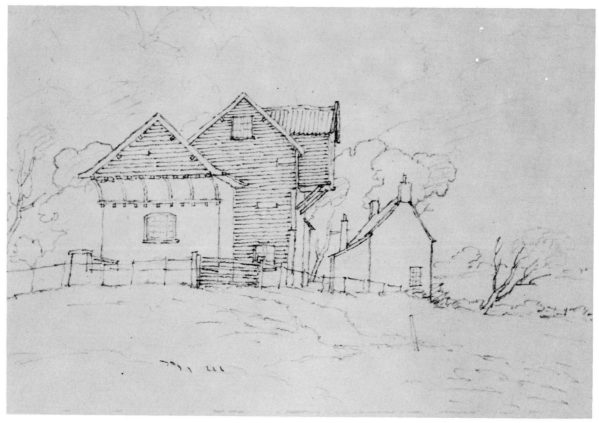

33 Marlingford Mill, Norfolk. Stage One

The sky had not as yet been touched and this was now painted with a light wash of blue to form the central white cloud and washes of grey for the clouds at the right and left sides. The foreground shadows were then painted in and the darker reflection shadows in the water. The ivy on the wall to the left and the young tree sapling over the wall were touched in and some darkening added to the trees here and there and the picture was finished.

You will notice that the treatment of the buildings was kept very simple as I wanted to concentrate on tone values, ie the strength of colour on walls and roofs and trees. A monochrome reproduction of a picture is always a good test of your tone values and if you have not varied these sufficiently, a picture can look very dead in black and white.

You will also note the important part that trees play in this little picture; how helpful they are to show up the building shapes. We mentioned this in the last chapter on trees.

I limited myself to six colours for this picture as I really did not seem to require any more – Cadmium Lemon, Raw Sienna, Burnt Umber, Indian Red, Cobalt Blue and Prussian Blue.

A further example of an individual building subject is another water mill of rather a different type, Marlingford Mill, Norfolk (36). It is one of those enchanting weatherboard mills which used to be found in large numbers in East Anglia and this one is perhaps even better than Shotesham Mill shown in Chapter Seven (28).

I often think these mills are some of the most beautiful buildings ever built and they are usually in lovely surroundings with trees and river to set them off. They are such honest functional buildings where every architectural feature is of special practical use.

Marlingford Mill sits very happily in the landscape with the mill house to the right and the trees forming a beautiful background to the white building. It was very paintable from various angles and I have painted different

views of it from time to time but this one is I think my favourite.

Incidentally, Shotesham Mill was pulled down some years ago by its owner who said he could not afford to keep it in repair. So I recommend my readers to sketch a timber water mill whenever you get the chance as they are, I am afraid, getting scarcer.

I think it might be a help if I ran through the painting of Marlingford Mill stage by stage.

Stage One (33)
I used a 'Not' surface white water-colour paper suitable for careful drawing, and a B pencil. The composition of this subject was pretty well ready made; my main concern was to have a gap between the mill and the mill house so that one could see the dark trees beyond. It was easy to adjust my position to this view and just see enough of the right-hand side of the mill and projecting gantry so that one could observe the supporting brackets clearly.

It called for fairly careful drawing, especially the curved brackets to the projecting gable at the near end of the building. I purposely drew in the weather-boarding rather clearly as I wanted this pencil work to show in the finished picture. I was very conscious of the 'pattern' that the buildings and trees made and I wanted the cloudy sky to contribute to this 'pattern', so I lightly drew in where grey and white clouds would come, and the blue sky area. This is something I very seldom do, but this picture was one of those exceptions.

Stage Two (34)
The sky washes were now mixed with Cobalt Blue and Light Red for the lighter grey clouds and adding some Burnt Umber for the darker grey one on the left. The grey area in the middle just over the gantry is in fact blue sky. This was Cobalt with a very little Light Red. The grey wash you will note was carried over the trees down to the horizon and care was taken to work round the outline of the roofs of

34 Stage Two

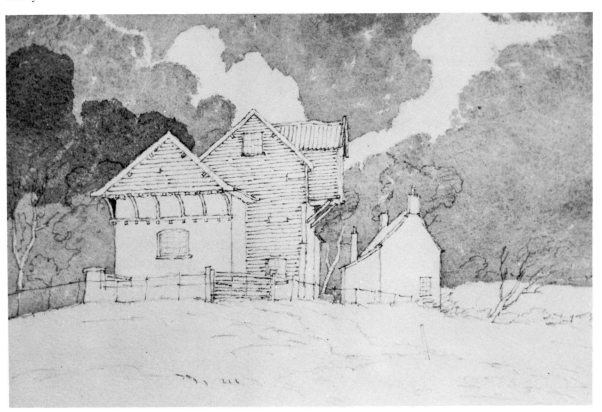

the buildings, leaving them for the time being white.

Stage Three (35)
Now the really interesting stage came of painting in the trees which had the effect of setting off the buildings in strong sunlight. The trees at this time of year, late summer, were a delightful mixture of yellows and greens. The large trees behind the buildings were various mixtures of Cadmium Lemon, Prussian Blue, Burnt Sienna and Rose Madder, using No. 5 and No. 7 brushes. The distant trees on the right were green-grey using Cobalt, Light Red and only a touch of Cadmium Lemon. The little tree on the right in the hedge was brownish-green mixed with Prussian blue and Burnt Sienna using a No. 5 brush for the foliage, smudging it on sideways, as described in Chapter 7, and a No. 1 brush for the branches. This tree, as you will notice, is half bare of leaves. The right-hand field was stubble and painted with Raw Sienna, Light Red and a little Cobalt.

The important item of the shadows on the buildings was now tackled using Cobalt and Light Red; this was just the right warm grey for these almost white buildings. Note the white railings and gate which came alive directly the dark shadows and trees were painted behind them, using a small brush of course.

The windows were painted in with dark touches of Ultramarine and Burnt Sienna. I used the same colour to draw in with a No. 1 brush the rough line of the cart track across the foreground field.

Stage Four (36)
The foreground was the main item left to be painted in this final stage. This field was a yellowish-brownish-green varying in different places and I used Raw Sienna, Prussian Blue and Burnt Sienna in differing mixes. First a flat wash went on over the whole field and when this was very nearly dry the darker tone indicating the right-hand slope was painted and then the dark foreground shadow, care-

35 Stage Three

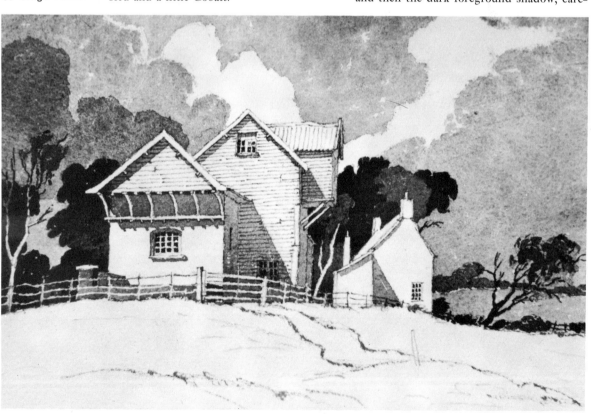

fully leaving, in light colour, the oak leaves on a fallen branch in the left-hand corner. When all was dry I touched in with a No. 3 brush a few indications of grass and the shadow of the post on the rising ground.

There were one or two important finishing touches required on the buildings now. The red roof of pantiles on the gantry and a small amount of pink roof on the mill house were just showing. I used mixtures of Light Red, Rose Madder and Raw Sienna for these items. This roof work was particularly helpful to the whole colour scheme of the picture and was left till last purposely as one could then judge how strong to make the colour.

I had noticed that the tone of the weather-boarding on the main part of the mill building was very slightly grey compared with the left-hand end with the projecting gable which was white. The wall below this gable was brick-work painted white and being smooth it looked whiter still. So I washed in a light grey all over the middle gable and this helped show up the left-hand building and gave a quality to the whole painting; the weather boarding had been a little too glaring before. One more subtle touch was given to the mill house on the right. This building was a very slight pink and I gave it a wash of Rose Madder much watered down. In this case, as with the roofs, it would have been inadvisable to paint the pink before reaching the final stage of the picture. These colourful touches should always be left to the end.

I did one more thing: I slightly graded the grey shadows on the mill by darkening one side; this gave me a feeling of reflected light which one sees particularly on a white build-ing, and I scratched in with a sharp penknife the sloping and upright bars on the gate. This is a legitimate ploy to be used only on rare occasions. Turner was a great man for scratch-ing out his water-colours. In fact he used white paint and all sorts of tricks now and then, such as dipping a picture into a bath of water to soften it down. The important thing

37 Farm near
Langdale,
Cumbria.
30 cm × 47 cm
(12 in. × 18½ in.)

is not to have your picture full of such tricks, but to employ them sparingly.

I used nine colours for this picture: Cadmium Lemon, Raw Sienna, Burnt Umber, Burnt Sienna, Light Red, Rose Madder, Cobalt Blue, French Ultramarine and Prussian Blue.

Subjects that make very attractive pictures are farms and the type of hill farm to be found in Cumbria is always very paintable. Figure 37 is typical of these stone built farms which always have a white-washed farm house and natural grey stone for the farm buildings. Note the solid stone porches to give protection against the severe weather conditions in winter; and the deep set windows in the thick stone walls giving lovely shadows.

This picture was painted on the spot on a beautiful day of clear blue sky, good for building subjects but not so good for mountain pictures. It did not take long to settle myself in a good position for getting a suitable composition. There was a danger of the picture being divided into two owing to the

road being central, but this was only a farm track with a lot of grass on it so the division was not too pronounced. What was important was the big dark green tree to the left of centre which swung the balance and was counter-balanced by the height of the farm-house on the extreme right and the brightness of its white walls. The far mountain peak was to the right of centre and thus helped towards a happy balance. I took all these matters subconsciously into consideration and I looked at the scene through half closed eyes. It always helps to assess a subject to look at it through half closed eyes; details become blurred and you see only the main masses and colour tone values.

I quickly but carefully drew in the scene with an HB pencil and then gave a very pale wash of Raw Sienna to the sky and let this dry completely before floating in Cobalt Blue, starting at the horizon and leaving the cloud shapes which were showing just above the mountain. I tilted the paper with the top of the sky downwards and added a stronger blue as

64

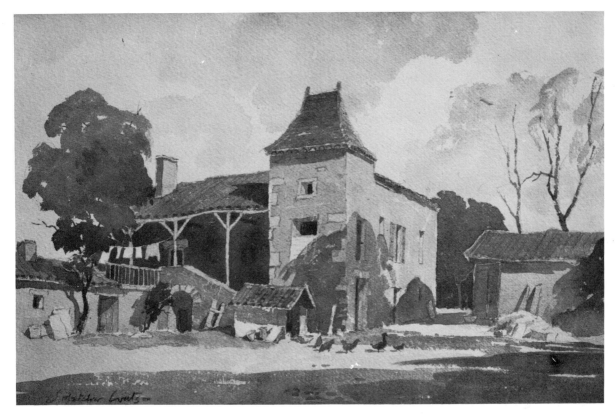

the wash was taken towards the top of the paper, thus giving a graduated wash. The sky had a very pronounced lightening towards the horizon on this day.

I will not go through the painting of this picture in detail but suffice it to say that there was a predominant greenish-grey colour throughout. The walls of the barns and buildings on the left were grey with a touch of green in them; the roofs were decidedly a greenish-grey being attractive Westmorland slate, and there was green grass on the farm track and a strong green-brown on the tree. The mountain, part of the Langdale range, was quite distant and was grey-blue, a mixture of Ultramarine Blue and Light Red, but the blue predominated. Of course I was careful to leave the white farm-house the natural colour of the white paper and only at the very end did I touch in the grey side walls of the two porches and the chimney and a little grey on a few places on the front walls.

In contrast to the Cumbrian farm is another farm in the Dordogne area of France (38).

This is the same farm near Masquières village that had the dovecote which I described in Chapter 5, (see colour plate 2, facing page 97).

Everything was just right for this picture; the shadows, the composition, the colouring were all superb and to add to it all there were farmyard animals strolling about. I had to sit by a very smelly manure heap, but that is part of the game of painting pictures. One has to make a few sacrifices sometimes for art's sake!

I got to work quickly with this picture, drawing it in rapidly as I wanted lightly to pencil in the shadow positions, especially those on the building cast from trees out of the picture on the right. It was late afternoon and the sun was getting low and I knew the shadows would change quickly. Sometimes it is a good thing to paint under pressure against the clock as one paints spontaneously and often pulls off a good picture not too carefully painted.

The farm-house was attractive with its tower with pointed roof and it was unusual in

38 Farm near Masquières, the Dordogne. 30 cm × 47 cm (12 in. × 18½ in.)

39 Stowe House, Buckinghamshire. 30 cm × 43 cm (12 in. × 17 in.)

that the door on the right-hand side near the corner of the tower lead through to some stone steps going up to the outside gallery where the washing was hanging up. The small building in front of the tower which looks like a dog kennel is covering a well. I drew in the hens and duck in pencil while they were in a good position.

I soon started to paint and I did not put in the sky first as I wanted to get straight onto the buildings while the colour and light were right.

First I wanted an overall wash and I used a mixture of Raw Sienna, Light Red and a touch of Cobalt. This gave me a warm stone colour and was used on buildings and ground and background trees.

Next came the various red roofs using Light Red and a little Cobalt and for the well building some Cadmium Lemon was added. The house walls were now seen to be too light and received a further wash of the same colour as first laid on. When this was dry I painted another wash on the left wall of the tower and the sloping wall to the left of it, as these were in slight shadow. You will notice the quoin

stones at the corners are left a lighter colour as these stones stood out quite strongly.

Next the dark background trees to the right were painted with a mixture of Cadmium Lemon, Prussian Blue and Light Red, and also the tall tree on the left with same mixture but with yellow predominating. The trunk of this tree was put in while the foliage was still wet. Then the trunks of the two trees on the extreme right were painted. They were partly dead with very few leaves. The brush on the extreme right was painted a bluish-green colour with a mix of Raw Sienna and Cobalt Blue.

Now it was time for shadows to go in and I had my very light pencil guide lines to help. The shadows had moved a little which did not matter. I used Cobalt and Indian Red, giving a purplish colour, and then dropped in a touch of Raw Sienna which gave me just the right grey for the tree shadows on the walls and shadows under roof eaves.

The deep shadow in the gallery to the left of the tower received a dark tone colour of Ultramarine, Indian Red and Raw Sienna. The vertical wood posts and washing had to be

picked out carefully with a small brush while placing these dark shadow washes. It is so often the *leaving out* that matters in water-colours and gives them their freshness.

I painted the ground shadows also at this time using Cobalt, Indian Red and Raw Sienna and when they were half dry I dropped in a little pure Raw Sienna in one place and some pure Cobalt Blue in another giving variety of strength and luminosity.

A dark brown-blue was next mixed for the few small dark areas of windows and doors using Burnt Umber and Ultramarine.

The picture was nearly finished now and I felt the need for the tree shadow on the left side of the tower to be a shade darker. I painted this in and it gave strength where it was wanted.

The hens and duck were next painted and one or two other small items such as a small shrub and the pile of sand on the right, also a touch of light Prussian Blue was added to one of the garments on the washing line.

One more thing required strengthening, namely the tower roof on the shadow side, and this was made a stronger red at the top and a touch of green added near the eaves where moss had collected.

I had left the sky till now as I had been so busy and in such a hurry with everything else. The darkish area over the tower roof is in fact blue sky painted with Cobalt and a touch of Light Red. Light grey clouds were added with a mixture of the same Cobalt and Light Red but a larger proportion of the latter colour to give the correct greyness. The position of the white cloud was important and was kept well to the right to give a happy balance. I think this whole picture took about an hour and a half and I was glad to get away from the manure heap; I think this partly urged me to be quick! The result is, I think, a picture without unnecessary detail, and with a feeling of directness. I used eight colours in this picture.

A short time ago I was commissioned to paint a very different sort of individual building. This was Stowe House, Buckinghamshire (39). It is a vast mansion and a very fine building; it was designed mainly by Robert Adam and built for Lord Temple and completed in 1780. It is now a school. One of its many historically interesting points is that 'Capability' Brown, the famous landscape gardener, was employed here in his early life as kitchen-gardener.

The house has a very big park full of beautiful large trees and I was tempted to paint the house from a distance with fine groups of trees and woods surrounding it. But my client was keen to have the architecture portrayed in some detail and so I settled on this fairly close up view partly framed in trees.

I chose a 'Not' surface white paper and settled down to a fairly long job of drawing the building with considerable care and accuracy with an HB pencil. I had my paints with me, but after a little thought I felt this subject could be dealt with better in the studio. There was a lot of fiddly work required with windows and blustrades and columns and I hankered after a firm table to work on. The important thing with this type of subject is to prevent it looking laboured. For instance the distant part of the building has the detail indicated with only a few lines, whereas one could actually *see* a great deal of detail.

When I had painted in the main washes and shadows I used a very small brush for drawing in the rusticated stone joints of the base of the building and also for cornices and caps of columns etc and some of this work was done with a pen using a dark grey-brown water-colour mixture.

I made a rough pencil drawing in a sketch book of tree foliage and foreground branches for reference when painting. The general colour scheme was greens, browns and yellows with a grey-yellow for the warm coloured stonework of the house.

Churches

I have given churches a separate heading because they are so different from any other type of building and they are worthy of special study. Artists down the ages have taken churches for their subject in one way or another and the great variety of English churches and cathedrals does give marvellous scope to the landscape painter, especially the water-colour painter.

I take first a picture of the west front of Binham Priory, Norfolk (40). It is a Bene-dictine Priory and used to be a very much

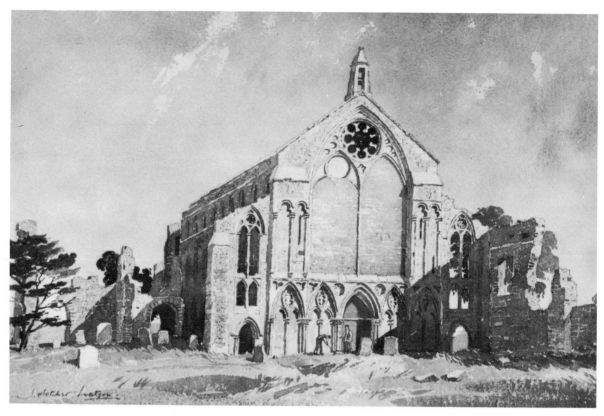

40 Binham
Priory, Norfolk.
30 cm × 47 cm
(12 in. × 18½ in.)

larger building with chancel, north and south transepts, a tower and a cloister. It was cruciform in plan originally but now all is in ruins except the Norman nave which stands today. My view is of the west front showing the thirteenth-century great west window blocked up with mellow pink brickwork which is not unattractive, contrasting with the grey stone tracery and flint work of the walls. The ruined walls and tracery of the Early English windows on each side through which a tree can be seen on the right, make a beautiful subject for the painter.

I first inspected this building to select a view point and see where shadows would fall at different times of day. The best time for shadows was going to be about mid-afternoon for the west front I thought, although I was looking at it in late afternoon. So I came back next day about mid-day with my sandwiches; this would give me time to do some careful drawing work first. One cannot always do this, of course, as one may be passing through and have no time to return to a subject next day.

The drawing took me about an hour and a half; it took a little time to plan out the right proportion of the facade so that the group of pointed Gothic arches below fitted in properly with the width of the big window above. There is no harm sometimes in putting in a lot of pencil work if you use an HB as this does not give a dark line and it is surprising how the pencil lines disappear when strong colour washes and shadows are applied. Of course it doesn't really matter if pencil *does* show in the finished picture. The stone quoins on the left-hand buttress were drawn firmly in pencil and the pencil work still showed after painting and this does not detract from the picture at all. After all, it is the end result which matters and it is sometimes quite pleasant to see a little pencil work showing through the water-colour.

The shadows of arches and mouldings were picked out with a very small brush in the usual way and if one has already had experience of drawing Gothic mouldings it does help in making a painting of this type.

My general method with this picture was to paint the sky first. It was one of those days when the clouds looked very blue and I used Payne's Grey with a great deal of water allowing the colour to run a good deal and obtaining the effect of wispy white clouds merging with grey-blue sky.

The building and ruins were washed over with a yellow-grey colour and then when dry I painted in the left-hand shadow wall of the nave and the high ruined wall on the right, leaving stone jointing in places to give texture. When this was dry I put in the cast shadows with washes of Cobalt and Light Red to start with and then over-painted them with a darker and yellower grey as necessary. Note the darker end of the shadow by the entrance door compared to its shade on the right where it starts at the top of the ruined wall. This is to give the effect of reflected light which one often sees on buildings in bright sunlight. Grading a shadow wash from dark to light helps to make a water-colour look sharp and interesting. This technique is often seen in the work of Cotman and Callow.

Windows and arches were darkened in towards the end of painting and the drawing of shadows on mouldings with the small brush was also one of the last things to be done. The dark green trees showing behind the various ruins were almost the last items to be painted.

Without going into the detailed painting of this picture I hope I have said enough to encourage some readers to have a go at what one might call 'portraits' of buildings of this nature. They really are worthwhile.

Figure 41 is a pencil study of a Gothic window which shows how Gothic mouldings actually work. It does one much good, as I have said earlier, to make detailed studies of various items of nature and also of architecture. Note the stone tracery, ie the carved cusping in-fill at the top of the window.

My next church picture is of Church Green, Burford (42). This shows the south side of Burford church and the old almshouses on the right. This is a winter painting executed from inside the car. I liked the subject particularly because the tracery of bare tree branches rather echoes the tracery of the Perpendicular church windows in an attractive way. The white posts and railing carry the

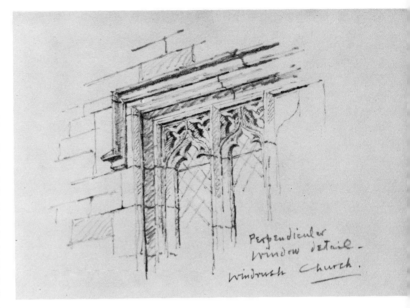

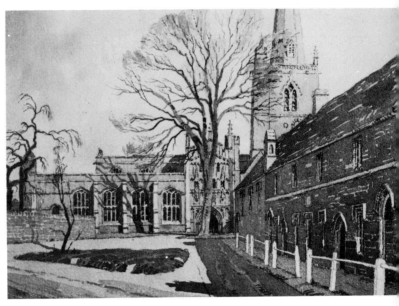

eye towards the splendid two-storey porch and south door and with the church spire going out of the picture, the subject makes an interesting if unusual composition.

Some careful drawing was necessary to start with but not so much as for Binham Priory. Gothic detail on church and almshouses was indicated mainly with a small brush.

The general colouring of the buildings,

41 (*Top*) Pencil study of Gothic window

42 Church Green, Burford. 30 cm × 43 cm (12 in. × 17 in.)

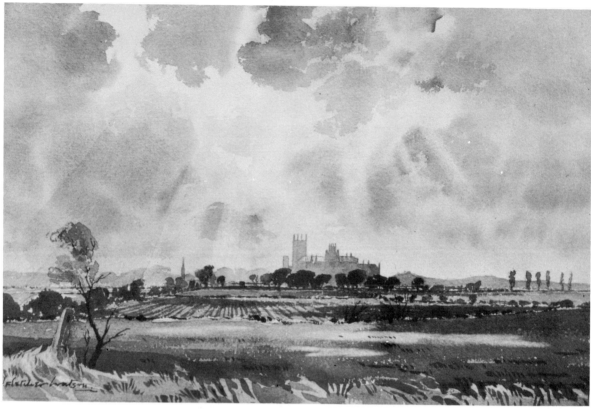

43 Ely Cathedral.
30 cm × 47 cm
(12 in. × 18½ in.)

which are all Cotswold stone including the garden wall on the left, was a warm yellow-grey. Of course a strong mixture was applied to the almshouse wall which was all in deep shadow and stone joints were indicated by leaving them a lighter colour than the stone. Note the way the joints run towards a vanishing point and thus help emphasize the perspective.

Another way in which churches make good subjects is when they are seen in the distance. Their tall towers or spires often stand out above tree tops and they make a good focal point. Ely Cathedral (43) was an irresistible subject especially on the day I painted this picture as it was a beautiful day for skies. Seen looking across the flat Cambridgeshire fens the cathedral was in blue-grey silhouette caused by sun and cloud shadows. It was autumn and trees were green and brown and an early ploughed field was a rich dark brown in the middle distance.

The picture did not require much preliminary drawing, just a few horizontal lines to

mark the horizon and foreground fields. The characteristic shape of the cathedral itself was touched in very lightly in pencil and then carefully painted with a very small brush making sure that the proper shape of the big tower and lantern tower half way along the nave roof was shown. Ely has a unique shape among cathedrals. Note its position in the picture, a little right of centre, which makes good composition.

Cloud shadows were in great evidence on this day; they were constantly moving and one could place them wherever one liked so as to suit the composition. Sometimes a picture is not quite in proper balance and judicious use of cloud shadows can bring it into a good balance. There were shafts of sunlight in the sky and I shall say something more about these in Chapter Nine.

A view of a church at closer range is shown in figure 44. This is Windrush Church, Gloucestershire, as seen across fields from the east. Washes of grey colour were applied to walls and tower in different layers so that the

70

buttresses where they faced the sun coming from the left would stand out in a lighter tone. A darker grey was painted on roofs to indicate the Cotswold stone slates which are so attractive in this part of England. Note the cloud shadow falling across the top of the tower – an old trick often used by the great masters but a very useful and genuine one.

The windy sky was painted in first and later the direction of the wind was indicated by the heavy smoke from the bonfire on the right. This is one of the few occasions when I have used white paint. It was mixed with Raw Sienna to give a yellowish white near the bonfire itself and then mixed with grey as it got further into the sky. It was, I think, the last thing that was painted in this picture.

The trees in their heavy summer foliage were beautiful, strong colours with their contained shadows and played an important part in the picture as they did in the picture of Marlingford Mill (36). They were a rich variety of dark green, yellow green and brown for which I used various mixes of Cadmium Lemon, Prussian Blue, Burnt Sienna and Burnt Umber. There were cloud shadows again in this picture on the foreground field which was a yellowish-grass-green mixed with Raw Sienna, Prussian Blue and Light Red. Grass texture was indicated in the immediate foreground using a large brush with a stiff mix of dark green and making the brush flat edged like a chisel before using it, to give thin blades of grass. This method is worth practising. Alternatively one can use actual square-edged brushes instead of pointed ones. All the well-known artists' colourmen sell these brushes in different sizes and I have illustrated one in figure 3, page 16.

Whilst on the subject of churches, don't forget to look at the interiors as they often make fascinating subjects for a picture. Figure 45 shows a pen and ink study of the interior of Windrush Church with its thirteenth-century Early English columns and arches, a view taken from the south aisle looking east towards the altar which is just seen through the oak screen.

44 Windrush Church, Gloucestershire. 30 cm × 47 cm (12 in. × 18½ in.)

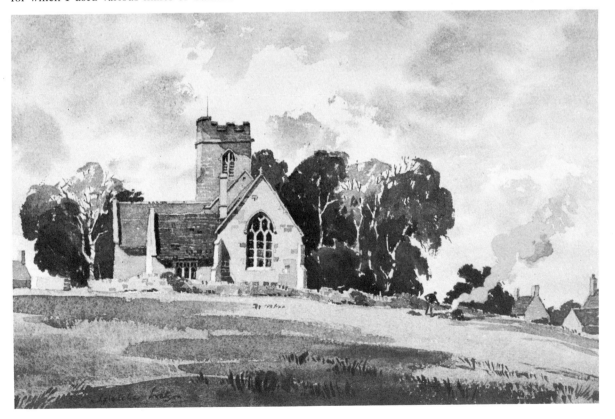

One can make interesting water-colours of church interiors and lighting effects from the Gothic windows can be most attractive. In Chapter Six, figure 17, I showed a water-colour interior of a Norwich church with sunlight coming through the south windows.

One last word about churches; it is always worth climbing the tower and having a look at the view from the top. The tower stair door is usually locked but the key is probably not far away in the vicarage and permission is nearly always willingly given.

Figure 46 shows a view of Windrush village from the top of the church tower. This little felt pen sketch was made in a Bockingford sketch book 21 cm × 30 cm (8½ in. × 12 in.) and afterwards coloured in the studio using Burnt Umber and Cobalt Blue to liven up the buildings and trees and give some tone values. These rough sketches are useful to show one

whether it is worth coming back another day to make a full water-colour, or they can sometimes be used to paint a memory picture in the studio during the winter months if it is too cold to be out of doors.

Villages

Many artists of the past became very addicted to painting water-colour pictures of the English country village, especially painters of the Victorian period. We all know those highly detailed pictures of thatched cottages with roses round the door and little girls standing at the cottage gate. And very beautifully painted they often were. Today we still find the English village makes a fascinating subject for water-colours but we leave out the Victorian detail. Painters like Peter De Wint knew how to paint old cottages and farm-houses to perfection with lovely dashing brush strokes and an impressionist style of picture leaving out all unnecessary detail.

I think today we appreciate a really unspoilt village more than ever before because so many of our villages in the British Isles have been spoilt by the wrong type of new houses being built, and sometimes whole new developments tacked on which are completely out of keeping with the original village. I probably should not use the word 'original' because most of our villages have grown up over centuries and they often have innumerable styles of architecture which up to the beginning of the Victorian period usually harmonized with each other extraordinarily well. The 'original' village may date back to the fourteenth century and include early medieval stone cottages, Tudor half-timbered buildings, Georgian brick houses and Regency houses with plaster walls. The building materials of course vary in different parts of the country.

My first village picture is of Minster Lovell, Oxfordshire (47). All the cottages are built of stone including the building at the far end which is the Swan Inn and dates from the sixteenth century. Most of the cottages are seventeenth century and the one in the right foreground is early Georgian with sash windows and not a very steep roof. Many of the cottages have thatch roofs and probably at one

47 Minster Lovell, Oxfordshire. 30 cm × 43 cm (12 in. × 17 in.)

45 (Left, top) Interior of Windrush Church, Gloucestershire. 23 cm × 28 cm (9 in. × 11 in.)

46 (Left) View from the top of Windrush Church. 21.5 cm × 30 cm (8½ in. × 12 in.)

73

48 Tournon, southern France. 30 cm × 47 cm (12 in. × 18½ in.)

time they all did. It is a charming village and there is no feeling of disharmony in spite of the mixed periods of architecture. The grass verges in front of every cottage give a very pleasant feeling and appearance.

I painted this picture on a cold January day; the bright sunshine was not very warming and I sat in the car to paint. I have an old car with, fortunately, plenty of elbow room in the front passenger seat. I can rig up a stout piece of board which jams under the dashboard and forms an excellent shelf for paint box and water jar. I shall never want to part with this car however old it gets and I hope my local garage can keep it going for many more years!

I am personally very fond of painting in winter as the colours can be every bit as good as they are in summer and sometimes with open landscapes very much better and more dramatic. This view of Minster Lovell had some nice winter trees with brown trunks and branches and some attractive distant woods which were that subtle brown-blue colour so typical of a winter landscape.

The thatch roofs of the cottages were a very

dark grey-brown, giving a rich colour contrast to the light yellow-grey of the stone walls. One or two of the cottage walls were in fact white colour-wash which gave an even better contrast.

I used a little pen-work for some of the nearer cottages and on parts of the grass verges. This was applied towards the end of the painting work to give some sharpening up which I felt the picture required. The picture took about an hour and a half including preliminary drawing but I was at least an additional 20 minutes looking for the right spot from which to paint and park the car.

In complete contrast to Minster Lovell we have the French village of Tournon (48). This is a picture painted in August with trees in full leaf and a different architectural style with arcading to give the shade required in a hot climate. The pointed arches and bell towers with steep roofs are typical of French medieval towns and villages. Tournon is actually a hill village and the road climbs steeply up and eventually lands you in this charming open market square in the centre of the village.

It didn't take me long to settle on my view point; I was largely influenced by the position of the sun and the shadows on buildings. This is always one of the main considerations in a townscape subject. This was indeed painting under ideal conditions – a hot sun to dry the paint fairly quickly on the paper. I always prefer this so one can work quickly and not have to wait too long between washes. I was actually sitting in the shade of a tree; a perfect arrangement so that the sun is not shining directly on your paper and causing a glare to the eyes.

I did my basic drawing work as fast as I could so as to be able to catch up on the painting and get in the shadows before they changed too much. It is always nice to be able to paint them as they are and not as they were. I drew shadow positions in very lightly in case they altered too much before I was ready. As things worked out I got ahead with the painting very quickly and shadows were still quite suitable by the time I got to them. I actually put them in half way through the painting and then went on with trees and building details which might otherwise have been painted earlier.

There were not many people about on this sleepy afternoon but I drew in various figures at odd times when they were where I wanted them to be. It is important to get the heights of figures right and this must be carefully observed – ie just where a man's head comes against a building. The wrong size of figure will throw the whole scale of a picture out of true.

The tower on the left was a pleasant grey stone with a blue slate roof; the other tower had a red roof. The walls of the houses were plastered and coloured, some yellow, some pink and some walls were grey stone. Roof tiles were the Italian flower-pot type and were pink and red. It was generally a most colourful scene and the light was bright giving beautifully strong shadows on walls and ground.

I had finished the picture by 3 pm and I had started at about 12 noon, so I hadn't done so badly and was glad to tuck in to my late sandwich lunch. I am sure many of my artist readers know only too well how time flies when you are painting, meals get forgotten and then hunger bursts upon you when at last you relax at the end.

My next village example is Chipping Campden in the Cotswolds (49). This shows the famous Elizabethan almhouses and the fine Perpendicular church beyond. It is a well-known view and must have been painted many

49 Chipping
Campden,
Gloucestershire.
30 cm × 47 cm
(12 in. × 18½ in.)

50 Painswick, Gloucestershire. 30 cm × 47 cm (12 in. × 18½ in.)
51 Northleach, Gloucestershire. 30 cm × 47 cm (12 in. × 18½ in.)

times before. It is a very architectural subject and calls for careful drawing and accurate perspective, and woe betide the artist who is callous about this as mistakes would undoubtedly detract from the picture. The almshouses are a very beautifully designed building and one has to give great credit to those clever Elizabethan stone mason craftsmen who designed and built it. The chimneys are so satisfying and the repetition of steep gables and the whole proportion of the building are a delight to the eye.

Architectural detail of window, door and chimney mouldings was drawn in with a No. 3 and No. 0 brush. This picture was a case where the sun and shadows were not right when I started at lunch time but I calculated that they would be about right by the time I had half done the painting and so it proved: the shadows had come round by 3 o'clock.

I would now like you to look at two more Cotswold village scenes for comparison purposes: Painswick (50) and Northleach (51).

The Painswick view shows that all the buildings are of stone and the streets are fairly narrow. I am looking up hill as can be seen by the way the stone joints of walls are running near ground level. The composition was not altogether easy as there was a danger of the focal gabled house in the centre middle distance with the shop front being *too* central. But I think this is counterbalanced by the heavy weight of dark shadows on the right-hand buildings and the tree and figures and shop with bow windows in sunshine on the left. This is very much an all-grey picture with so much stonework but this is relieved a little by the dark green tree which was a fortunate feature and which I enlarged slightly: a legitimate ploy of artistic licence.

Now look at the Northleach picture. This is another all stone village but not so confined as Painswick and two of the houses with shops below are colour washed white over stone wall or cement rendering. This gives a brighter appearance and a good contrast is obtained with the dark tree behind the left-hand gable. The open village green gives a spaciousness and the view of the church gives a pleasant feeling of depth. I think the composition is slightly happier in this picture.

However, both pictures are good examples of village subjects showing what can be made of them. I cannot stress too strongly the matter of shadows in townscapes. The subject is always more interesting if the shadows are coming from one side or the other. A lot of the interest of buildings is lost if the sun is immediately behind the viewer and falls straight on to the buildings; this tends to give a flatness to everything.

Now let us look at quite a different type of village, the Italian hill village of Lierna in Tuscany (52). This was a painter's dream subject. The strong Italian sun gave a crispness to the white and yellow stucco buildings and I chose a slightly off-white paper with rough texture.

There were many view points from which one could make a satisfactory picture and I spent a little time looking round, enraptured. I eventually chose this view from a fairly high point, my eye level being about half way up the village as a whole. You will notice the perspective of the roof lines. The higher ones slope slightly downwards and the lower ones slightly upwards.

I used an HB pencil and drew in the village quite lightly and the surrounding hills and trees were only roughly suggested. I felt this subject could be almost entirely a painting job with very little pencil detail.

The sky was painted first and then the surrounding hills; they were a greenish-grey but the far one on the right was quite blue. Next the foreground yellow-green washes went in and the tree groups. I then had the village itself left completely white; it was going to be important not to paint the houses too dark a tone as they could very easily get lost in the background and they did in fact stand out tremendously. One could notice this especially through half-closed eyes. I therefore only painted the roofs of the buildings in next and still left the various house walls pure white.

I continued painting the trees and foreground until they were completed, all but some final strengthening which was reserved until the end.

I next painted the many windows and at last I dared to touch in some dull yellow walls in *very* light tone and one or two a light pink leaving most the pure white of the paper.

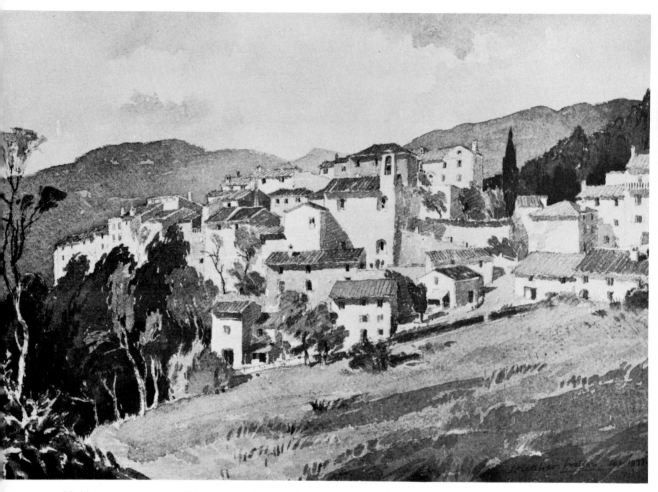

52 Lierna,
Tuscany.
30 cm × 43 cm
(12 in. × 17 in.)

Then came the very important part; the shadows on walls and under roof eaves; the eaves had large overhangs as do all Italian houses and they cast beautiful shadows.

I could now stand back and consider finishing touches. The trees on the right behind the village required darkening, including the tall cypress tree and one or two trees on the left of the village. Some slight darkening to shadows on buildings by the church and in one or two other places was needed. Some roofs required slightly darker reds, and then it was finished. Leave well alone is always a good motto if one is tempted to go on fiddling with a picture.

I used the following eight colours for painting this picture: Cadmium Lemon, Raw Sienna, Burnt Umber, Light Red, Indian Red, Cobalt Blue, Prussian Blue and French Ultramarine. That is to say two yellows, one brown, two reds and three blues. This was ample for my needs.

Towns

We have seen what a variety of subjects are to be found among individual buildings and villages, but how much greater is the variety when we come to towns. The great painters of the past have found a never-ending source of inspiration in towns: Vermeer the great Dutch painter with his beautiful oil paintings of Delft, Canaletto with his oil paintings of Venice and London, and Turner with his ethereal water-colours of Venice and pictures of towns all over England. But we must particularly look at the water-colour paintings of towns by J S Cotman; his views of old Norwich are masterpieces. There are also

Samuel Prout with his special technique for architectural detail; Bonington whose street scene water-colours are a delight (it is hard to believe that he died at only 26); and we must not forget William Callow and his superb rendering of buildings and streets with dextrous drawing with the small brush, following closely in Bonington's footsteps.

With such a great tradition and inspiration there is every reason for we present-day painters to go out and paint towns and cities in our own way but remembering the splendid quality of colour, tone, perspective and composition of the great exponents. We are of course sadly handicapped by present-day traffic, cars, buses, enormous trucks, not to mention hideous lamp-posts, traffic islands in the middle of the road and advertisement hoardings covering up buildings. There are artists who make very good pictures of modern traffic for their subjects and the buildings take second place, but I am interested in this chapter in concentrating on beautiful buildings themselves.

What more lovely city than Florence to choose for my first town picture? The coloured illustration of the Piazze di Firenze in colour plate 5, facing page 120, shows a view with the Bargello and bell tower on the right and the tip of the dome of the cathedral just showing over the roof tops on the left.

I sat on my stool half way up the wide steps of the church on the right hoping to be out of the way of pedestrians. But there were a large number of people about including children who jostled close to where I was sitting and there was quite a lot of traffic on the road also. I decided that it was not going to be easy to paint this picture on the spot and I would do a careful drawing with notes of colours etc and paint it later. This is the sort of decision one has to make sometimes according to circumstances. The more experience you have of painting buildings, the easier you will find it is to paint them from memory.

So I settled down to make a careful drawing. I decided to use a 'Not' surface French Arches paper which has the very slightly cream colour eminently suitable to the subject. I used an HB pencil for all of the drawing and gave careful consideration to perspective and making roof lines and foot-path lines etc converge on various imaginary vanishing points.

But first a word about the general view point. The danger was having the two towers about equally placed on each side, but the high Bargello building on the right and the lower roof lines of the buildings on the left gave the necessary unbalanced arrangement and the church on the extreme right, even though not much of it would show, was a help. Also the weight of dark shadows on the right brought the eye to that part of the picture, and from there the eye was led into the picture down the narrow street in the distance. I felt that the composition would be all right in spite of the two towers.

I took special care to draw in a number of people, noting the height of their heads particularly against walls of buildings. Getting the figures smaller as they go further into the distance is very important and helpful to perspective. The only vehicle I was prepared to put in was the horse-drawn carriage coming out near the base of the Bargello building and it was a useful position here for the composition. I completed all the basic drawing in about an hour and a half and this included lightly marking in shadows and making notes about the sky and building colours generally.

The next day I was back at the villa where I was staying, some miles out of Florence, and I got to work on the painting, starting with the sky. I will now run through the painting as it was carried out.

It had been a good day for the sky with clouds moving across in a good breeze and patches of blue coming and going all the time. I first wetted the sky area, going over the tops of buildings but not using too much water as I wanted the paper to dry fairly quickly. When half dry I washed in grey clouds using Burnt Umber and French Ultramarine which gave the right warm grey and for the lower clouds a little Raw Sienna was added. These washes ran slightly on the damp paper and gave the uneven edges that were required. I then mixed a light blue using Ultramarine and Prussian as I wanted a slightly greenish blue and I painted this behind the Bargello bell tower so that it also showed through the arch; the mixture was fairly dry so as to give sharp edges to the white clouds. When all was dry I painted in the small

grey cloud in the centre which overlaps the white cloud and also some darker cloud at the top left making both of these run a little by adding clear water. It is always possible and advisable to design one's cloud arrangement to suit an architectural subject as this can help the composition considerably.

With clouds that are not too dark like these, one should run them actually *over* the tops of buildings and not try and stop them along the exact roof lines; this could lead to grey edges drying with an unwanted line. When the buildings are painted the light grey wash is covered up and does not show.

The next stage was to give an overall wash to all the buildings and road etc using Burnt Umber and a touch of Raw Sienna, but a weak mix, the colour of the lightest building. The buildings in the distance had the wash diluted to lighter still. Care was of course taken during this wash to miss out the figures and certain windows and shutters leaving them white.

When this was dry the buildings on the left received further washes of Burnt Umber and Raw Sienna again, to a slightly darker tone, and later when dry I picked out areas of stonework with the same two colours but darker still with either more brown or more yellow as required. This treatment gave the stone texture and the big wall areas variety. The buildings on the right of the picture were a rather rich brown in colour and were given a wash of Burnt Sienna and Cobalt, keeping the nearer four-storey house lighter than the Bargello building behind it. Again individual stones of the walling were picked out with a stronger mixture.

Roofs were now put in using varying mixtures of Raw Sienna, Light Red and Indian Red. When dry they had lines of tiles touched in with a small brush using a brownish red colour.

The strong diagonal shadows on walls and horizontal shadows under eaves were now painted in using a darker tone of the wall colour itself. Cobalt Blue was added in some places to give a darker shade. The shadows on the far buildings down the street were a mixture of Cobalt and Light Red as distant shadows do become much greyer. The shadows on the road were now painted in a brownish-grey colour using Cobalt and Burnt Umber and a stronger mix of the same colours was used for the church in deep shadow on the extreme right.

The many windows were now painted using Burnt Umber and Cobalt; a small brush was used and for some of the mouldings and shutters a pen was used. Details of the tall thin tower on the left were dealt with by using the same mixture but rather more blue than brown.

Cloud shadows fell on the two towers from time to time and these both received washes of warm grey using Cobalt and Light Red. The tree top showing over left-hand roofs was a mixture of Prussian Blue, Cadmium Lemon and Indian Red.

The final stage of the picture was to paint in the figures. There always seems to be a great deal of white worn in hot countries, even the men wear white or light coloured coats. I used some pure Prussian (but not too strong) on some, and pure Indian Red and Burnt Umber on others. The figures in the shadow on the right were of course painted over with dark grey. The horse and carriage were picked out in Burnt Umber and Cobalt and some pen work was used. The foreground steps required some additional treatment with darker colours with a small brush and some pen work.

The picture was now largely finished and I gave it a distant look with half-closed eyes. The diagonal shadows on the right-hand buildings required strengthening, picking out the individual stones a little more and one or two windows required darkening with Burnt Umber and Ultramarine and the horse and a figure or two needed darkening. These little finishing touches can sharpen up a picture and pull it together. Of course if over-done you can ruin it; you have to be careful and know when to stop! As I have said before, even when a picture has been painted on the spot, when you get it back to the studio and put it in a mount you can detect deficiencies which can so easily be put right with a touch or two. In fact it is often advisable not quite to finish a painting on the spot and leave the finishing touches, if any, until you reach the studio; you may just possibly find that the little unfinished passage is better left as it is.

This Florence picture was painted with

nine colours: Cadmium Lemon, Raw Sienna, Burnt Sienna, Burnt Umber, Light Red, Indian Red, Cobalt Blue, French Ultramarine, Prussian Blue. I could have easily done without Cadmium Lemon for the tree and used Raw Sienna instead. The brushes used were Nos 0, 3, 5, 9 and 12.

We will now leave Italy and go to Norwich, a wonderful old medieval cathedral city which still has a number of its old streets left although they are disappearing far too quickly.

Cow Hill is a fascinating steep little road and is illustrated in figure 53. The three-storeyed house in the centre has the gabled dormer windows which are so typical of Norwich and East Anglia, and the Crow-Step brick gable shows the Dutch influence which was very marked in Norfolk buildings of the seventeenth and eighteenth centuries.

I am using this example of a townscape mainly to illustrate *tone* values. A black and white reproduction of a coloured picture is always a test of its tone values. Sometimes of course the actual subject does not have much variation of tone such as a moorland scene on a grey day. But a town scene even on a grey day usually has plenty of tone variation. And on a sunny day as in this case the tone variations are strong. This is helped if, for example, there is a white stuccoed house like the three-storeyed building in the centre of the picture. This house was the object that caught my eye and made me really want to paint this picture. The big tree behind the house is the key to the picture and is the darkest *tone* in the picture; its very dark nature makes the white walls stand out brilliantly. This green tree also looks pleasing against the rich red pantile roof of the dormer windows, green and red being complementary colours.

53 Cow Hill, Norwich. 25.5 cm × 35.5 cm (10 in. × 14 in.)

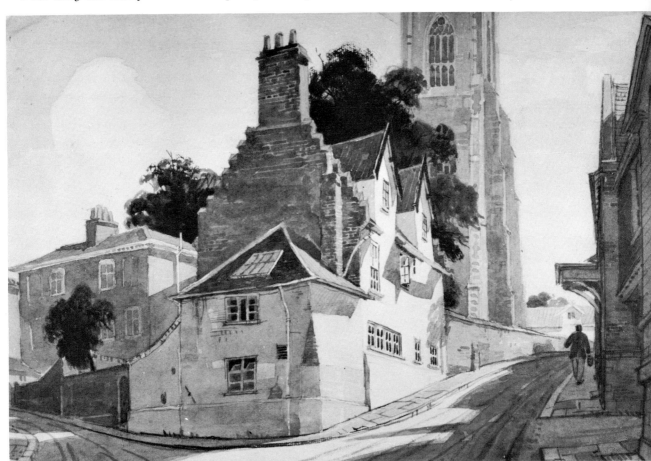

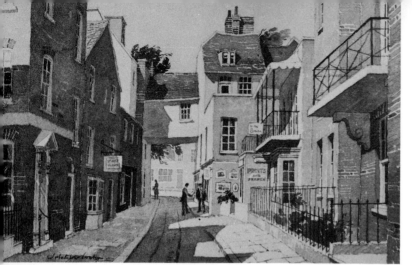

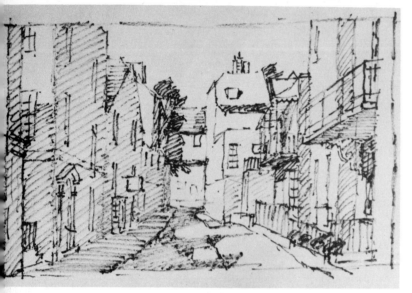

balanced with the sunlit wall areas. The white cloud was of course put there purposely and it counterbalanced the white area of house walls.

Next I would like to look at a view of old Hampstead; this was originally a village which grew into a town and is now a part of greater London. It still has a village atmosphere in parts however, and when exploring and looking for a subject I found Perrins Court (54) quite by chance; it is a delightful traffic-free spot.

I could see at once that it was a good subject for perspective and it had that three-dimensional quality which is so worth looking for in town subjects. The shadows were right too so I settled down quickly to make a rough sketchbook drawing with a felt pen to record the shadow positions and check the composition. Figure 55 shows this rough sketch which took about 15 minutes.

I got going with the main picture as quickly as possible as there was the same problem that one is so often having of trying to beat the clock and get to the stage of putting in shadows before they change too much. A smooth white paper was used and a B pencil which was not too soft for this type of paper. I had a feeling that I would not have time to finish the picture completely on the spot because of its detailed quality and it was already late afternoon, and so I drew in doors, windows and balconies rather carefully so that I should have plenty of guidance for painting later.

I then started on the painting with a clear light blue sky; there were no clouds. And then I laid in an all-over wash of warm yellow-grey on the buildings but leaving the first floor archway building the dead white of the paper. I carried on with various washes for the red brick walls, the yellow stucco-rendered houses on the right and the brown-red roofs and reached a point where a grey wash for shadows could be applied on walls, balconies and road etc. This was just a guide following my rough sketch as the actual shadow positions had now changed considerably. This was the moment to stop so I packed up and returned to my temporary studio-bedroom where I was staying. It was easy to put in window and door details and overpaint with the proper colours the light grey shadow washes that I had put

54 (*Top*) Perrins Court, Hampstead. 30 cm × 47 cm (12 in. × 18½ in.)

55 Perrins Court: preliminary sketch

The red brick gable wall of the tall house is a much darker tone than the yellow plastered wall of the two-storey part just below it; they are both in shadow but the texture of the brick and its colour combined make it the darker tone. The church tower is a light tone, in spite of being built of dark grey flints, because it is further away.

Another point to note is the brickwork of the chimney which has a few individual bricks picked out with a small brush and more bricks painted on the wall below. This is best done with a small *old* brush with a blunted tip. I think I used a No. 3 in this case.

As far as composition was concerned the buildings seemed to fall into place without much contriving and the shadows across the road and on the buildings were happily

on. The whole picture took me about an hour painting on the spot and another hour in the studio.

I was lucky to have some small parts of trees showing through the arch and over roof tops; this always helps to relieve the severity of buildings and various hanging signs and the old print shop with pictures hanging on the outside wall all added character and interest. You will note that I again used the brickwork technique as done in the Norwich picture (53).

This picture of Perrins Court is an example of half painting on the spot and half painting in the studio, and I recommend trying out this method as you will find it extremely useful on occasions when time is short.

While I was staying near Hampstead I made another discovery of a quaint little corner, namely the Holly Bush Tavern (56). This small picture was painted quite quickly taking just over the hour and I show it as an example of a really small town subject that can never the less make quite an interesting picture. It is amazing how the modern car can get along such tiny lanes which were only made for horses and carriages. But cars do go along them – luckily not while I was painting.

Another even smaller and quicker sketch, 14 cm × 20 cm (5½ in. × 8 in.) is a view of Shepherd Market, London, (57). This is right in the heart of London, just off Piccadilly, and it is a miracle that it has survived. It was painted in an 18 cm × 25 cm (7 in. × 10 in) Bockingford sketchbook with thick heavy weight paper that did not buckle. I was using a 2B pencil and the drawing and painting took three-quarters of an hour. I added a little penwork in the foreground after getting home. These note book sketches are well worth doing as often as you can; they keep your hand in and form a useful record for reference and telling you where to find a good subject when you want one. Also they can sometimes be popped into frames and sold as there are many people who will buy a small picture but have no room for a big one.

Talking about where to find a good subject to paint makes me think of one of the very best places – Venice. We have all heard about the wonders of Venice and what an idyllic place it is for artists, but I had always wondered how true this was in spite of having seen many

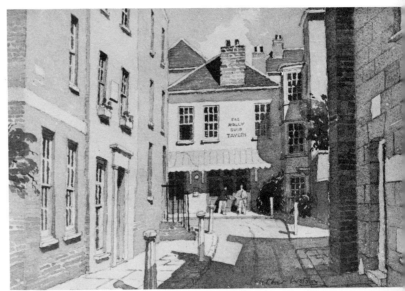

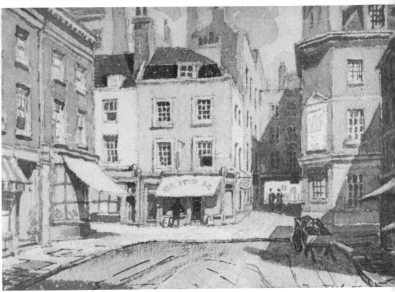

paintings of Venice in art galleries. But at last the opportunity came to go to Venice and I realized it had been no exaggeration – Venice to me was quite marvellous. I thought it was goint to be daunting and perhaps difficult to paint, but to my joy I soon realized that one could find quite simple little subjects round every corner as well as the large vistas of the Grand Canal which are so well known.

I want to show you two small paintings of Venice, both 20 cm × 30 cm (8 in. × 12 in.) and painted in a simple way.

56 The Holly Bush Tavern, Hampstead. 20 cm × 30 cm (8 in. × 12 in.)

57 Shepherd Market, London. 14 cm × 20 cm (5½ in. × 8 in.)

58 (*Below*)
Campo San
Giovanni and
Paolo, Venice.
20 cm × 30 cm
(8 in. × 12 in.)

59 (*Bottom*)
Piazza San
Marco, Venice.
20 cm × 30 cm
(8 in. × 12 in.)

The skies in Venice can be spectacular, beautiful quite apart from the buildings, and in both these pictures I had good cloudy skies to paint but with plenty of sun as well to give good shadows.

Figure 58 shows a typical Venetian foot bridge; they are not always of stone and brick but often have wrought iron balustrades and they make splendid features for a picture. There are always plenty of boats on the canals of the attractive gondola shape and the people always seem to dress artistically and colourfully.

Figure 59 is a bigger subject in a way but was simplified almost into an impression. I concentrated on getting the dramatic light and reduced architectural detail to very simple terms. There was a lively patch of strong blue sky just behind the pointed top of the Campanile and cloud shadows were moving across the Campanile and the paved floor of the Piazza all the time.

The particular type of houses and palaces and churches of Venice lend themselves to sunlight and shadow in an almost theatrical way, and the brick or plastered walls are of such varying colours, and this all gives the place its great charm. Venice, I would say to the water-colour painter, is a must.

My last town picture is a view of The High, Oxford, shown at figure 60. I am showing you this picture in order to illustrate what I believe is a justifiable thing to do to a beautiful street scene. I have made a few physical alterations to the street by removing the traffic islands from the middle of the road and also removing the very large neon lamp standards from various places on road and footpath as they are completely out of scale with the buildings. Who knows, one day an enlightened City Council may *really* remove these unattractive objects, but I suppose they would have to remove the traffic also and that would be more difficult.

The traffic is very heavy in Oxford and completely blocks the view if you stand as I was standing on a traffic island in the middle of the road. In the circumstances one had to be content to make a series of pencil sketches at different times of day when the traffic was less intense and take a few photographs and build up the picture in the studio. It was fun doing this, especially putting back the old lamp posts which I found out about from looking at old prints. I think I can say that the architecture of this painting is fairly accurate and correct in spite of not being able to paint it on the spot. The sycamore tree in the centre of the picture is a great asset as it breaks up the big mass of buildings in a most pleasing way. As this is one of the classic views of the world one could say that the tree is one of the most important trees in the world. It must be several hundred years old and I hope it will last for many a long day yet.

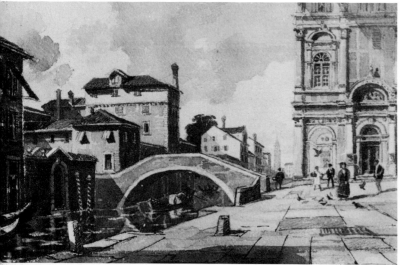

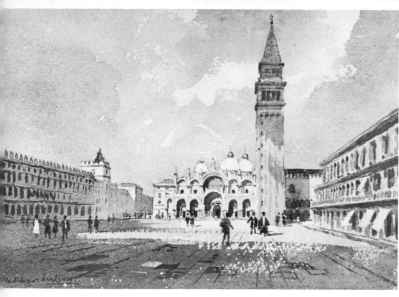

I used Arches 'Not' surface paper and an HB pencil and I drew everything with considerable care especially the detailing of Queen's College in the right foreground. The more distant buildings including St Mary's church spire were drawn more lightly and when it came to painting windows and doors etc I used a No. o and No. 3 brush and sometimes a pen dipped in brown or grey water-colour. Some pen work is also used on the foreground road and footpaths.

The general colouring of the picture is greys, browns and yellows. Nearly all the buildings are in stone but one or two by the sunblind have plastered external walls. One of the objectives with the picture was to obtain a real feeling of distance and this is done by perspective, ie buildings getting smaller and smaller as they recede and also making the far away buildings lighter in tone and very simple in detail. Conversely the buildings near to were given strong shadows and tone values, bringing them into sharp focus.

The composition of the subject is almost self-made and it was only a matter of adjusting one's position a little back or forward to gain less or more of the foreground buildings to right and left.

60 The High Street, Oxford. 30 cm × 43 cm (12 in. × 17 in.)

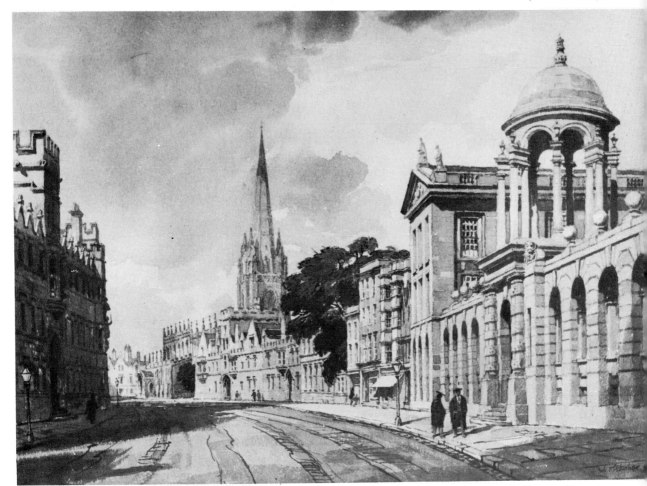

Mountains and skies

We now come to the exciting subject of mountains, which enables you to get close to nature and feel an inward stirring as you tread over the moss and heather of mountain scenery. The very loneliness and majesty of mountains calls to the painter to get out his paints and brushes and record the lovely landscape which the hand of man has not tarnished. Where man's hand *has* been at work it has usually been in sympathy with the surroundings and he has built a stone wall or stone roofed farm or a twisting mountain road which invites us to travel it into the unknown depths and distances. Much of our countryside remains unspoilt because of its mountainous character and we should all be thankful for this.

Skies are a separate subject and yet they form a part of every landscape picture in a lesser or greater degree. They play a particularly important part in a mountain landscape and that is why I have coupled these two things, *mountains* and *skies*, together in this chapter. I have mentioned skies in previous chapters but in this one I hope to say something about the actual technique to be used in painting them in water-colour.

Let us look first at a typical mountain scene in the Lake District with typical mountain clouds. Figure 61 shows a view looking northwest into the Mickleden valley with the Langdale Pikes on the right. The cumulonimbus clouds were particularly effective, gliding over the higher peaks sometimes rolling down lower and then clearing again. The cloud shadows on the valley fields and on the mountain slopes were beautiful and gave those dramatic effects which are always a pleasure to see.

It was mid-morning when I found my view point on some slightly rising ground to the south and I first made a quick sketch in a cartridge paper note-book 20 cm × 28 cm (8 in. × 11 in.) using a stick of charcoal (62). Charcoal is a versatile medium to work in as you can get very thick or very thin lines by varying the pressure on the paper and turning the stick this way or that. You can obtain a tonal effect with charcoal very quickly and it is ideal for open landscape views. I wanted to make this preliminary sketch to see how the

61 (*Below left*)
Langdale Pikes,
Cumbria.
31 cm × 43.5 cm
(12¼ in. × 17¼ in.)

62 (*Below right*)
Preliminary
sketch: Langdale
Pikes

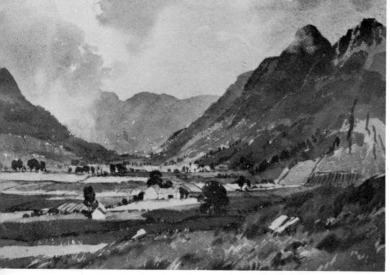

composition would work out and to check the positions of farm buildings and trees. The large tree in the right middle distance was a vital factor and so was the large barn in the centre of the view. These two items together with a foreground rock, whose position I conveniently adjusted, helped to lead the eye into the distant valley.

I decided when painting the finished water-colour (61) to have the clouds coming over the distant mountain in the centre; they were constantly doing this and brought out the left-hand mountain in silhouette dramatically. The method of painting this cloud effect was as follows. I first damped the sky area with a sponge and painted in the whole sky with various grey tones and some blue sky at the top centre position. The mountains had been drawn in lightly with pencil. The grey washes were carried down over the mountains and allowed to dry. The distant mountain was then painted in a grey-blue tone with a sharp edge on the horizon and stopped where the cloud came down over it. Then clear water was added, at this point not very much, and the edges of the very light grey cloud were allowed to run. By using an almost dry brush I could manage the cloud shape as I wanted it by pushing the mountain colour into it.

The next step was to place first washes on the other mountains, letting them dry sharp against the sky. The time of year was Autumn and the mountain colours were very rich browns, yellows and dark blues. The mountains' first wash was continued over the fields to the bottom of the picture, making it more yellow than brown in colour and quite a light tone as this was to be the final colour of the sunlit patches on fields.

Later, much darker washes were painted over the mountains and fields and finally the dark cloud shadow washes, especially dark at mountain tops.

One of the last items to paint was the dark trees and indications of stone walls or hedges at edges of fields giving their shapes and lines of perspective going into the picture. The foreground rough grass was painted in on dampened paper at this time also.

Another almost last item was to put in the thin misty cloud drifting over the Langdale Pike mountain on the right. This was done by

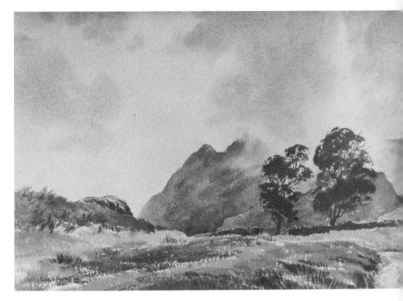

63 The Langdale Pikes in the clouds

using a stiff, hog hair, oil painter's brush specially kept for this purpose. The brush is wetted in clear water and worked gently over the paper; you have to be careful not to lift too much paint, and go slowly at it. The use of blotting paper can be helpful to prevent the clear water running too far and causing a mark. This exercise should be practised in the studio on a rough sketch before trying it out on your finished picture.

Finally I darkened some of the cloud shadows which of course vary in strength according to the density of the cloud throwing the shadow.

Some time after I had painted this picture I found an illustration in a book on Constable of exactly this view painted by him in Indian ink. It was a cloudy and blustery-looking day and I imagine it was a sketch made quickly on the spot with the idea of executing a painting of the subject at a later date in his studio. The date of the picture was 1806 and there were plenty of trees shown in the valley. Probably some of the very same trees are there today over one hundred and seventy years later.

Another subject in Langdale I would like you to look at is figure 63 which is a view of the Langdale Pikes seen from much higher up where the narrow road climbs to the foothills of Lingmoor Fell to the south. This was a showery day with low clouds drifting across hiding the mountains one minute and expos-

ing them the next. I was safely painting inside the car and protected from the wind and rain. The Autumn colouring on this sort of day is quite spectacular: rich mossy green foreground and yellow and orange bracken and grass. No sun could penetrate the misty clouds and the general dampness brought out the foreground colours with great clarity. The distant mountain was grey-blue and the two ash trees were turning yellow-brown and stood out sharply against the misty clouds.

I cannot resist quoting Dorothy Wordsworth who wrote in the Lake District in her Journal in 1801, just five years before Constable was painting there:

As we ascended the hills it grew very cold and slippery. Luckily the wind was at our backs, and helped us on. A sharp hail-shower gathered at the head of Matterdale, and the view upwards was very grand – the wild cottages, seen through the hurrying hail-shower. The wind drove and eddied about and about, and the hills looked very large and swelling through the storm.

This was very much the kind of day on which I was painting. I wouldn't like you to think that one must only paint on a fine day. These wet days in the mountains can be very moving and inspiring; the vital thing of course is that one must have adequate protection.

The process of painting this picture was the usual one – a few pencil lines to start with

64 Little Langdale Tarn, Cumbria.
30 cm × 47 cm
(12 in. × 18½ in.)

indicating mountains, trees and foreground; then a plentiful mixture of light grey, Burnt Umber mixed with Ultramarine and a big wash of this over the whole picture including sky and foreground. While it was drying a stronger grey of the same mixture washed in the cloud shapes. Then the tricky part came of waiting for the first coat of light grey to dry or almost dry so that the mountains could be painted in using a rather dry stiff mix so that it would not run. Some clear water had to be introduced where the clouds came *over* the mountains and the misty shapes controlled with an almost dry brush. The mountain colour was a mixture of Ultramarine and Light Red.

Then quite a long wait was necessary to dry everything out. The damper the weather the longer a painting takes to dry out as I am sure many of my readers will know only too well. I had a very welcome hot thermos drink at this time.

The next stage was the foreground which was painted in a series of washes using different mixtures of Raw Sienna, Burnt Sienna, Burnt Umber and Prussian Blue to obtain the mossy greens and yellow grasses and brown bracken. There was a sizeable outcrop of rock on the horizon to the left which was light and dark grey. The stone wall was painted a dark green-grey and then finally the two trees could be painted. They were fun to put in with a No. 5 and No. 7 brush and strong mixes of brown and yellow and some green colour using the technique for trees described in Chapter Seven.

While I was on the autumn painting trip in the Lake District I experienced a great variety of weather; we had a certain amount of rain which one expects in mountainous country, but one morning it was suddenly and unexpectedly perfectly fine with a blue sky and not a cloud in sight. Here was a chance to paint mountains in full sunlight with no cloud shadows. I found a beautiful subject which included water and still reflections – there was not a breath of wind; this was Little Langdale Tarn (64).

I used a 2B pencil to sketch in very lightly the mountain outline and the lake. Very little drawing was wanted for this picture which was going to be almost entirely a matter for the

brush only. Holding the picture the wrong way up I started my graded sky wash beginning on the mountains themselves with clear water and then as I worked towards the top of the paper brushing the wash in steady strokes right across the paper, I added a little Cobalt Blue already prepared in the paint box. As I worked towards the top of the paper I added some slightly stronger Cobalt and so on until the sky was completed.

The paper was held at a slant of about 20° down towards the top of the sky all the time and allowed to dry off completely on this slant. This time of day was late morning and the light part of the sky near the horizon was white rather than yellow. If it had been early morning or evening the horizon sky would have tended to be a light yellow or pink.

This graded wash is not very noticeable on the illustration but it is clearly visible in the coloured original picture. I shall be showing later a much more noticeable graded wash (see figure 76).

I next painted all the mountains and foreground leaving the tarn or lake unpainted until all was dry. The mountains were beautifully soft, bathed in sunshine and their shadows were on the right-hand slopes as the morning sun was coming from the left. The paper was kept a little bit damp all the time because I was not waiting long between different washes of browns, yellows and blues.

The trees on the far side of the lake and trees in other places were painted after the mountain washes had dried. These trees all stood out fairly sharply.

I could now turn my attention to the lake, and a wash of mixed browns and blues reflecting the mountain colours but a very little darker, was painted in. Before this was dry the tree reflections were painted and they ran only *very* slightly as the lake first wash was nearly dry. As I have said, it was very still water and I did not want the tree reflections to run too much.

This picture is an illustration of a very peaceful mountain scene compared with the more stormy previous illustrations.

I would now like to look at a coloured illustration with you and take you through the process of colour mixing and painting sky and mountains in further detail. This illustration

65 Bleatarn house: preliminary sketch

is called Bleatarn House, Langdale, and is shown on the front cover of the book. I was in fact staying at this farm-house and a beautiful position it was as one could find subjects to paint all round within walking distance.

It was a late October morning when I painted the picture; there was a beautiful cloudy sky and the general colouring was superb. I walked about a little, examining different view points and adjusting the position of the mountains behind the farmhouse. There were various alternatives and I decided a preliminary sketch would help me make up my mind. Figure 65 shows my rough drawing made with a felt pen in a 25 cm × 35 cm (10 in. × 14 in.) sketch book of Bockingford paper. This only took about eight minutes and told me what I wanted to know, namely that the various trees and mountain positions were all right for composition. The buildings were rather central but that did not matter as the right-hand house was white and the left-hand farm buildings were grey and this adjusted the balance. This colour scheme, incidentally, is rather a nice Lake District tradition. The farm-houses are always white-washed over the stone and the barns which are usually attached to the house are left the natural stone colour. They would soon get dirty from animals in the farm-yard if they were white-washed.

Coming now to the water-colour picture, which was 30 cm × 47 cm (12 in. × 18½ in.), I decided on a rough surface Arches paper and drew in the Langdale mountain range with a B pencil including the trees and foreground, all

very lightly drawn. For the house etc an HB pencil was used with a fairly definite line. For mountains one wants to make any pencil work very unobtrusive so that the painting goes onto the paper as a direct clean wash, and I try to avoid following any pencil line with the paint as one often wants the mountain edge against the sky to be slightly rough. It is better to have no pencil at all for mountains if it can be managed. A clean stroke of the paint brush is much more effective and attractive if there is no sign of pencil underneath.

I used eight colours for this picture – Cadmium Lemon, Raw Sienna, Burnt Umber, Indian Red, Burnt Sienna, Cobalt Blue, French Ultramarine, and Prussian Blue.

I first damped the sky area and partly over the mountains with a sponge. Then I mixed a pan full of grey using Burnt Umber and Ultramarine. I washed the grey colour over the damp paper and half way down the mountain using a No. 14 brush and left a white area of cloud near the centre.

I then used a No. 12 brush and some strong Cobalt with the faintest touch of Indian Red for the blue sky patch over the big tree, but first I had dried part of the white paper with blotting paper so that I could obtain a sharp ragged edge to form the white cloud shape. While the grey wash was still damp I painted in some blue sky to the right and it ran nicely into the grey cloud giving the appearance of thin cloud moving across blue sky. The great secret of sky painting is to paint blue into grey and then the grey *looks* as if it is coming in front of the blue.

Some darker grey cloud was added on the left side of the sky which ran slightly into the still damp original grey wash; the sky was now finished.

I next carried the same sky-grey wash right over the whole picture but being careful to leave the white house and bits of washing and the window and door of the farm building the natural white of the paper. I could now have a short rest while everything dried out completely. The atmosphere was damp and I had in fact to wait half an hour – rather patient work when one is wanting to get on with the next stage.

The background mountain range was now to be painted and I started with the left-hand mountain top which was blue-grey and I used a mixture of Cobalt and Indian Red for this. As I worked the wash downwards I added some Burnt Sienna, giving a red-brown colour and then at the very bottom I brought more blue in. I worked the wash across to the right changing it to a mixture of Raw Sienna and a little Cobalt and the mountain top was almost pure Raw Sienna. I allowed this almost to dry and then painted a stiff mixture of Cobalt and Burnt Sienna lower down and to the right, dragging the brush quickly across the sky to give a rough edge and allowing the brown mountain edge to be seen against the yellow mountain behind. When this was dry I added some darker brown at the top and in one or two other places on this right-hand mountain. This mountain background painting was almost the most important part of the picture, and it was important to keep the sky line edges a little bit rough. At this time of year the lower parts of the mountains are covered with dying grass and bracken and have an inviting mixture of yellow, brown and red colours.

Next came a wash of green on the foreground grass; this was a mixture of Cadmium Lemon and Prussian which gives a very bright green and this is toned down with Indian Red which gives just the brownish green that is wanted. This wash was varied a little by introducing more yellow in places.

I then painted the leaf foliage areas of the tall trees; these were fun as there was a variety of colour in them ranging from a mixture of Raw Sienna and Indian Red and a little Cobalt giving a yellow-brown colour, to Burnt Sienna and Cobalt giving darker brown-reds. I used a No. 5 and No. 7 brush for smudging in these tree shapes. The trunks and branches were next painted with No. 1 and No. 3 brushes and a mixture of Burnt Umber and Ultramarine.

My thoughts were just turning to the next and most interesting part of the painting, namely the darker trees behind the buildings, when it started to rain! I quickly turned over the paper to save the picture from ruinous rain drops. The rain was only slight but enough to stop any further painting. It looked like settling in wet for some time. So I had to pack up and take myself back to the farm-house, not a very long walk. The scene was well impressed on my memory and it was not at all

difficult to continue painting in my bedroom. It is sometimes no bad thing to finish a picture away from the spot as one can almost calculate better the tone values and where to put in the final strong accents of colour to pull a picture together away from the actual scene.

Continuing with the painting: I started on the trees behind the house and farm buildings. These were mostly a mixture of Burnt Sienna and Cobalt Blue but the darker trees were Burnt Sienna and Prussian Blue, giving a deep brown-green. I used a No. 5 brush and a stiff strong mixture and was very careful in painting up to roofs and walls of the buildings as these had to be made to stand out. Care was also taken painting in between the foliage of the big central tree. After painting these background trees there was more punch to the picture and it started to take on an interesting appearance and the white house was standing out well.

It was now time to put in the light green-grey roofs and the grey-brown walls of the farm building to the left with a No. 5 brush. The roof colour was Indian Red and Cobalt and a little Cadmium Lemon and for the farm building walls, Ultramarine, Indian Red and Burnt Umber. When this was dry I painted in the shadows under the eaves and at the side of the porches etc using Indian Red and Cobalt and a No. 5 brush again. The windows were now painted in dark with a No. 3 brush using Burnt Umber and Ultramarine.

There were shadows on the foreground grass partly from clouds and partly from trees and these were next painted with a No. 9 brush and the same green mixture but a darker version, ie Cadmium Lemon, Prussian and Indian Red. The foreground rocks had been left a light grey from the original wash and they now required strong grey-blue shadows of Cobalt and Indian Red. A few dark brown touches were put in to the near-foreground grass areas.

The work now only required finishing touches; these were brown fencing posts on the left and some tree branches required a little strengthening using a small brush. The grey wall in front of the house required stone texture with some darker grey touches and the far left-hand wall wanted darkening with blue-grey. The hens were touched in and the pink and blue washing on the line was painted. A dark brown thin line painted with a No. 0 brush was drawn along the bottom of the garden wall and the picture was now complete.

I have said quite a lot about the technique of painting a mountain and painting a sky, so let me now say something about *choosing* a mountain subject. I think of all the types of landscape subject, a mountain view can stir one inwardly more than anything else one ever looks at. The type of day has a great deal to do with it and on a certain day in late summer I found myself in the Honister Pass in the Lake District in mid-morning and the lighting effect was perfect. Figure 66 shows the pass looking eastwards from a position near the road which comes from Buttermere and twists up and up over into Borrowdale. There is a great massive black rock which the road has to circumvent and this rock is seen in the middle foreground of the picture. The road can be seen again over the rock in the far distance, winding to the top of the pass. The subject made a perfect composition with the large area of mountain known as Fleetwith Pike on the right, mainly in shadow, and the lesser area of mountain on the left in sunlight with cloud shadows racing across it. The stream or 'beck' as they say in Cumbria, just shows in the right foreground and the black rock is in the perfect strategic position for good balance.

The clouds were partly over the right-hand mountain and the sun was breaking through with occasional shafts of light. I had seen this pass many times before and it always stirred

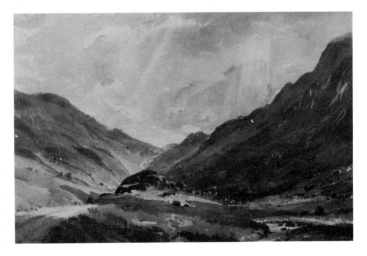

66 The Honister Pass, Cumbria. 30 cm × 43 cm (12 in. × 17 in.)

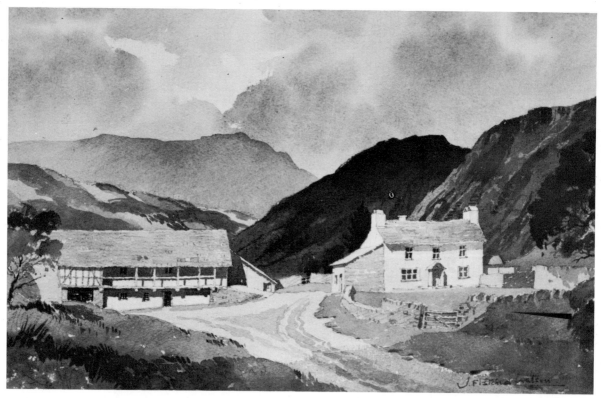

67 Yew Tree
Farm, Coniston.
30 cm × 47 cm
(12 in. × 18½ in.)

me in any weather, but on this day it was irresistible and had to be painted.

With very little pencil preliminary work I got onto the painting quickly and was able to nearly complete it in about an hour and a half before the light changed appreciably. A few minor finishing touches were put on, such as clumps of grass in the foreground, after I had got home.

What is it we look for in a mountain subject? There is no set arrangement but one does want a mountain to have a good shape. Some mountains are quite frankly dull; they are too rounded and hump-backed and too smooth to be interesting. What one looks for is sharp irregular skylines such as we saw in figure 61 of the Langdale Pikes or the steep side with irregular outline of Fleetwith Pike in the Honister Pass picture.

One also looks for a *distant* view in a mountain picture: a far away mountain that gives a feeling of great space. I am coming to some illustrations of this in a moment. And one wants some good foreground objects to throw the middle distance back. Loose rocks

are one of the best things, but a road can be useful and attractive, running into a picture, and even tufts of grass will do. You also need something to give scale to the picture. Buildings of course help to do this whether they are in the foreground or background. The road itself in the Honister Pass picture gives excellent scale to the size of the mountains; it is both close up and far away.

Let us look at figure 67, Yew Tree Farm, Coniston. Here is a subject that has plenty of foreground, a farm track, walls, buildings, and a good middle distance too in the form of the very dark mountain under heavy cloud shadow. And then there is a distant mountain which was painted in light grey-blue.

There was a brilliant light effect the day this picture was painted. The dark mountain consisted of dark brown rock and brown bracken and even when it was in sunlight it looked dark, so when it was in shadow it looked *very* dark and had the effect of showing up the white painted farm-house in a most dramatic way. Nature sometimes conspires to give us a great drama and this was certainly a

subject which had to be chosen as soon as it was seen. The big barn on the left is called the spinning gallery and the first floor gallery had beautiful shadows.

Another type of mountain picture has water in it and trees. Figure 68 shows a distant view of Brothers Water; the lake was fore-shortened and the light shining on it gave it a silvery look. The trees in various places made the picture interesting and the big tree on the right was especially helpful to the composition. There was a pleasant arrangement of distant mountains and sloping foreground that made this subject worth choosing. The grey sky had patches of blue and there were good cloud shadows on the foreground.

One more mountain picture with water as part of the subject is shown in figure 69. This is Wast Water in the south western area of the Lake District. The view is looking north eastwards up the lake with Lingmell, the very dark mountain, rising 2649 feet, and the taller Sca Fell mountains on the right partly covered in clouds. The colour of the lake is always dark

as it is very deep and the mountains on the right, just out of the picture, run sheer down into the water.

There was no difficulty in choosing this subject; it was crying out to be painted at first sight. It was only a matter of adjusting one's position to obtain a good foreground. There was bracken and sloping grass and rocks to juggle with, all the right ingredients for a good foreground.

There were wisps of cloud drifting over the mountain tops which gave them height and put them in their proper perspective. The colouring in this Autumn picture was pre-dominately browns and blues using Burnt Sienna and Ultramarine a good deal. For the lake itself I used Payne's Grey which was exactly the right colour without mixing it with anything else.

There is an element of *design* in the making of all pictures and particularly with the mountain landscape. Take for example figure 70, the Llanberis Pass, North Wales. This is a valley type scene with high mountains on either side

68 Brothers Water, Cumbria. 30 cm × 47 cm (12 in. × 18½ in.)

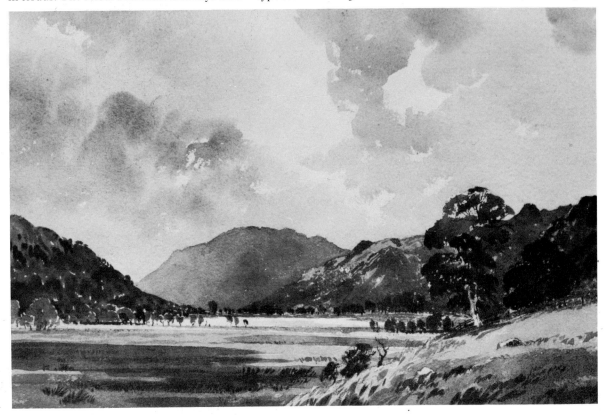

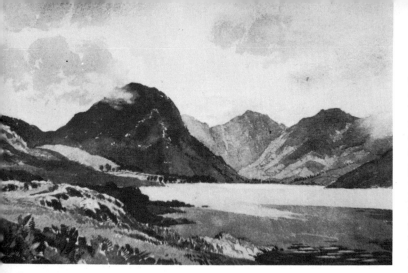

69 (*Above*) Wast
Water, Cumbria.
30 cm × 47 cm
(12 in. × 18½ in.)

70 (*Above*)
Llanberis Pass,
North Wales.
28 cm × 47 cm
(11 in. × 18½ in.)

71 (*Below*) The
Snowdon range,
North Wales.
30 cm × 53 cm
(12 in. × 21 in.)

and the focal point is the two lakes in the distance. The design element is the position of the higher mountain on the left compared with the lower craggy-rock mountain on the right and the position of the woods in the middle distance and the emphasis these items are given by their strength of colour or tone. Design is, I suppose, another name for composition, but I am calling it design so as to draw attention to the idea of making nature to a certain extent conform to *your own* idea of what you want the picture to be. Nature herself is of course the *origin* of the idea, ie a mountain valley, but your own ideas must come in quite strongly in using the darks and lights and colours to give a happy balance and general feeling of satisfaction.

This view as a matter of fact, was a wonderful stroke of luck as it was the view from my bedroom window in the shepherd's cottage where I was staying. I had not booked to stay there, I simply tried my luck and was taken in. It was so ideal in stormy weather when rain was coming and going as it was on the particular day this painting was made. I always think Wales is at its best in stormy weather as the skies are exciting and the damp mountains are gorgeous dark colours.

I *designed* this picture by moving only very slightly the position of the foreground cottage a little to the right and the tree and road with it – a thing you cannot do with your camera. The slatey black rock on the right-hand mountain was moved into the picture fractionally and the shape of the lakes was slightly improved. After painting a number of landscapes you learn to do these little manoeuvres subconsciously. A view from nature is very seldom quite perfect and that is the artist's job, to make a perfect view to his own way of thinking at any rate.

The left-hand mountains are part of the Snowdon range and the Llanberis Pass is altogether a very exciting valley in which to paint and I recommend it to those who do not yet know it.

The sky in this picture is a good example of the cumulo-nimbus rain clouds. There were several patches of light and dark blue as well as many shades of blue-grey cloud.

I called the last picture we looked at 'the valley type' picture and we will now look at the

opposite type, namely 'the mountain peak' type. Figure 71 shows the Snowdon Range and the focal point this time is not low down but high up on the mountain top. This is a stunning view on the road from Capel Curig looking towards Snowdon and painted on a lucky day when the clouds were off Snowdon itself. A feature of this picture is the road running into it which leads your eye into the mountains in an inviting way. It is always a good thing to have a road going into a picture and it is an enormous help in giving distance to a landscape, something we should always aim to achieve. I made a very rapid charcoal drawing of the view in my sketch book before starting on the painting (72). A drawing is so useful to confirm you have chosen the right view point and to see that you do not want to move further up the road or further back. The cloud shadows were good on this day and the positions where they have been painted are all part of the 'design'. Again this is where we can score over the camera. A curtain of rain is seen to the left in the sky drifting away and only two minutes before this grey curtain was enveloping the whole scene. I need hardly say I was painting this picture from safely inside the car.

We will go to Scotland for another mountain road picture. Figure 73 shows Glen Voil, Perthshire, on a rather different type of day when there was low cloud and mist in the distance. I was travelling with the family on this occasion and we had not time to stay very long and so I stopped working half way through the painting. I had painted the sky and mountains in and the first washes of the foreground and I was a little discontented with the result so far. The distant mountains were much too strong in tone and so were the nearer mountains.

When I was eventually back in the studio some days later I realized that something drastic would have to be done and I decided on the old Turner trick of putting the painting into a bath. Well, I did not actually do that but I very gently sponged the whole picture over with masses of clean water and gradually increased the sponging until the far mountains and sky became beautifully misty and distant and the nearer mountains and foreground were softened and lightened.

The whole picture was then allowed to dry

72 The Snowdon Range: preliminary sketch. 20 cm × 28 cm (8 in. × 11 in.)

out for about an hour; I could then start painting again. The middle distance mountains on the left and right were a marvellous olive green and brown; I had made a note on the side of the picture and it all came back to me in memory most clearly. I used a mixture of Cadmium Yellow, Prussian Blue and Burnt Sienna. While it was still damp I painted in some darker brown using the same mixture but more Burnt Sienna on the left-hand slopes. Then some small blobs of distant trees were touched in with a small brush and the same colour for a belt of trees on the left along the river which just shows in a thin white line.

Then came the marshy area of flat low lying land in a yellowish green with Raw Sienna and a touch of Prussian and as the ground came towards the foreground it was a browner colour using Burnt Umber added to the yellow colour.

At this point I started to use a pen with a dark brown mixture of water-colour. I drew in the tree, the wood fence and some of the road and foreground clumps of rough grass. This brought these items into close focus. When dry the dark tree was painted with Prussian and Burnt Umber; this always gives a beautiful dark green. Certain areas of foreground

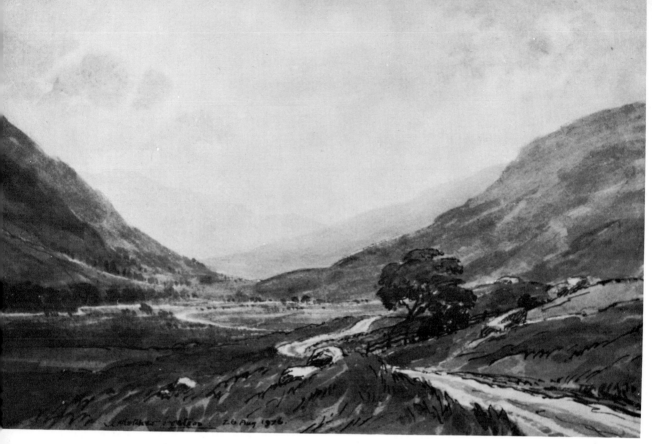

73 Glen Voil,
Perthshire.
30 cm × 44 cm
(12 in. × 17½ in.)

grass and left-hand marsh were painted with
Prussian and Burnt Sienna, the road received
a grey green line of grass down its centre and
the rocks were given some dark grey shadow
and the picture was done.

I recommend the sponging-out method for
mountain scenery on a misty day; it is well
worth doing some experimenting. You will
find that some colours have a stronger staining
power on paper than others. Raw Umber
for instance has a weak staining power and will
wash off very easily and it would be safer to use
a large soft brush instead of a sponge for
wiping out. On the other hand Prussian Blue
has a strong staining power and will take more
washing with a sponge. But don't worry over
much about colours, just try the idea on a half-
painted picture whatever colours you have
used and I think you will be delighted with the
result. Of course you preferably do want to use
a heavy weight paper for this experiment.

Another mountain with road picture is
figure 74, the road to Uig, Skye. This is an
example of how simple a subject can be and
yet give plenty of interest. There was some-

thing moving about this lonely road across a
Scottish Moor with distant mountains. It was
a very narrow road and probably a very old
one, having started life as a cattle and sheep
track. The colouring and cloud shadows were
what made the picture. Some of the grass and
moss was a deep green, a mixture of Cadmium
Yellow, Prussian Blue and Rose Madder, the
latter giving the darker tone to some areas.
The lighter grass was Raw Sienna, Light Red
and Cobalt Blue.

Coming back to skies again I would like
you to look at one more picture with cloud-
mist. Figure 75 shows the bridge at the head of
Loch Ainort, Skye, The high mountain was in
the cloud but at the same time there was bright
sun shining on the top of the bridge and on the
river. I was looking into the sun as I painted
this picture and the face of the bridge was in
dark shadow and so was the mountain range.
There were sheep in the foreground with the
sun shining on their backs and it also glinted on
the stones and rocks.

In fact this is an example of painting into
the light and you always have very pleasing

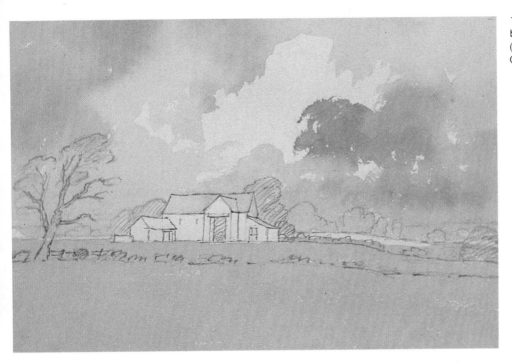

1A Cotswold barn. 20 cm × 30 cm (8 in. × 12 in.) Stage One

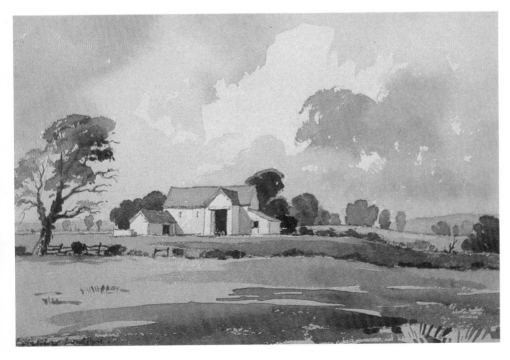

1B Cotswold barn. Stage Two

2 Dovecote at
Masquières,
France.
30 cm × 47 cm
(12 in. × 18½ in.)

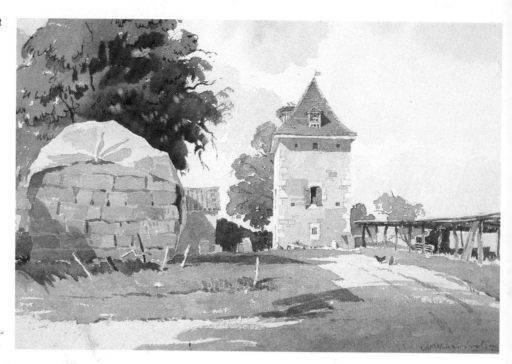

3 Great Langdale,
Cumbria.
30 cm × 47 cm
(12 in. × 18½ in.)

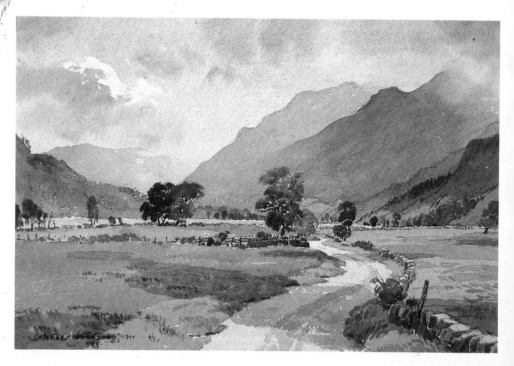

shadowy tones and colours when doing this. It was one of Turner's favourite ways of painting.

The cloud sometimes lifted off the mountain and I painted the whole mountain shape in and then lifted the colour off with a hog hair brush and plenty of clear water as described earlier in this chapter.

Now that we are talking about painting into the light I will refer to the colour reproduction shown in colour plate 6, facing page 121. This is a view of Blakeney Church, Norfolk, seen from across the marshes and looking south into the afternoon sun. The sun is partly behind a big dark cloud and rays of light are shining down in all directions. One often sees these lovely sky effects and very often in the early morning or late evening.

Directly I saw this excellent sky I decided to have a go at it at once as a sky study and put in a landscape later if necessary.

I did not draw anything on the paper at all as I did not want to lose time and risk the whole cloudscape changing as it so often does rather quickly.

I first lightly damped the whole sheet of paper with my small sponge. The paper chosen was Greens 300 lb pasteless board

rough surface. Then I mixed a good quantity of grey with Burnt Umber and Ultramarine Blue and painted in the big clouds at the top with a No. 14 brush. They ran slightly on the damp paper which is what I wanted. I worked the grey washes downwards making them yellower by adding in a little Raw Sienna. I had no horizon line of course at this stage and the wash was taken almost to the bottom of the paper. I then used blotting paper on some of the white cloud areas to dry them.

I then quickly mixed some Prussian Blue, well diluted, and smudged in the light blue patch of sky half-way down the picture while the grey was still damp, but the white paper was dry and I could obtain sharp white cloud edges. Then, again quickly, I mixed Ultramarine and painted in the darker blue sky at the top left of the picture leaving a nice jagged white cloud shape. I also dabbed in some dark blue onto the damp grey cloud near the top on the right. Still working quickly I mixed some darker grey with the same two colours, Burnt Umber and Ultramarine, and gave the central dark cloud a darker wash while it was still just damp and added some darker touches here and there. This about finished the sky except for the sun rays. I painted some indications of

74 The road from Brogaig to Uig, Skye. 20 cm × 30 cm (8 in. × 12 in.)

75 Bridge at the head of Loch Ainort, Skye. 30 cm × 44 cm (12 in. × 17½ in.)

rays on the left with light grey washes and one grey wash on the right side.

The next thing was to form the more distinct rays from the sun. This can be done by washing out with a hog hair brush or rubbing out with an india-rubber; I used the latter method in this case. You wait for the sky to dry completely and then take a piece of stiff white paper about 30 cm × 15 cm (12 in. × 6 in.) and use it as a ruler to mark the rays coming from a point just above the dark cloud where you guess the sun actually is. Hold the paper firm over your painting and use a good quality clean rubber and rub out a straight line in the various positions of the rays. You make one side of the paper radiate from the appropriate sun position and move the paper round as necessary. The danger is overdoing the rubbing out. Don't do too much and make the rays fade out; they don't always come down to ground level.

Having finished the rays the sky was complete and I could get on with the landscape.

The church and background trees and the

rising ground were all in shadow but there were a few cloud shadows in the foreground. It was not necessary to use any pencil ground work for this simple landscape and I started straight in with the brush.

Using a No. 3 brush and a grey-brown mixture I drew in the line of the horizon on which the church sits, right across the paper and also the base line of the little hill and a few other guide lines. Then with a grey mixture of Cobalt and Light Red I drew in with a No. 1 brush the church with its main tower and roofs and also the little tower at the east end which is the most unusual characteristic of this church. In old days it is said they put a light in the top window of this small tower to guide fishermen out at sea.

Next I drew in with the small brush the outline of the house on the left and farm buildings to the right and then I blocked in the church with grey using Cobalt and Light Red and the house and farm buildings with a warm grey-yellow using Cobalt, Light Red and Raw Sienna. When these were dry I painted the background trees with different mixtures of

Burnt Sienna, Prussian Blue and Cadmium Yellow. The trees behind the church and to the right of it were various shades of dark green and away to the far left and right they were blue-grey using Cobalt and Light Red. I used a No. 5 brush for all this work. A light wash was now put over the whole ground area of Burnt Umber, Cobalt and a little Cadmium Lemon well diluted. As this dried I brushed in some darker areas of the same mixture and then when dry I used my No. 3 brush and a strong mix of Cobalt and Burnt Sienna and drew in the formations of the uneven sloping ground with its few gorse bushes etc. Then using the same two colours and adding Cadmium Lemon to give a greener tone for some areas, I filled in this broken ground, making some of it quite dark where there were cloud shadows.

The foreground fence was painted using a mixture of Burnt Umber and Ultramarine and the bank was painted a dark green with a mix of Prussian Blue, Cadmium Yellow and Indian Red, and a foreground shadow was washed in on the left using the same colour. A lighter wash of this mixture was used on the middle distance marsh land being careful to leave the thin strip of water the white of the paper. Some reeds were indicated with a stiff

mix of Prussian Blue and Burnt Sienna.

The church now needed finishing with a darker grey wash and when dry the windows were touched in with a still darker grey. The house and farm roofs were painted with Light Red and Cobalt and windows indicated with Burnt Umber and Cobalt.

On this type of day, with the sun mainly behind the cloud, the land is mostly in cloud shadow but the sun was not entirely obscured by the cloud and glimpses of light caught the marsh and hill. One has to watch rather carefully how the general landscape is in a mixture of light and dark whilst the rays shine across the sky at the same time.

I spoke near the beginning of this chapter about a graded wash for a blue sky in a Cumbria picture (64). Before I leave the subject of skies I feel I ought to mention one more example of the graded wash; it is a very important exercise to learn and it particularly applies to water-colour.

Figure 76 shows Stifkey Marshes and Blakeney Church in the far distance. This was painted in August when the sea lavender is just over and there is still a trace of lavender colour on the marsh land. The sky on this late afternoon was a beautiful blue fading to yellow-pink on the horizon. I was using a

76 Stifkey Marshes and Blakeney Church, Norfolk. 30 cm × 45 cm (12 in. × 18½ in.)

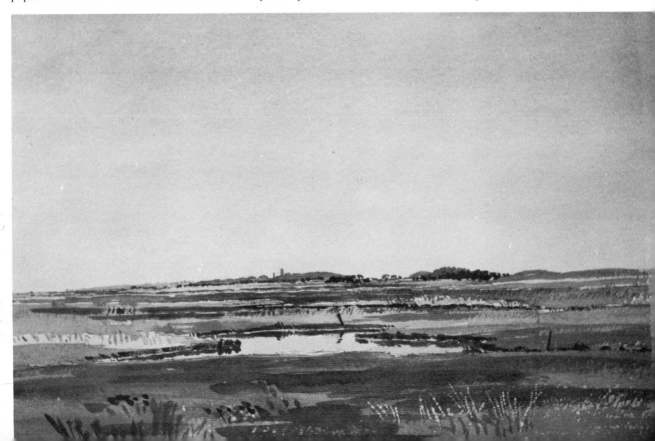

toned paper called Two Rivers, the colour being light oatmeal, and it lent itself to this type of sky and to the marshy landscape.

I first put a wash all over the sky of a mixture of Raw Sienna and Light Red watered down to a pale colour. This was allowed to dry completely before putting on a blue wash. I mixed plenty of Cobalt Blue in my pan first, of not a very strong tone. Then with the picture turned upside down with the top towards me and held at a slope of about 20° the bottom of the picture being uppermost, I started a *graded wash*. To begin with I just washed clear water over the warm yellow sky. After a few brush strokes right across the paper from left to right with a No. 14 brush I dipped it into the Cobalt mixture and made several strokes with that. After laying on about three inches of this pale blue I added more Cobalt colour to the pan and then painted a few more brush strokes. I continued painting darker and darker washes of blue and eventually adding in a very little Ultramarine for the last few brush strokes to give the blue a slightly darker tone. The graded wash was then finished and it was allowed to dry completely with the paper on the slope all the time; this is most important. The final result, when the picture was held the

correct way up again, was a sky fading from quite strong blue at the top down to light warm yellow at the horizon. The art of doing this successfully is not to allow any brush strokes to show and that is done by watching that the consistency of the colour mixture is kept the same all the time. Do not allow too much moisture to come in by mistake or it will cause a patch to dry more slowly and make a mark in the wash. If it becomes too dry it will show a brush stroke.

Using a thick paper with a rough texture is a great help in achieving success.

Having finished the sky I painted the rest of the picture in the ordinary way. The little pool of water was fun and the blue sky colour was of course reflected in this.

I would mention one further item about skies before we end this chapter. If you look at figure 77 of Norwich Cathedral you will see a sky which has the thin wispy cirrus clouds way up above the big cumulus clouds. There is a special technique for making these cirrus clouds in water-colour. You use a piece of *wax candle* and draw it firmly across the white paper before you start any painting. The wax will stick to the paper and prevent any colour going over it. In the case of the Norwich

77 Norwich Cathedral. 38 cm × 68.5 cm (15 in. × 27 in.)

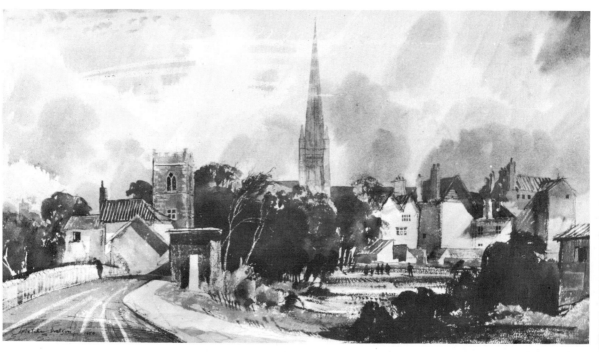

picture I first drew in with pencil all the buildings etc and then before starting to paint the sky I drew four or five strokes with an old piece of candle across the sky. The next step was to paint blue sky over the area of the wax marks and leave the formation of the white billowy cumulus clouds. The wax marks immediately showed up white against the blue most effectively and with rough edges and they did not look too hard and straight. I could then proceed with the rest of the sky, washing in grey clouds as required. This picture is a large one, 38 cm × 68 cm (15 in. × 27 in.) and it was painted in the studio from a small painting made on the spot.

Towards the end of the painting I used my wax candle again on the road, making a few wheel tracks before painting the grey-yellow surface, a mixture of Raw Sienna and Cobalt.

As the picture was a large one I made a bold broad drawing with a black Conté pencil except for the cathedral spire for which I used an HB pencil. Incidentally you will notice two white houses on the right and the right-hand house is where the famous J S Cotman lived for some years.

Of course you can obtain the thin cirrus cloud effect *without* using a wax candle if you like by leaving a white line or two when painting your blue sky, but it is not quite so effective and I recommend you to try some experimenting. You can use smooth or rough paper but I think the latter is slightly more suitable for this technique.

Open landscape and places to go painting

The subject of open landscape is a wide one and embraces some of the items we have already written about. It covers open moorlands, farms, villages, churches, windmills and abbeys, all of which subjects are to be found in profusion in the British Isles let alone on the Continent of Europe. These subjects form much of the landscape water-colour painter's work and I want in this chapter to deal with the *suitability* of subjects and if I can to help those who are less experienced in *finding* a subject which appeals to them. I would like to suggest a few districts where you might like to go to find good landscape painting subjects.

Let us start with Tintern Abbey in the beautiful Wye Valley (78). This was painted in July when everything was green and it was a cloudy day with gleams of sun lighting up the old ruined Abbey from time to time.

This subject was easy to find as my view point was in a sloping field beside a main road. I had a feeling I was going to find a good view as I drove along the road and saw the top of the Abbey, so I quickly stopped and climbed the fence and walked down the slope a bit and there it was – a perfect view. I went back to the car and collected my painting materials with that grand feeling that I had got my subject without much searching. I had been driving along with no particular subject in mind but I knew I was in a good district as the Wye Valley abounds in beautiful views.

The first thing I felt was that the sloping foreground of rough grass was perfect as it gave the feeling that the Abbey was in a

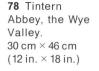

78 Tintern Abbey, the Wye Valley.
30 cm × 46 cm
(12 in. × 18 in.)

hollow, which it was, with the river over to the right, just out of sight. The lesson to be learnt here is to stick to a view directly you find it and don't go hunting round for what might be a better one. I could have walked down to the river to see if I could get that in as well as the Abbey, humping my painting kit with me, or I could have gone on to look at the other side of the Abbey, getting tired in the process. But I have learnt to resist these temptations and get on with a good subject.

I always have an old rug with me when painting so that I can level up uneven or sloping ground and I can open my paint box on something level. This is essential so that you can mix a good pan full of colour without it overflowing, and the water jar can be made to stand up safely in the folds of a rug without danger of falling over. It is not so easy to fix one's chair or stool on sloping ground but one can usually find a stone to prop up a leg or dig a leg into the ground.

I was now ready to start and a little careful pencil work was required to get the ruined Abbey properly drawn. I had purposely got myself into a position that would make the right-hand end gable of the Abbey cut into the sky line and the way one could see green hill and trees through some of the topmost window openings was attractive.

The fairly stormy sky was painted in first and then the hills and trees and foreground were completed before putting any wash over the Abbey itself. It was left completely white.

I laid on light washes of yellow-grey, being careful to leave an extra light portion to the lower right wall. Darker washes were gradually build up, including the shadow on all right-hand walls as the sunlight was coming from the left. Finally the dark window openings and arches were painted.

There were farm buildings and even a hay stack in front of the Abbey; the latter is a rare thing to find in these days of mechanical farming. There were some beautiful dark woods on the right running towards the Abbey and altogether the view made a well balanced composition. Many artists have painted Tintern Abbey in the past including Samuel Palmer in 1835, and many present day painters also I am sure. It remains unspoilt in beautiful surroundings so do go and enjoy a day painting it if you get a chance.

We will now leave the Welsh border and travel to one of my favourite parts of the world, the north-west of Scotland. Here in Sutherland are to be found wonderful open moorland subjects with dramatic mountains rearing up and seen across the landscape.

Figure 79 shows a distant view of the sharp

79 Suilven, Sutherland.
30 cm × 48 cm
(12 in. × 19 in.)

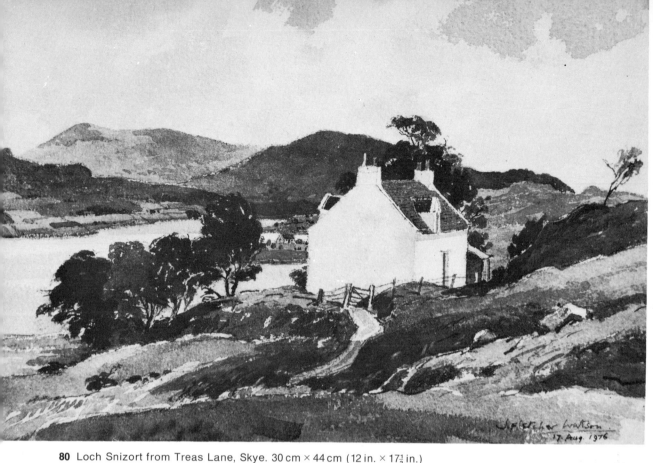

80 Loch Snizort from Treas Lane, Skye. 30 cm × 44 cm (12 in. × 17½ in.)
81 Salthouse, Norfolk. 30 cm × 44 cm (12 in. × 17½ in.)

mountain called Suilven, looking across the moorland road near Altnacealgach, of all unprounceable names. Once you get the hang of it it rolls off the tongue quite attractively! The time was October and the colouring out of this world. The heather was mostly over but there were still little bits of purple left but most of it had turned Burnt Sienna and Burnt Umber colour. There were boggy parts which had turned yellow and dark green.

The sky on the horizon was pale yellow and there were touches of blue amongst the grey clouds. A passing hail storm obscured the distant mountains on the left and cloud shadows gave a richness to the foreground colouring. A cloud shadow across a road is always an attractive and helpful thing in modelling the shape of road and bank and you want to keep an eye open for these shadows and memorize how they go as they are usually moving quite fast.

My wife and I found a little hotel to stay at in the hamlet of Altnacealgach and I can recommend this as a wonderful centre for painting subjects all around.

Just a word about the painting of figure 79. I first damped the paper which was white rough surface Green's Pasteless board heavy weight. Then a very pale wash of Raw Sienna was put over the lower half of the sky only and allowed to dry. Then I damped the sky again and ran in the various grey clouds and painted a small area of Cobalt Blue high in the sky and Prussian Blue weak mixture, half-way down. The grey curtain of hail storm to the left was also painted while the paper was still damp.

All was then allowed to dry as the horizon was very clear and I wanted a clean soft line of hills there. Various washes of browns, yellows and greens were laid in and the painting of the dark cloud shadows was done while everything was still damp so that these washes were slightly blurred.

The road was left white until nearly last and then a very light wash of Burnt Umber was painted over it and when dry, in went the mossy, grassy marks in the centre. The Suilven mountain on the right had been given a preliminary grey wash and it was now painted a medium strong Ultramarine Blue with a little Indian Red mixed in. And the left-hand faint mountain was brushed in *very* lightly with a blue-grey mixture.

Whilst our minds are still on Scotland let us look in on the Isle of Skye which has some very beautiful wild landscape views. Figure 80 is a view looking south-east up Loch Snizort with a typical crofter's cottage in the foreground with its white-painted stone walls and blue slate roof. These little cottages are dotted all over Skye and make good subjects for the painter. They are particularly suitable for the beginner in water-colour painting, as they are attractive buildings, very simple to draw and fit in well in a mountain landscape. Perhaps a less complicated background of mountains and loch would be better for a beginner.

What appealed to me in this view was the tree behind the cottage which was a dark green, showing up the light colour of the building. I also liked the run of four or five small old ash trees to the left and being able to see the water through the trunks and branches. The undulating ground with long grass and rocks made a good foreground.

So far we have been in mountainous country. Let us now look for some subjects in the flatter country of East Anglia. There are plenty of open landscape views in that part of England which have appealed to generations of painters.

The fishing village of Salthouse on the north Norfolk coast is a delightful place and is situated on the edge of the coast road with miles of marshland to the north and in the distance can just be seen the sea (81). Some of the cottages are built of flint and very often of stones taken off the beach, some are of brick and others plastered and colour washed. All the roofs are different shades of red Norfolk pantiles.

In this part of Norfolk you see the wide, open skies with a long thin strip of land below. The coast is full of attractive spots to paint; further west is Cley with a windmill, Blakeney with a superb Church with two towers, then Morston and a few miles further still Overy Staithe and marshes all the way with very paintable views. Most of these villages have little pubs or hotels where you can stay and many cottages will give you bed and breakfast.

In the Salthouse picture I kept the sky area wet with grey clouds running into the white all the time except for a little patch of blue sky at

the top left where I used blotting paper so that a sharp-edged white cloud could be created.

I used some pen work on this picture when it was half painted, for the tree on the left, some of the cottages and some of the foreground.

Before moving on from Salthouse you must climb up a steep hill at the back of the village along a narrow little road that leads to Salthouse Heath. It seems a high hill for Norfolk and you get a superb view looking west towards Blakeney and you can see the church peeping through the trees (82). To the north is a fine distant view over the flat marshes and the sea, as seen on the right in the picture. On a cloudy day the cloud shadows are fascinating and greatly add to the perspective. There is a profusion of gorse bushes on the heath which makes a good foreground.

82 (*Above*) Salthouse Heath, Norfolk. 30 cm × 46 cm (12 in. × 18 in.)

83 (*Below*) Cley Mill, Norfolk. 30 cm × 47 cm (12 in. × 18½ in.)

Now we can move up the coast a couple of miles to Cley which has a beautiful windmill (83). This mill was converted into a house very skilfully about 50 years ago and there is a chimney cunningly concealed at the very top. The circular rooms inside the brick tower are most attractive partly because they have wonderful views over the marshes. Many of these marsh areas are bird sanctuaries which are noted for having many types of sea birds and other rare breeds.

The mill is an imposing structure and stands well on the east bank of the river Glaven. Here it is seen from the west side, but there is an equally good view from the east.

Moving on again, only a mile this time, we come to Blakeney and I show a painting of the marshland with Blakeney Church on the rising ground (84). We have already seen views of Blakeney Church in Chapter 9 on skies but I could not resist including this very lovely marsh view with an old cattle track and cattle in the distance, seen from the north-east. A sea breeze was blowing from the north at the time this was painted and the clouds were racing by. Practically no pencil was used, just a very faint outline of the church and the horizon line, the rest was entirely brush work. That is how I like to paint a water-colour when the subject allows.

The colouring was almost entirely greens and browns with a blue-grey for the church and far trees and a touch of yellow to the fields near the church.

Continuing west after Blakeney the coast road has salt marshes and after a mile and a half you arrive at Morston. As you come down the hill towards the village you see a lovely view of the church sitting on a little hill of its own. I parked the car on a patch of grass near the church and walked back up hill a bit and into a nearby cut corn field and found the perfect view point (85).

This is the sort of simple subject I would advise people to paint who have not done a great deal of outdoor sketching. It is very straightforward and easy to draw and makes a very pleasant picture: farm buildings on the left, rising ground on which the little country church sits, a large cottage partly behind the church and a fine belt of trees. There is a foreground of stubble which gives texture and

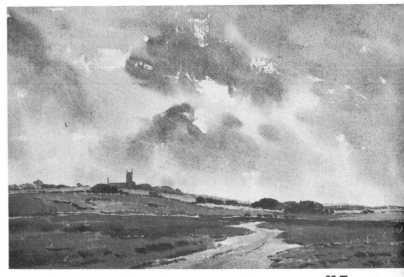

84 ▲

85 ▼

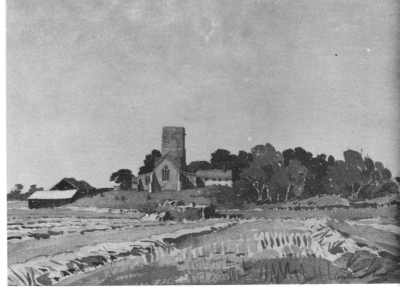

perspective with the lines of straw left behind by the harvester.

The grey flint church is unusual as it has the right-hand half of its tower built in red brick. This was a repair some hundred years ago after the tower partly collapsed but the brick work has mellowed and does not clash with the grey flintwork.

The sky on this bright sunny day was a pronounced *graded* one fading from blue above to yellow on the horizon but there were also some white clouds very high up, which I

84 (*Top*) Blakeney Marshes and Church. 30 cm × 47 cm (12 in. × 18½ in.)

85 Morston Church, Norfolk. 30 cm × 43 cm (12 in. × 17 in.)

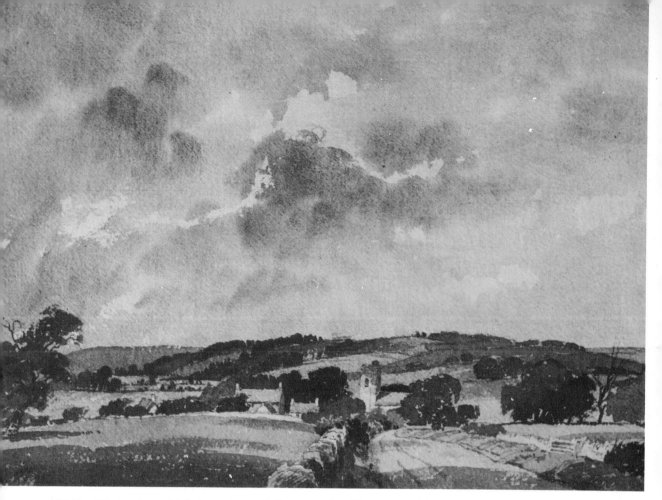

86 The Windrush
Valley.
30 cm × 47 cm
(12 in. × 18½ in.)

think the experts call cirro-cumulus. They are
fleecy little white clouds and I indicated them
by using a not too wet mixture of Cobalt Blue
and a fairly dry brush full of paint, and with
each stroke across the paper, when getting near
the top, I gave the brush a blob or dabbing
motion and this had the effect of leaving light
patches in a regular form. With a little
practice you will find this treatment is quite
effective.

I hope some of my readers will try explor-
ing this part of Norfolk if they have not been
there before. It really is full of painting
subjects at almost all times of the year includ-
ing winter. Not far inland from Morston is
Binham Priory illustrated in Chapter Eight and
the little town of Holt has some lovely street
scenes and old buildings.

I will now take you to a different part of
England, which I call the 'stone wall country' of
the Cotswolds.

Figure 86 shows a view of the Windrush
Valley as you come down the hills into

Windrush Village from the main Oxford to
Cheltenham road. This is the village where I
live and the country around is a constant
source of inspiration. The Cotswold stone
church and cottages make a pleasing focal
point with the sun catching them as the cloud
shadows scurry by. It was a beautiful cloudy
day in summer when this was painted and I
chose a rough texture Arches paper 300 lb
weight.

The sky was a big feature of this subject
and I always recall Constable's written words
about skies:

The sky is the source of light in Nature,
and governs everything. The difficulty of
skies in painting is very great – because
with all their brilliancy they ought not to
come forward, or, indeed, to be thought of
any more than extreme distances are –
there is no class of landscape in which the
sky is not the key note, the standard of
scale, the chief organ of sentiment.

I have looked at many of Constable's pictures and many illustrations of his pictures in books and I can not recall a single one which has a plain blue sky; they all have a cloudy sky of one type or another. That is not to say that we should not sometimes paint blue skies, of course we should, but my point is that we should give a lot of thought and attention to cloudy skies, particularly for subjects in the British Isles and especially when we are painting water-colours.

To get back to the Windrush picture, the sky was certainly an exciting one with plenty of movement and gaps in the clouds showing strong Cobalt and Ultramarine blue high up and the pale green-blue of watered-down Prussian Blue lower down. I will not give details of the painting of this sky as I have said it often enough about similar skies in Chapter Nine. Suffice it to say that I kept the paper fairly wet using blotting paper twice, for the high white cloud and the smaller low one and the grey clouds were allowed to run into each other a good deal.

The distant hill was the first thing I painted after the sky was dry, using our old friend the blue-grey obtained with Cobalt and a little Light Red. A quick stroke of the brush was made so that the colour missed some of the rough paper hollows and left small white gaps. This indicates a belt of distant trees on the hill top.

I next mixed a large amount of green for a wash over the remainder of the picture excepting the road and stone walls and church and cottages. This green was a mix of Cadmium Lemon, Prussian Blue and a little Light Red, giving a warm yellow-green. This was going to be an all green landscape and I wanted a pale wash of green everywhere to start with. Some people are frightened of using too much green in a picture as they say it makes it garish and cheap looking. I think this idea arises from seeing paintings where too much Emerald or Viridan Green has been used straight out of the tube without mixing it with any other colour first. You will notice that I do not use any of the paint manufacturers' greens myself, but mix my own with yellows and blues. By this method you ensure that you do not get a garish or unnatural green. There are of course many well known and first-class painters who

do use the standard greens but they know how to mix them before putting them on paper and there is the danger with the less experienced painter of using them neat and un-mixed.

I next started to paint in the various wooded areas and tree groups and drawing lines of hedges in the distant fields and on the hills with a very small brush. I always find this part of the painting is fun as you are meta-phorically walking about the landscape making it take shape. Remember always that the further away the subject the less detail there is required. I used various greens for this tree work: Cadmium Yellow (because it is more opaque than Cadmium Lemon) Prussian Blue and Burnt Sienna give a good variety for most of the trees. For the big leaning Ash Tree on the left foreground, Cadmium Yellow, French Ultramarine and Burnt Sienna was used as this gives a bluer green.

For the dark group of trees to the left of the church tower I used Cadmium Yellow, Prussian Blue and Rose Madder and gave predominance to Rose Madder in the darkest part so that you can actually see the red showing through. This somehow gives a quality and depth to shadowy green trees.

Some of the fields were now given a wash of yellowish green, especially the foreground field.

A light grey was now washed over the buildings, road and wall, but the church tower was left almost white as the light was catching it.

Shadows on cottages and church and the stone wall in the foreground were painted with Cobalt and Light Red and a cloud shadow on the tower with the same colour. The fore-ground road shadows from clouds were again the same grey but a little neat Cobalt added as they were drying gave them a bit of life. Green grass shadows from clouds were also added.

Distant cloud shadows were painted with a blue-grey-green ie a mixture of Cadmium Lemon, Prussian Blue and Rose Madder.

Standing back from the picture I felt something was wanted to give it a little bit more punch – yes, the distant trees on the sloping hill ought to be darker when they were in cloud shadow which they often were. I gave them a coat of Ultramarine and Indian Red

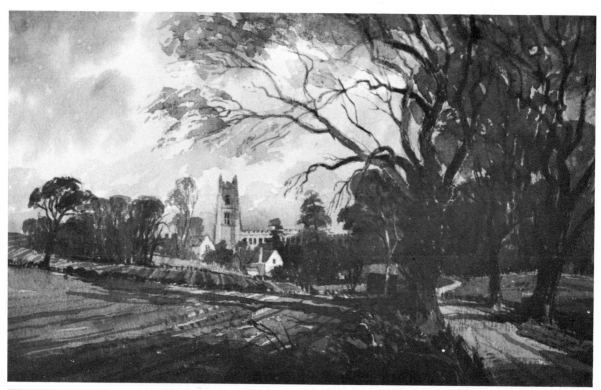

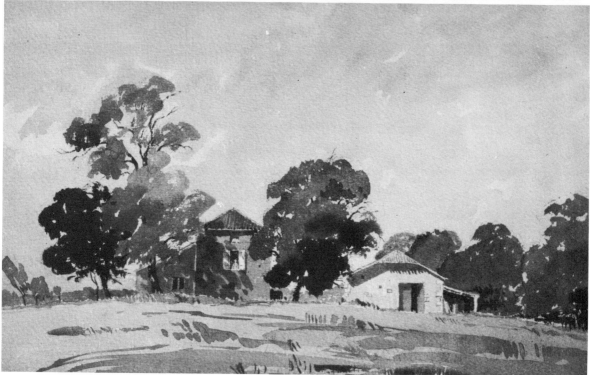

which was virtually purple but on top of the green it looked about right. I also darkened the trees seen over the church roof which sharpened up the sunlight and made the bush in the right-hand foreground by the road darker. The picture was now finished and had taken about two hours.

There is much to paint in Gloucestershire and Oxfordshire, one of the great features of course being the stone villages and towns. There are still some wonderful large stone barns which make lovely subjects for the painter, not forgetting an interior barn study.

Just a quick look at two more subjects to give you some more ideas of where to go. First Stoke by Nayland, Suffolk (87). This is a lovely little view of the church which is a very fine one with an extremely tall tower. There is a story attached to this picture. I was commissioned to paint a picture of the church by a man who wanted to give it as a wedding present to a couple who were getting married there. When I arrived at Stoke by Nyland in rather stormy weather I first looked at close up views of the church and I didn't take to them particularly so before going further afield I looked inside this big church and immediately saw a pamphlet on the history of the church with a lovely reproduction of a Constable oil painting on the outside cover. This gave me a splendid idea for my view point if the view still existed. Of course I was right in the middle of Constable country.

I went off in a southerly direction out of the village in search of the view and low and behold I found it looking almost exactly the same as Constable's picture 170 years earlier, complete with white cottage in front of the church. I decided to waste no further time and get on and paint this view but by this time the stormy weather was developing into a slight drizzle of rain. I had driven over from Gloucestershire specially to paint this picture and paint it I must, so I got myself under a very bushy branched tree wedged on top of the bank with my back against the trunk. Although it was March and the trees were bare there seemed to be quite a lot of protection from this tree. I was determined to paint this picture in spite of the rain drops and the difficulty of balancing my paint box and water on the bank and brambles.

I worked quickly and in about one hour and a quarter the thing was done. If you look closely at the sky on the left you can detect one or two rain drops! It did not rain all the time but it was showery on and off. I was able to put on a few finishing touches when I got back to my studio.

I only mention this story because it shows how someone else's idea for a picture subject can help. I don't mean you to copy my picture subjects but I humbly hope that some ideas in this chapter may lead you to finding good subjects yourself.

The other subject to look at is a French Farm in the Dordogne (88). This is a district of France which I recommend most strongly to the painter. It is, I am afraid, a long way to travel by car into southern France but infinitely worthwhile when you get there. I have already shown illustrations of the area in Chapter Eight and you have seen what delightful buildings and villages France has to offer.

This farm-house had lovely old ash trees round it which cast pleasing shadows onto the buildings. It was a brilliant hot sunny day in August with a yellow stubble field in the foreground. The buildings had stone walls and pink roofs of Roman-type tiles. This is another simple subject which would be a good starting point for the new comer to water-colours.

87 (*Top*) Stoke by Nayland Church, Suffolk.
30 cm × 46 cm (12 in. × 18 in.)

88 (*Bottom*) Dordogne farm, France.
30 cm × 47 cm (12 in. × 18$\frac{1}{2}$ in.)

Water, boats, snow, winter painting in the studio from sketches

Water and boats

I have touched on water very slightly in Chapter Nine when painting mountains with a lake but I would like to say a little more on this important subject.

We will start with *still* water which gives good reflections and a picture of Windrush marshes with a drainage dyke full of water illustrates this (89). This little picture was started off with pen drawing with dark brown water-colour mixture. I then painted the sky and everything else before touching the water.

It is as well to remember that water always tones down what it reflects; the colours are less intense and the darks become lighter and lights are a little darker. The rocks standing in the water were grey and the shadow edge next to the water was dark grey-brown so I painted

89 Windrush Marshes, Gloucestershire. 20 cm × 30 cm (8 in. × 12 in.)

the reflection of the rock a slightly lighter grey-brown using Burnt Umber and Ultramarine Blue. The small, dark bush on the left was a very dark green-brown and so the reflection was painted a slightly lighter mixture of Burnt Sienna and Prussian Blue. Parts of the far bank were bare earth using Burnt Umber and therefore the reflections were the same colour watered down a little. The wood posts were important and gave nice reflections with a slight twist to them as the water was very slightly in movement and a long thin reflection always shows this up. The colour of the posts was dark, being Ultramarine and Burnt Umber, and therefore their reflections were painted a lighter version of this mixture.

Apart from these reflections I had not put

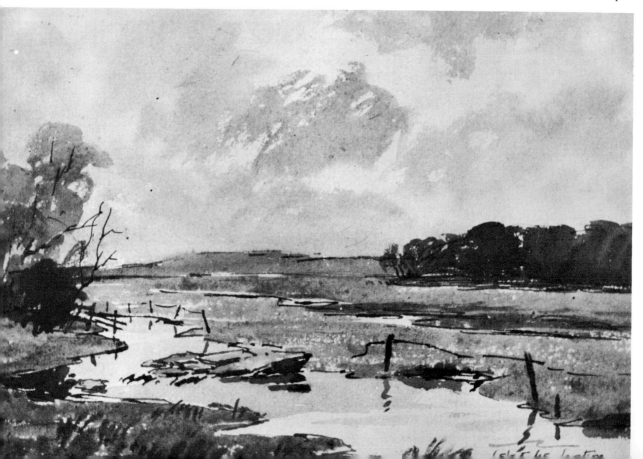

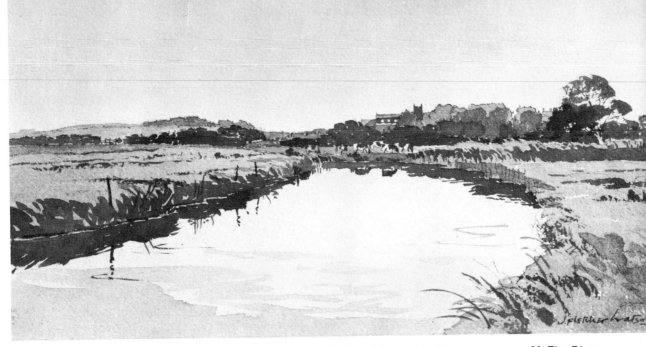

any wash on the water so far so when they were dry I gave the water a light wash of the sky colour, a grey blue, and this end of the water was left white reflecting the white clouds. The wash had the effect of blurring the rock reflection and those of the posts etc.

With still or almost still reflections like these it is advisable not to damp the paper first so as to make the reflections run and be blurred. With still water, reflections are *sharp*, while moving water reflections are more blurred.

An example of slightly moving water is the slow running river Glaven shown in figure 90. This was painted on a clear blue-sky day and the sky reflection in the water was the same blue but a very slight tone darker, hardly noticeable in a monochrome illustration. The reflections of the river bank and the distant cows were still fairly sharp as there was not quite enough movement to disrupt them.

Lake water can look very different to rivers and dykes and figure 91 shows Tal-y-llyn, Wales. The wind is moving the water slightly in this picture and mountain reflections are not very distinct as seen on the left of the lake. At the far end of the lake which is about a mile distant the sun light catches the water and

there is no reflection. Near at hand immature waves are coming in to the shore.

The sky was mainly grey with an odd peep of blue here and there and the water was correspondingly grey of a slightly darker tone.

This mountain subject is a very lovely scene and so much of Wales is unspoilt and most paintable.

Water can play a big part in one's choice of landscape subject and I do advise you to give a lot of practice to painting it.

Look for example at the lovely subject Eilean Donan Castle in Scotland (92). This picture has everything a painter could desire: mountains, a castle, water, boats, rocks; what more could you want? There is always the danger of it becoming a 'picture postcard' painting because of the popular appeal and I must say I found it a very easy picture to sell. But I had not as a matter of fact ever seen a painting or photograph of the castle before I painted it and so I came fresh to the subject and could choose my position without the influence of having previously seen any popular view points.

The Castle is situated on a sea loch, Loch Alsh. The water is therefore tidal and I realized that the tide was coming in, so directly

90 The River Glaven, Norfolk. 30 cm × 47 cm (12 in. × 18½ in.)

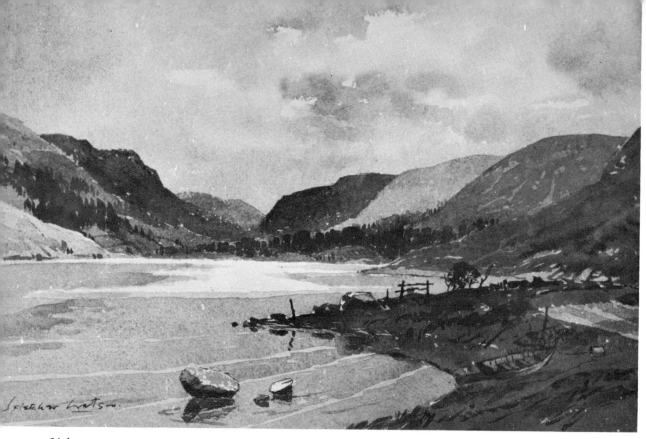

91 ▲

▼ 92

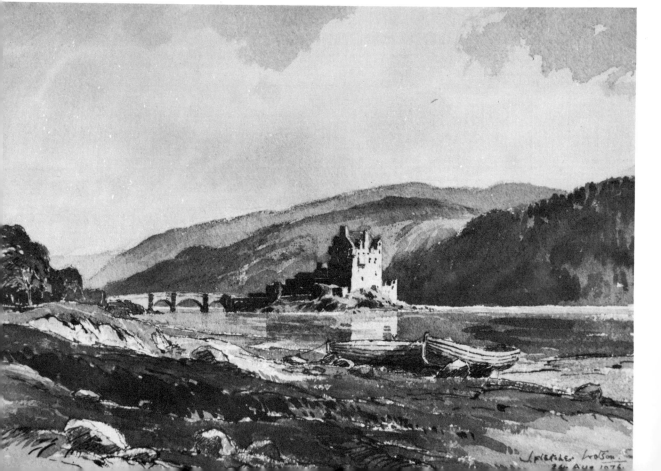

I had settled on my view point I got to work rather quickly as I knew my foreground boats would be floating before long and I particularly like them resting on the foreshore. It made a lovely composition with the trees on the left, the castle just right of centre and the boats a little further to the right still. The mountain background was good in relation to everything else and the water reflections were perfect. There was just enough movement for there not to be too much reflection, for instance the bridge was not reflected but the castle was. This meant that wind or current was varying in different parts of the water. This often happens in wide rivers or lochs and one must scrutinize the water carefully before painting.

I made a careful drawing of the castle and lightly touched in the rest of the picture but used careful drawing again for the boats; one must always draw them carefully as nothing looks worse than a badly drawn boat. I did not paint the sky next as I was anxious to get most of the picture painted before the tide got in too far. The mountains were painted first and then the trees on the left. You will notice I have used a little pen work on these trees and also the foreground, including the boats. Having completed the first washes on the foreground I tackled the castle itself, which had to be painted before I could come to the water and reflections.

I then put a wash of yellow-grey over all of the water except the narrow strip on the right at the far side of the loch which was almost white. The wash was the same colour as the castle wall in sunlight. When dry I could paint the darker greens, browns and greys in the water that was reflecting the mountains, and I carefully left the light reflections of the castle. As these washes half dried I painted in some darker areas of water.

I could now finish off the foreground just as the boats were beginning to move with the incoming tide. I was just in time! The castle needed one or two finishing touches, strengthening the shadows a little.

I could now relax and paint in the sky and then the picture would be finished. I was just able to withdraw without getting my feet wet.

I would now like to come back to the Norfolk coast to a delightful little place much beloved by bird watchers and yachting men. It is Overy Staithe. The name 'Staithe' is an old English word meaning landing-place and from here one can go by motor boat to Scolt Head Island where there is a bird sanctuary owned by the National Trust. The island has a wild remoteness of sand dunes and mud flats and is an extremely sketchable place. But I want you to look at a painting I recently made of Burnham Overy Staithe (colour plate 7, facing page 121) as this shows an example of tidal water which flows up the muddy creek through the salt marshes from the sea.

I caught this view when the water had almost reached high tide and although there was movement the reflections at the water's edge were good. In other parts the wind prevented reflections in detail but the bright sunny, cloudy sky gave a good, bright reflective colour to the water. The view was looking *into the sun* and this always increases the brightness on water and is a very desirable way of painting. The darks are darker and the lights are lighter and you will notice how very dark green the distant trees are and this in turn gives strikingly dark reflections in the water.

It was a day with one of Norfolk's typically lovely cloudy skies and I painted the sky in first using Burnt Umber and French Ultramarine for the grey clouds and a mixture of Cobalt and Ultramarine for the upper blue sky and Prussian Blue for the lower one, keeping the sky washes wet all the time except for one little bit of white cloud at the top of the picture which I blotted dry in order to give it the usual sharp edge. This is a technique I have mentioned several times before.

I next washed in a diluted Burnt Umber on the foreground beach and the more distant beaches and rising ground by the trees, mixing into it a touch of Cobalt to give it a more sepia colour. Burnt Umber is a very useful colour for a beach as beaches are often not as yellow as you might at first think. I next painted the buildings with some warm browns and reds using Burnt Sienna, Light Red and Rose Madder and toning them down with Cobalt.

When all was dry I could deal with the really enjoyable part of the picture, the dark trees. These were Raw Sienna, Prussian and Light Red for the left-hand belt and Burnt Sienna, Prussian and Indian Red for the really

91 Tal-y-llyn, Wales. 30 cm × 47 cm (12 in. × 18½ in.)
92 Eilean Donan Castle, west Scotland. 30 cm × 43 cm (12 in. × 17 in.)

dark right-hand group: they seemed almost black in places.

The beach areas now received further washes of brown-grey and the boats were painted and some figures. The water all this time had been left untouched white and I could now deal with it. First a wash of light grey was applied using a well diluted mixture of Burnt Umber and Ultramarine over all the water except far away where a sweep of white was left. When dry a wash of the same mixture but a tone darker was put over the foreground water, curving the wash to follow the line of the small wave made by the in-coming tide. Then, when this was dry I painted the dark tree reflections not quite so dark as the trees themselves and taking care to leave the white sail reflection and a light coloured curve indicating movement of the water. The house reflections were also painted a red-grey colour.

The picture was now finished except for one or two touchings in of shadows from boats and stones and the jetty.

In discussing Overy Staithe I mentioned yachting and do not let us forget boats themselves when we are talking about water.

I include a sketch of boats on shore and distant sailing boats in figure 93 which shows Pin Mill, Suffolk a great place for sailing boats and particularly old Thames barges. This picture shows what good subjects boats are when on dry land; their lovely curving shapes can have beautiful shadows on them. There was some nice grouping in this picture with boats and masts, trees and cottages and a view of the Orwell river away to the right. One could happily do a whole series of boat pictures and many artists specialize in this, hence The Royal Society of Marine Artists,

which holds its own exhibition in London every year.

Another study of a sailing ship is shown in figure 94, a two-masted schooner at Copenhagen. This was purely a study of the ship and the houses along the quay were sketched in in pencil and were given light washes of colour only. Even the reflections were very sketchy. When I made this sketch I had not got time for a full blooded water-colour and my main interest was the ship. These types of sketch often come in useful for painting a picture at home in the studio in the winter months.

Let us now look at quite a different type of water in the picture of sailing barges in the Thames estuary (95). This shows choppy water which is almost like rough sea.

I made a series of sketches of Thames barges while they were sailing and they were used in reconstructing this scene back in the studio. Figure 96 shows one of the rough sketch book sheets, drawn in felt pen.

I made several rough paintings of water showing some white foam and a few sea gulls and then set about painting the whole picture from scratch at the studio.

The sky had been cloudy and windy and having first drawn in the boat positions I wetted the whole sky area and used pure Paynes Grey with a little Raw Sienna at the horizon. Next I painted the boats with strong red-brown sails for the near one, and the others becoming greyer and greyer as they got further away. The one on the right almost disappeared in a curtain of rain. The water was largely Paynes Grey but quite a lot of Ultramarine was added in the foreground and also some quite green passages. I was leaving out white areas for the wave crests and eventually I used the penknife for a few, but not too many scratchings out.

Cloud shadows are very effective on big stretches of open water and I used a warm grey wash of Paynes Grey with a touch of Light Red for the foreground shadow and also for a thin streak of shadow far away on the right.

In figure 97 I show the Thames in a different mood with calm water and barges at one of the few remaining repair yards at Rotherhithe. There is an old sailing barge with sails furled and in the foreground one of the big metal cargo barges which are still occa-

93 Pin Mill, Suffolk.
30 cm × 43 cm
(12 in. × 17 in.)

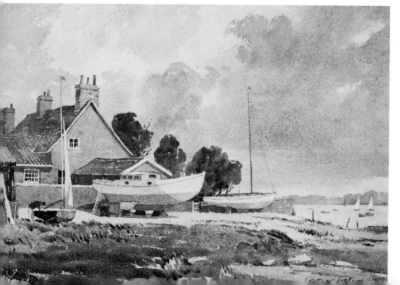

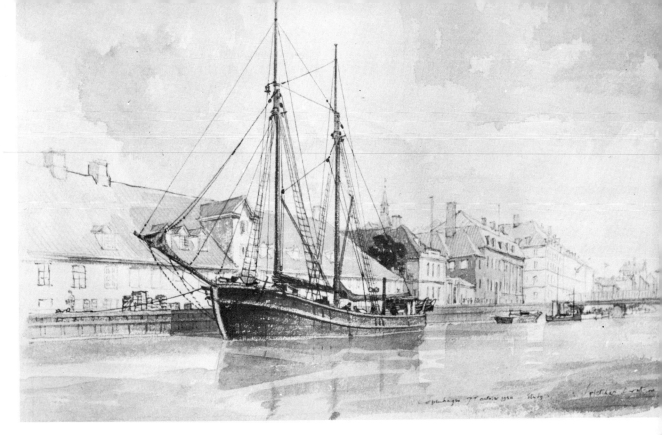

sionally seen being towed along the river by tugs. There was riveting in progress and the noise was deafening at times. These Thames-side subjects are delightful but are getting more and more difficult to find. One of the charms of sketching on the Thames is the people you meet. I had a long talk with an old cockney who had worked as a crew of a sailing barge all his life; he was obviously sorry to see the passing of these wonderful craft out of commercial use. This subject I was easily able to paint completely on the spot and I recommend anyone to explore Rotherhithe.

Racing at Cowes (98) shows some real sea water and quite rough water at that. This picture is another case of making many pencil sketches on the spot of the yachts and a rough painting of the sea and then painting the actual picture in the studio. Most of the yachts are sailing close hauled into the wind and two in the distance on the left have turned round and are running back before the wind. Ability to paint the sea comes after a bit of practice and it is wonderful what a lot of colour there is in the water on a cloudy, rough day. Greens, blues and greys join with each other in a fascinating colour scheme and cloud shadows play their

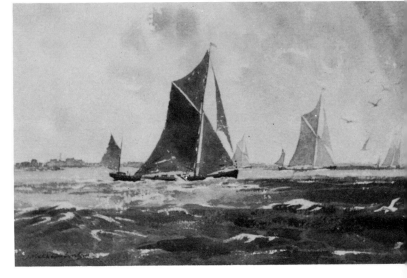

important part in giving lovely dark areas. Strangely enough one does not keep the sea area too wet otherwise the establishing of wave shapes would be lost and blurred too much. The modelling of waves can be really quite sharply painted.

The sea itself is a subject that can give endless interest to the painter and I show a

94 Schooner, Copenhagen. 30 cm × 46 cm (12 in. × 18 in.)

95 Thames barges 30 cm × 47 cm (12 in. × 18½ in.)

117

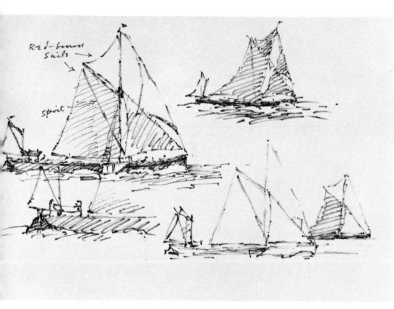

Red-brown sails →

spirit

simple seascape in figure 99. This is Aberdaron in North Wales. One can start painting the sea with a simple subject like this and then work up to the more exciting seascapes with a rough sea breaking over foreground rocks later.

The great thing is to practise painting one wave and note the dark mass of the green shadows which run each side of the white, breaking wave. The shallow water which runs up the beach is usually green-yellow and finally ends in thin white foam. Little white streaks can be left indicating distant crests breaking on waves when painting the main sea area wash. If it is a cloudy day as this was, there will be dark areas of sea to paint which will give lovely variations of colour from deep blue to light green. I would strongly recommend you to try sea painting when you get the chance. If you live on the coast then you will have great opportunities in all weathers.

Still in North Wales, another type of water

96 Thames barges: preliminary sketch
97 The Thames at Rotherhithe. 30 cm × 47 cm (12 in. × 18½ in.)

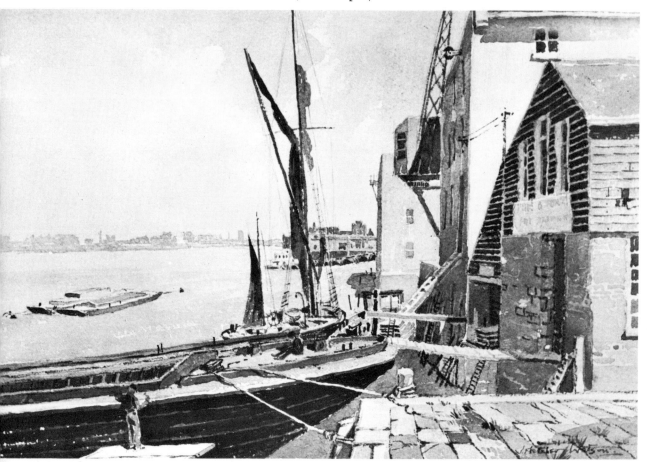

can be considered, namely the waterfall on a stream at Pontenyd which is shown in figure 100. Wales is full of little streams which have attractive rocky waterfalls and unusual trees sometimes growing almost out of the rock. They make fascinating subjects. The principle governing the painting of this picture was to leave the water till *last*. Everything was painted in, leaving the water as white untouched paper. One could then establish the right shapes and tone of the falling water with grey-blue or green-blue painting work, using a small brush and being careful still to leave plenty of white. It is so easy to paint out the white by mistake. The flatter part of the stream had reflections of brown-grey rock to colour it and sometimes the colour of the water itself was dirty brown or the shallow bottom of the stream would show through.

98 (*Above*) Racing at Cowes, Isle of Wight. 30 cm × 43 cm (12 in. × 17 in.)

99 (*Left*) Aberdaron, north Wales. 30 cm × 43 cm (12 in. × 17 in.)

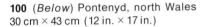

100 (*Below*) Pontenyd, north Wales 30 cm × 43 cm (12 in. × 17 in.)

Snow

This is a very attractive subject for the water-colour painter and the first thing we have to remember is that the snow is our *white paper* and we must not on any account rely on white paint. If you are using gouache which is body colour paint then of course you can paint white over your paper but for water-colour I prefer to be a purist and leave the paper exposed for the snow, and end up with a really fresh, translucent picture.

I have already touched on snow painting in Chapter Seven on Trees and figures 26 and 27 show snow subjects. But I would now like to mention a few more guide lines about making snow pictures.

If we look at figure 101 we have a simple snow scene of house roof tops showing over a hill, some dark winter trees and distant hills. This was painted on the spot and I was wearing my thick overcoat and shepherd's mackintosh and mittens part of the time until it came to detail painting with a small brush, when I removed the mittens.

The amount of preliminary drawing was minimal and it only took a few minutes to draw a line for the foreground hill and the roofs and chimneys of the house and barn and to indicate the few hills behind. The house is actually Windrush water-mill and is very close to where I live.

The sky was washed in with grey, being a mixture of Paynes Grey and Light Red. There was a touch of blue sky at top right of the picture with a small white cloud. This grey sky established the whiteness of everything else which is always a good start with a snow scene.

I next used a small brush and drew in with a dark grey mixture the background hills and hedges and also the nearer hedges on the right. Then with a blue-grey using Cobalt and Light Red the horizon woods and bigger bushes in the hedges were put in. Then the closer block of wood just to the left of the house roof was painted with a mixture of Cobalt and Burn Umber.

I could now come to the close group of trees just behind the roofs using Ultramarine and Burnt Umber mixed and darkly applied. A stiff mix was used so that little bits of white paper would show and indicate some thin, snow-covered branches. The same treatment was given to the block of trees on the left of the picture but in a lighter tone.

Now the house gable end and chimneys could be painted with Raw Sienna and Cobalt mixed giving a suitable stone colour.

A blue-grey was painted on the left-hand slope of the house roof which was in shadow, the sun being on the right, and some faint cloud shadows of Cobalt with only a very little Light Red on the foreground snow.

The individual trees by the barn roof were

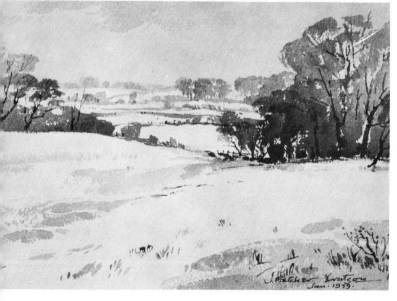

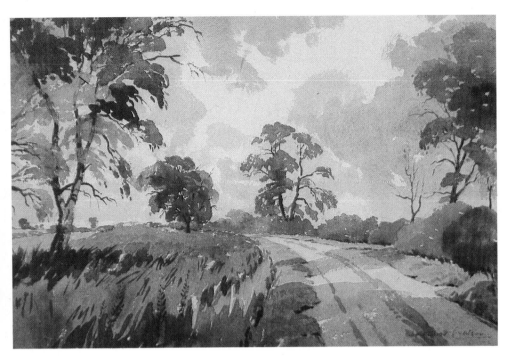

4 Cotswold
country road.
30 cm × 47 cm
(12 in. × 18½ in.)

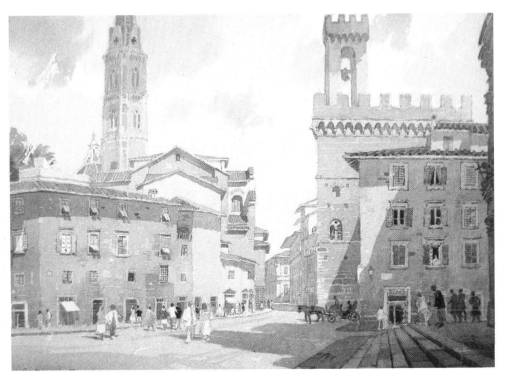

5 Piazza di
Firenze, Florence,
Italy. 30 cm × 45 cm
(12 in. × 17½ in.)

6 Blakeney
Church, Norfolk.
30 cm × 47 cm
(12 in. × 18½ in.)

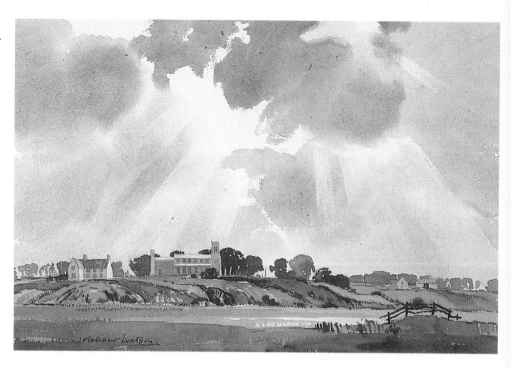

7 Burnham Overy
Staithe, Norfolk.
30 cm × 47 cm
(12 in. × 18½ in.)

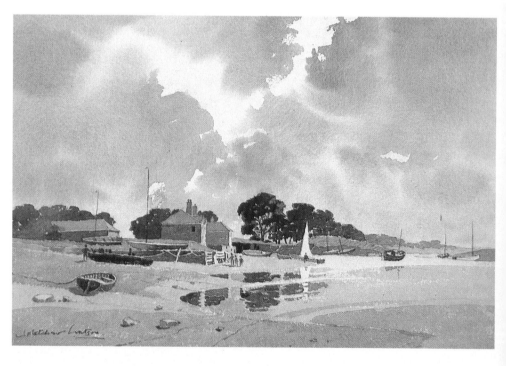

now painted in dark brown with a small brush and the post and rail fences in the hedges. A few touches of yellow grass sticking through the snow in the foreground was the final touch.

This picture took about one and a quarter hours to paint and I had kept fairly warm by stamping about from time to time.

Another snow scene is figure 102, 'Snow in the Cotswolds'. This is a view without any buildings and was again painted on the spot and fairly quickly. One thing about a snow subject is that it makes you *work quickly* as you don't want to hang about getting cold, and working quickly in water-colours is very good for your painting. Your mind concentrates on the items that have to be painted and the colours that have to be mixed. This is when all that practice you have been doing comes in as regards the limited number of colours you use and which colours to mix together in order to get an immediate result and splash quickly onto the paper. I would much rather see a painting which may be a little bit rough but has superb colours and spontaneity of application.

The painting of this picture followed the same lines as the one in figure 101: sky first, then distant fields and trees, then nearby trees and washes over the snow.

Painting in the studio

When I refer to painting in the studio I am figuratively speaking and I know that we have not all got room for a studio. I mean painting at home whether it is in the dining room, the sitting room or even your bedroom – it doesn't matter. If you can manage to give up a whole room to your painting so much the better; you can have your painting board and your paints always ready for immediate action.

I think about 60% of my pictures are painted on the spot and 40% in my studio, including some half finished work that requires finishing off at home.

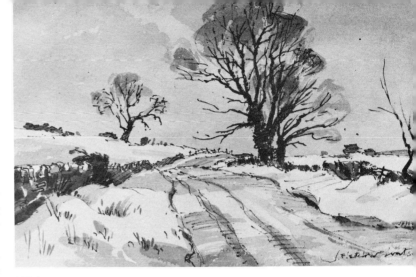

103 ▲

▼ 104

105 ▼

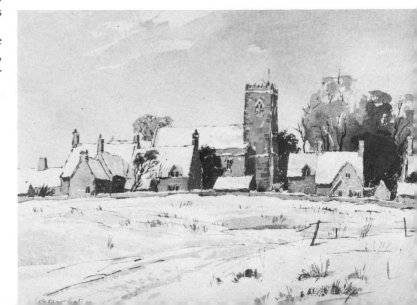

103 Country road, winter. 21.5 cm × 30 cm (8½ in. × 12 in.)

104 Preliminary sketch. 18 cm × 23 cm (7 in. × 9 in.)

105 Windrush village in the snow. 30 cm × 43 cm (12 in. × 17 in.)

In the winter there are bound to be some months when it is impossible to paint out of doors and I recommend that one should make a habit of accumulating drawings in pencil, pen or charcoal in various sizes of sketch book during the year, summer and winter, so that you can refer to these in the bad weather months and from which you can paint pictures in the comfortable conditions of your home. This indoor painting is most rewarding work and it means you can keep your hand in and be ready to go out of doors and paint whenever the weather changes for the better.

Sometimes you are doing a subject that is impossible to paint on the spot in any case, such as Oxford High Street which I referred to in Chapter Eight, because the traffic and general situation prevent you from doing so quite apart from the weather.

At any rate do remember this idea of filling sketch books with drawings whenever you can and I can assure you they will come in useful in many ways and it is all good for the training of the eye.

Figure 103 'Country road, winter', shows a little road leading out of our village and I drew the view one cold winter afternoon with a felt pen very rapidly – it is only a small picture. It was too cold a day to stay and paint so I kept it by until I had time a few days later to paint it in the studio. There had been a little weak sun giving good shadows across the road and the disposition of trees made a very well balanced picture. This is an example of winter painting in one's studio when the drawing for the *finished* water-colour has been made on the spot.

Now let us look at a different case. Figure 104 shows a small felt pen sketch book drawing 18 cm × 23 cm (7 in. × 9 in.) of Windrush village in the snow. This was used some weeks later in the studio to make the painting shown in figure 105. In this finished picture which is 30 cm × 43 cm (12 in. × 17 in.) I used pen with brown water-colour as ink and the subject was lightly drawn in before painting. It is surprising how the colours all come back to one when looking at a rough sketch made on the spot. The church and cottage walls were warm grey-yellow stone and the trees different shades of brown except one tree near the church tower which was a dark green yew.

106 Preliminary sketch.
18 cm × 23 cm
(7 in. × 9 in.)

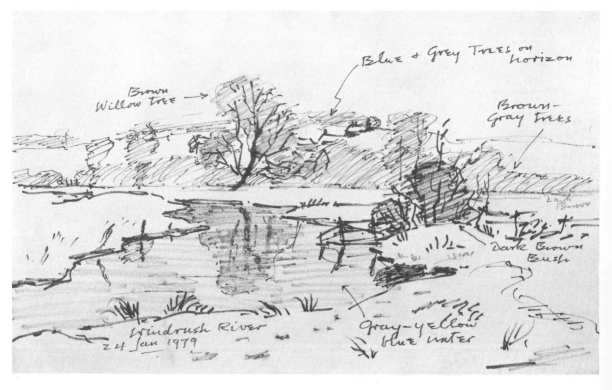

107 The River Windrush on a winter day. 21.5 cm × 30 cm (8½ in. × 12 in.)

108 Preliminary sketch. 25.5 cm × 35.5 cm (10 in. × 14 in.)

109 Baylham Mill. Suffolk. 21.5 cm × 30 cm (8½ in. × 12 in.)

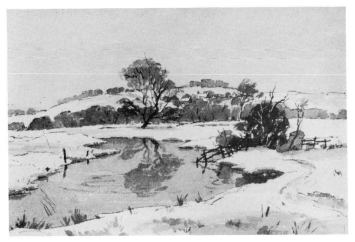

If we look at figure 106, here is another sketchbook drawing in felt pen of a river snow scene. It was made one cold and windy January day, too cold to be sitting out of doors for long. I painted a picture from it in the studio several months later (107). This is the river Windrush and the dark tone of the water compared with the blue sky was very marked. I used a little pen work in the finished picture.

Figure 108 is a pencil sketch of Baylham Mill Suffolk made in early summer in a sketch book 25 cm × 35 cm (10 in. × 14 in.). I was on my way to London at the time and unfortunately there was not time to stop and paint. I had seen this white mill from a train once and I was now determined to find it even though it meant hunting down country lanes to do so. It is a charming subject and about a year later I painted it in the studio from the pencil drawing (109). I used a little artist's licence with trees and I reversed the direction from which the sun was coming. This is quite a legitimate thing to do as long as you don't make the sun come from the north!

We will now take a look at a Lakeland picture of Cockley Beck which is useful in one or two ways (113). This shows an interesting group of a bridge, a river, trees and a typical white Lakeland farm house.

I am looking half into the sun and the picture illustrates fast moving water with sunlight on it. It is also an example of drawing the full size picture on the spot and painting it later in the studio. I think it may be helpful if I run through the painting process stage by stage.

Stage One (110)
I first made a careful drawing with a B pencil on 'Not' surface white paper of 300 lb weight. The sun was coming from the left, slightly into my face and I shaded in quite a few areas to remind me just what was in shadow. The bridge was certainly dark and the trees and

107 ▲ ▼ **108**

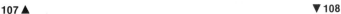

109 ▼

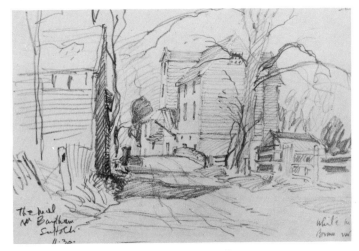

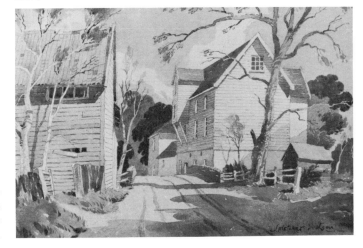

110 (*Below*)
Cockley Beck.
Stage One.
30 cm × 47 cm
(12 in. × 18½ in.)

111 (*Bottom*)
Stage Two

some of the grass bank and the right side of the house were in shadow. It was a cloudless day with a pale blue sky and I made a note of this and a few other items like the darkness of the rocks on the shadow side, leaving them almost white on the sunny side. Wet as they were they were glistening in the sun. At this point I had to pack up and go as I was short of time.

Some weeks later I was able to paint the picture at home in the studio. Still looking at Stage One, I laid in a graded wash for the sky using Raw Sienna at the horizon and quite soon changing it to a very pale Cobalt Blue and gradually darkening the blue as I worked towards the top of the picture. I was sloping the picture upside down towards the top in the manner previously mentioned in Chapter 9. I included the mountain in the graded wash.

When the sky was dry I put in a grey-yellow wash over the whole of the remainder of the picture using Raw Sienna, Light Red and Cobalt but I *excluded* the house and the river leaving these as white paper.

Stage Two (111)
The mountain on the right was now painted grey-blue with a mix of Ultramarine and Light Red and the hill behind the house a light wash of Burnt Sienna. I should have mentioned that the time of year was late September and colours were beginning to be autumnal.

The whole group of trees was given a wash of Cadmium Yellow and Prussian Blue and a little Rose Madder. The grass banks received a very yellowish green by mixing Raw Sienna and Cobalt.

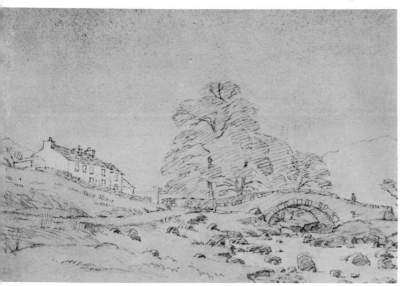

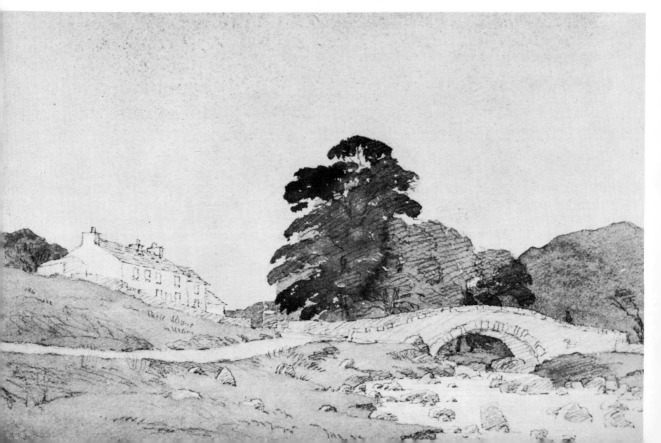

Stage Three (112)
I could now give the trees their final colouring.
There were three of them and I think they
were all ashes, but they were all turning
different colours. The tall one on the left was
dark green, a mixture of Cadmium Yellow,
Prussian and Indian Red varying the strength
and making a little foliage on the right extra
dark. The middle tree was quite yellow, being
Raw Sienna and a touch of Prussian and the
third one on the right was very brown and I
used Burnt Sienna and a little Prussian. The
small bush to the left of the house was this
latter colour also.

Now I painted the stone bridge a good
strong grey using Cobalt and Light Red
carefully leaving the very light grey top of the
parapet which was catching the sun. The
shadow side of the cottage was also painted
this grey colour but diluted to a light tone.
The underside of the bridge arch was dark-
ened with this grey and Ultramarine added.

Stage Four (113)
Now the final stage could be completed. The
water was given some quick strokes of blue-
grey again using Cobalt and Light Red and a
dry brush so that the white paper showed

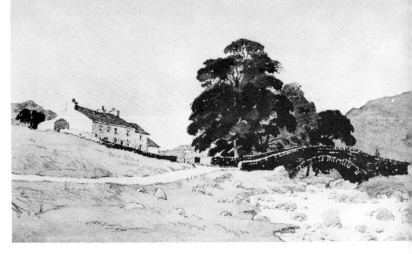

through giving the sparkle of moving water.
The rocks were painted on the shadow side
only a very dark grey using Ultramarine and
Light Red and the various shadow areas of the
foreground grass banks received washes of
Cobalt and Raw Sienna mixed rather thick
and darkly. The little bare tree on the right was
put in with a small brush and the figure on the
bridge. Some reeds growing in the grass were
touched in and the shadow on the house
garden wall was painted.

Note the stone jointing of the bridge was
indicated by leaving light coloured joints
when painting the dark grey shadow.

112 Stage Three

113 Stage Four

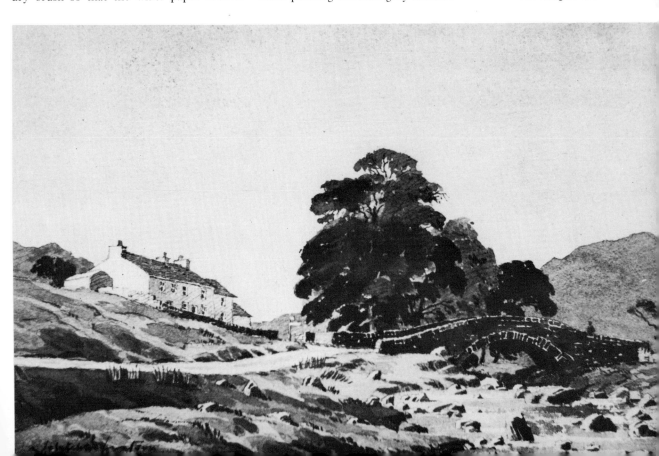

There are other things to be done at home when the weather is too bad to go out of doors. Figure 114 shows a pencil sketch of my hall. This sort of drawing is a useful exercise in perspective and to keep your hand in for drawing.

Another subject for indoors is shown in figure 115. This is a still-life group consisting of a pewter pot of autumn flowers and leaves, a photograph frame and some books on a round table. It was drawn with a felt pen. It is easy to find all sorts of still life groups around the house and it is all very good practice. You can even try drawing with a small *brush* only, and then add washes of colour to give tone.

Sometimes a finished water-colour painting can be made from one of your rough indoor sketches. You should never feel short of a drawing or painting job during the winter months. Sketch books should be filled with subjects indoors and out; it is all part of the process of making yourself more and more competent.

114 Pencil drawing of the hall. 20 cm × 28 cm (8 in. × 11 in.)

115 Still life: felt pen sketch

Pen and ink work, foregrounds, figures and animals

Pen work

Pen and wash can be a most attractive technique for water-colour painting and I have mentioned pen work from time to time in this book, but I would now like to say a few more words about it.

Figure 116 shows a pen and ink drawing of Gloucester Street, Cirencester, using a felt pen and a 6B pencil for a few shaded areas. This was made on Bockingford paper. It was later painted in water-colour in the studio. I had not originally intended to paint this picture, hence the rather full pen and pencil shading. But I got the urge to see it in colour and it finally made quite a nice water-colour. The painting brought out the lights and darks in a helpful way.

No pencil was used as a guide to begin with; I drew straight off with the pen and you

116 Gloucester Street, Cirencester. 24 cm × 33 cm (9½ in. × 13 in.)

will find this is the best way after a little practice. You can make little pen dots on the paper as a guide to the position of things like roofs and chimneys and the road and footpath.

The finished water-colour is shown in figure 117.

Figure 118 shows the delightful hamlet of Wharfe in Yorkshire near Settle. This was first drawn in pencil on De Wint toned paper. I was using old stock paper and it is a pleasing buff colour with a nice texture for water-colour. The new De Wint paper is, I am afraid, not quite so good for water-colour but I am hopeful that the makers will improve it.

Having half-painted the picture I introduced pen work using a water-proof brown ink. I find that using a pen on trees and plants growing over walls is particularly useful and also good for drawing stones in the foreground.

The sunny side of the buildings was left the natural colour of the buff paper; that is what is nice about tinted paper, the first wash is, so to speak, on before you start and this suits certain types of subject.

I used only five colours for this picture: Raw Sienna, Burnt Umber, Light Red, Cobalt Blue and Prussian Blue.

Another pen and wash picture is shown in figure 119. This is the Gateway to the Bishop's Palace, Norwich. It is a very pleasing corner of old Norwich with the cathedral spire showing in the background. The spire was left in faint pencil, and with only light washes of colour it was pushed well into the background. This is one of the advantages of using pencil and ink together.

As in the previous picture of Wharfe, I drew the subject with an HB pencil first and then having put on the preliminary washes of water-colour I added quite a lot of pen work. On the gateway building I used brown water-colour in the pen and for the tree and road etc water-proof brown ink was used.

117

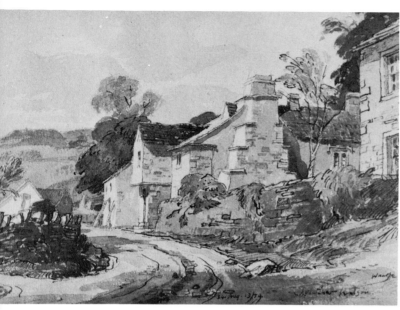

118 (*Left top*) Wharfe Hamlet, North Yorkshire. 24 cm × 35.5 cm (9½ in. × 14 in.)

119 (*Below*) Gateway to Bishop's Palace, Norwich. 30 cm × 43 cm (12 in. × 17 in.)

120 (*Opposite top*) Duddington, Northamptonshire. 20 cm × 29 cm (8 in. × 11½ in.)

121 (*Opposite middle*) Tixover Church, Northamptonshire. 20 cm × 28 cm (8 in. × 11 in.)

122 (*Opposite bottom*) Boats at Overy Staithe, Norfolk. 20 cm × 30 cm (8 in. × 12 in.)

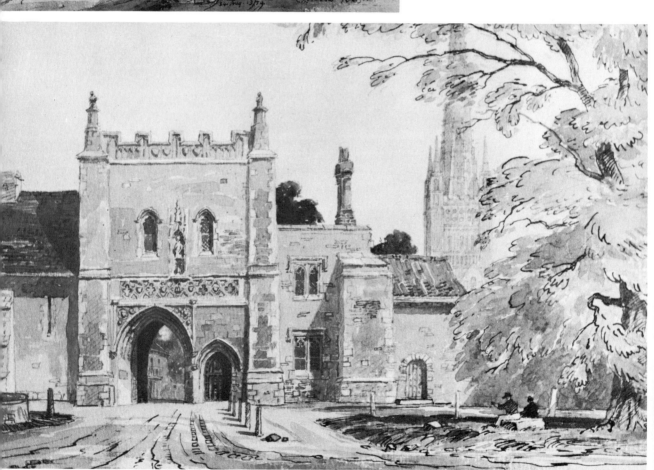

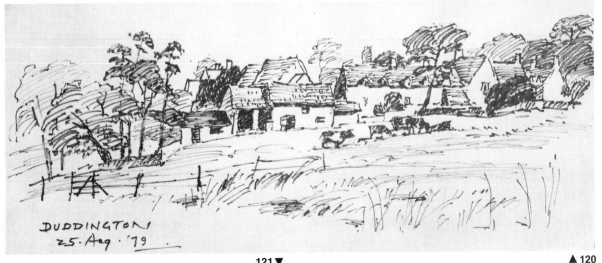

DUDDINGTON
25. Aug · '79 ·

121 ▼ ▲ 120

A sketch-book pen drawing is shown in figure 120. This is Duddington in Northamptonshire, a stone built village on a sloping hill, drawn with felt pen. This is the sort of sketch that gives plenty of information and could easily be used for making a water-colour painting in the studio during the winter months. When I look at these sketch book drawings the whole scene comes back to me with all the colours.

Another little sketch-book drawing is figure 121 showing Tixover Church, Northamptonshire. I sat on a wall making this drawing, again with felt pen, but with no pencil ground work, just drawing straight off in pen. It was a beautiful solid little Norman church miles from anywhere in the middle of fields with only a cart track leading to it. The churchyard was virtually a hayfield of long grass with no attempt to cut it. But on a hot summer's day in August it was all very attractive.

I sometimes make a complete pen drawing on water-colour paper and then paint it on the spot. An example of this is 'Boats at Overy Staithe' (122). I used heavy weight Arches paper 'Not' surface and a black felt pen that was waterproof; this is important as you do not want it to 'run' into the water-colour. Boats lend themselves to pen drawing as you can show their tricky shapes and construction well. I used the same five colours as for Wharfe in figure 118. The sky was a graded wash of Prussian Blue.

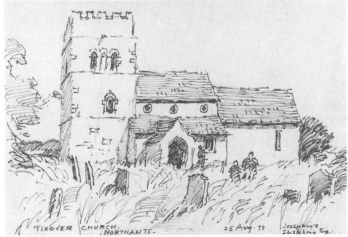

TIXOVER CHURCH.
NORTHANTS- 25 Aug · 79 Joseph Kite
 Sketching Too·

122 ▼

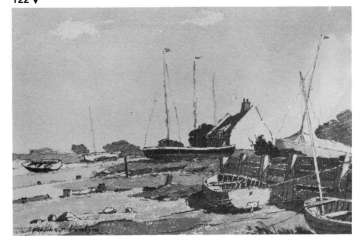

A pen and wash picture painted on David Cox water-colour paper is shown in figure 123. This paper is oatmeal colour and an ideal texture for light water-colour and pen work. Unfortunately it is no longer made. I still have a few old sheets left and occasionally give myself the luxury of using it. I suppose Two Rivers tinted paper is the nearest thing to it today.

I drew the pen work with brown water-colour, not ink, before applying any water-colour washes and it is a lovely feeling dashing broad pen strokes onto a virgin sheet of tinted paper of this type. You must not be timid about it; just dash straight in. I put the foreground in first and worked back towards the lock and then lightly touched in the far hills in pencil. The painting was more fun still, washing in big areas of light brown-yellow and leaving certain parts of the natural light sand colour of the paper. Darker washes of yellow-green followed and then grey-browns for the middle distant hills and blue-grey for the far distant ones. A great deal of the sky was left natural paper colour.

Colours used for this picture were: Cadmium Lemon, Raw Sienna, Burnt Umber, Light Red, Indian Red, Cobalt Blue and Prussian Blue. With these seven colours one was able to produce the rather subtle shades and tones which there were on this sunny day in August.

I strongly recommend you to try experimenting with dark brown water-colour and pen and then washes on tinted water-colour paper.

123 Loch Ainort, Skye.
30 cm × 43 cm
(12 in. × 17 in.)

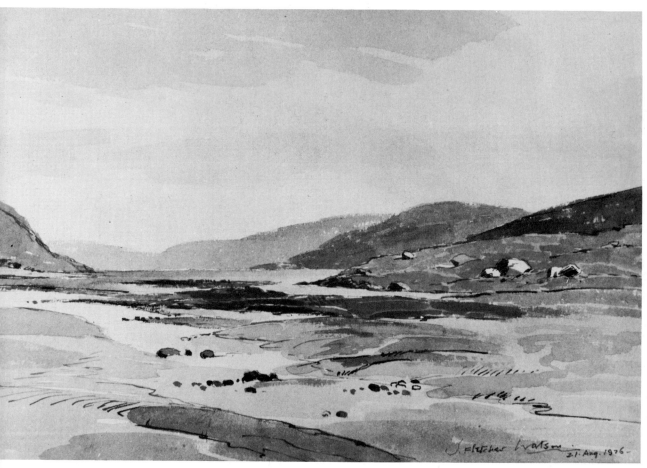

Foregrounds

When looking at picture exhibitions by present-day painters one is often struck by the lack of good foregrounds in landscape paintings. Without good foreground handling, the bottom falls out of the picture. There are exceptions when the picture is an unfinished rough sketch and the foreground tails off in a couple of loose strokes of the brush and that can look all right. But for a finished picture the foreground is a most important item; it helps to give good perspective and greater distance.

Rocks are most useful and attractive objects in open landscape foregrounds such as mountain or moorland scenes and figure 124 is a page from my sketch book showing rock studies made in Cumbria. It is a good thing to make plenty of drawings like this from time to time to familiarize yourself with the shapes of rocks and the way they lie on the ground at odd angles. Sometimes they look as if they are about to fall down the slope they are on. These sketch notes can be very useful when painting a picture in the studio from a rough sketch made on the spot.

I would draw your attention to one or two illustrations in previous chapters where foregrounds play an important part:

Chapter 7. Colour plate 4, facing page 120. The road in this picture forms an excellent foreground in itself and leads the eye into the picture. The foreground shadow across the road helps and also the rough long grass detail to the left.

Figure 27, page 54. This snow landscape has a fence cutting across the foreground which helps to set back the rest of the picture.

Figure 28, page 55 of Shotesham Mill has strong reeds and posts and rails in the foreground.

Chapter 8. Colour plate 5, facing page 120 shows Florence, and the foreground steps running into the picture are a great help to perspective.

In figure 52, page 78 the rough grass treatment helps to send back the hill village of Lierna.

Chapter 9. The colour plate on the front cover shows a good foreground interest of rough grass and a rock or two and figure 70,

124 Rock studies

page 94, has a cottage roof and rocks giving a useful foreground to the distant valley beyond. Figure 73, page 69, of Glen Voil has a well detailed foreground of rocks, grass and a road.

Chapter 10. Figure 78, page 102 has sloping ground as the foreground to Tintern Abbey and figure 92, page 114, Eilean Donan Castle has boats and rocks forming the foreground.

Figures and animals

If you can attend a life class and draw the human figure this is an invaluable training, but if you do not have this opportunity you can draw people at all sorts of times of day as circumstances permit. For instance, sitting in a car in a small country town where parking is allowed is an excellent way of observing men, women and children in all types of attitudes. People meet friends and stand and gossip for a minute or two and just give you time to make a quick drawing. To get a moving figure you have got to memorize; you can get a second look as you draw and they walk down the street but that is all. Go for the essentials, the swing of arms and legs and carriage of the head.

Figure 125 shows some quick studies of people doing different things. It doesn't take long to fill a sketch book with this sort of thing and you improve as you go on. You will find it

125 ▲ ▼126

a most useful reference for when you come to
painting a landscape, especially a townscape.

With a town subject, always be careful to
note the height of the person against a door or
window, make a little dot on the paper so that
you can put the person in later if necessary.
Figures always diminish in height as they get
further away and this is a great help to
perspective and it can be a calamity if you get
the height wrong.

On my walks in the country I always have a
sketch book with me and I often take a
shooting stick which has a convenient device
so that the seat can be lowered to an excellent
sitting position. One *can* stand and draw but it
is very much easier with a sketch book when
you are sitting.

Figure 126 shows a few sketches of sheep
and hens etc. It is important to make studies of
these animals and birds so that when they
appear in the landscape that you are painting
you can paint them in without any difficulty.
Sheep can be difficult to draw owing to their
roundness and lack of form and a little practice
does help. I always like a farm subject that has
hens and ducks; they give the right atmos-
phere. A lot of the Cumbrian farms have
plenty of hens about and this is also very
much the case with farms in France.

Cows are particularly desirable animals to
have in a landscape when the chance comes
along, and even if they are in the far distance it
is important to know how to draw them.
Figure 127 shows a page from one of my
sketch books of cows and horses. Cows have
rather a solid wedge shape with long straight
backs. Horses have a more hollow back and big
rounded quarters and they carry their heads
well up. But a horse grazing with his head
down is often seen and should be drawn.

The great thing is to practise drawing
animals as much as you can and you will
benefit enormously when you come to your
painting work.

▼127

125 (*Top*) Figures

126 (*Middle*) Sheep, hens etc

127 (*Bottom*) Cows and horses

THIRTEEN

Framing and exhibiting

Framing

Early in your painting career you will probably paint pictures of many sizes as the spirit moves you, but as you get more experienced and paint more pictures you will find that it pays to standardize the sizes of paper that you use. The reason for this is that most water colour and drawing paper is made to what is known as *Imperial* size which is 56 cm × 76 cm (22 in. × 30 in.). When this sheet of paper is cut in half it is 38 cm × 56 cm (15 in. × 22 in.) and this is a very handy size for the average water-colour picture. Most of my pictures are 30 cm × 47 cm (12 in. × 18½ in.) which leaves a margin of a few cm/in. round the edge which is useful for trying out colour mixes while you are painting.

When you order your frame from a framing shop you first give them the size of the *mount opening* ie the actual size of the picture which I have suggested above as 30 cm × 47 cm (12 in. × 18½ in.). You must then tell them how wide you wish your *mount* to be and I suggest the sizes should be 7.5 cm (3 in.) top and sides and 9 cm (3½ in.) bottom (128). One usually wants what is called a 'landscape' picture frame which means the long side is horizontal and the short side vertical. If you have painted a tall thin picture this is called 'upright' (120).

You must next choose the type of frame you require and framing shops usually have a great variety of moulded frames to offer. The most inexpensive is usually a plain oak frame about 22 mm–25 mm (⅞ in.–1 in.) wide looking from the front. You can have coloured frames in grey or green or gold.

The 'landscape' *frame* I have mentioned above will be 47 cm × 62 cm (18½ in. × 24½ in.) and a 25 mm (1 in.) moulding looks right and is strong enough for this size.

If you wish to paint a smaller picture,

which I often do, you should cut the 38 cm × 56 cm (15 in. × 22 in.) sheet in half again and you will have a sheet 28 cm × 38 cm (11 in. × 15 in.). I paint a picture 20 cm × 30 cm (8 in. × 12 in.) on this which I find a good 'landscape' proportion. If you follow this practice you will get *four* small pictures out of an Imperial sheet or *two* large ones. As water-colour paper is very expensive I strongly advize this economical method of cutting up the sheet.

The frame for the small picture can follow the same method, ie mount 7.5 cm (3 in) top and sides and 9 cm (3½ in.) bottom, moulding 25 mm (1 in.) wide.

This standardization of picture size and frame size has a further advantage, namely that if you send a picture to an exhibition and it does not sell you can take it out of its frame when you get it home and use the frame again for another picture. I always have a number of empty frames ready for an emergency and if I suddenly have to send some pictures in for an exhibition I can pop a picture into a frame when I have only just painted it. It is also extremely useful to be able to put your newly painted picture into a frame to see how it looks. Sometimes you find that one or two parts of the picture require strengthening up when it is seen at a distance in a frame.

Of course there are occasions when you want to paint an extra big picture or one to a special shape, perhaps a long thin one, and then of course you have to order a special frame.

Most picture framers will offer you a reduction on cost if you order two or three frames of the same size.

The mount itself is an important item. You can get different colours of mount. I usually use a slightly cream colour for most of my

pictures, but I sometimes use a dead white one and occasionally a light grey or a dark grey one. An interesting idea is a double mount, one set about 12 mm ($\frac{1}{2}$ in.) inside the other. This can be very attractive especially if you use a grey and white mount together. They do of course cost more.

Then there is the *wash-line mount*. This consists of a series of coloured lines, usually light brown, ruled round the edge of the mount near the bevelled opening and a very light blue or brown wash painted between two of the lines which are about 16 mm ($\frac{5}{8}$ in.) apart. The lines are ruled with a draughtsman's bow-pen, as it is called, and a tee square and drawing board. The framer does this work and charges quite a lot for it but it is not difficult to learn to do your own; I always do and save myself the cost.

You may not wish to have wash lines; they are in fact only used by about 40% of painters exhibiting today and they are perhaps more suited to the traditional painter. But these things go in fashions.

Your best plan is to find a good picture framer in your local town – there are plenty in London if you live there – and have a general discussion about colours of mounts (they have all colours), types of frame mouldings and costs. If necessary shop around as framers' prices vary considerably.

It is possible to learn to cut your own mounts and a very good mount cutter is the 'dexter' sold at most large art shops. A good assistant will demonstrate how to use it.

One last word on framing. Make sure that your framer gives you a good thick hardboard back and not a bendy cardboard one. And it is *much* better to frame up your picture yourself; don't let the shop put it in the frame, as they often get it in crooked. For example, the horizon line could be put in slightly slanting instead of dead horizontal. And instead of fixing the back with hammer and nails buy a useful gadget called a *Red Devil Point Driver*; it is spring loaded and drives in a little steel diamond at the back of the frame very efficiently and quickly. You can get this at: S Tyzack & Son Ltd, 341 Old Street, Shoreditch, London EC1V 9LN, Tel: 01-739 8301. I find this gadget a tremendous time saver.

You might get one at an ironmonger's shop as they are used also for fixing glass into windows.

Exhibiting

There are many art societies up and down the country and many in London too and they have annual or bi-annual picture exhibitions.

You may belong to one of these societies and already exhibit your pictures but I will give one or two hints for those who are not familiar with the procedure.

You usually have to fill up an application form giving the title and price of your picture and fill in a label to be stuck to the back of your picture. These forms and labels can be obtained from the Secretary of the Society. Pictures have to be handed in on a certain date. With some Societies you have to join first, others are open to anyone who cares to send in.

If you do not know of a local society in your district I advise you to write to the Editor of an Art Magazine called *Leisure Painter*, 102 High Street, Tenterden, Kent TN30 6HT Tel: Tenterden 3315.

They will tell you of art clubs and societies all over the British Isles, and they sometimes publish a list.

Whilst speaking of art magazines I would highly recommend this one to beginners and experienced painters alike. It specializes in illustrated articles telling you 'how to do it' by professional painters in all mediums, oils, water-colours, etchings, pastels and so on. This magazine is reasonably priced and it has good advertisements for painting courses. Another excellent magazine is *The Artist* whose editor is at the same address. Both these magazines advertise where to purchase artists' materials and water-colour papers of various types which is most useful.

Art societies and picture galleries do not like one to have very wide mounts as this makes frames large and take up too much wall space which is always at a premium. So keep your mounts down to the sort of sizes I have indicated if you can, as this will help your chances of acceptance. Always use a frame that looks good and is as new as possible. I have seen tatty second-hand frames and bad home-made mounts sent in to exhibitions and I know

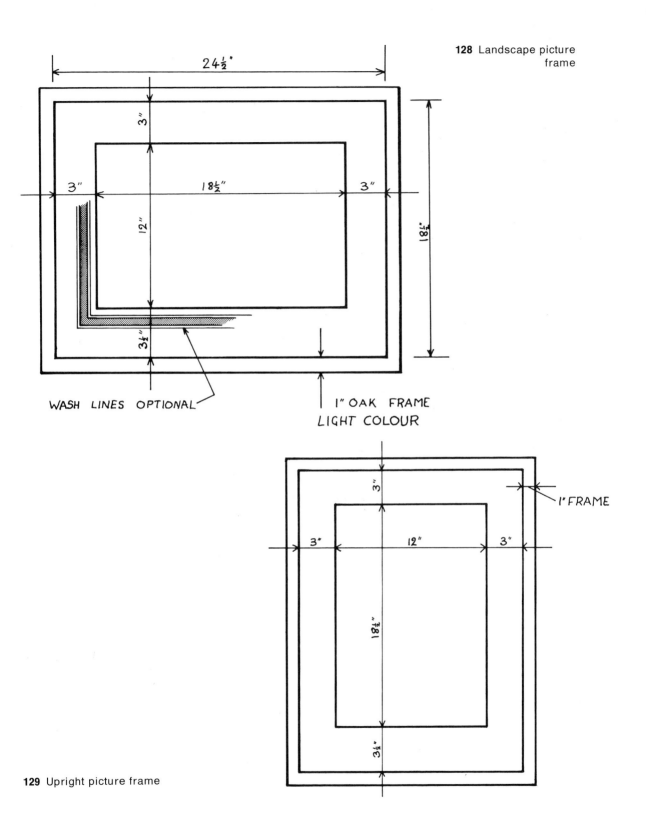

128 Landscape picture frame

24½"

3"

3" 18½" 3"

12"

18½"

3½"

WASH LINES OPTIONAL

1" OAK FRAME
LIGHT COLOUR

129 Upright picture frame

3"

1" FRAME

3" 12" 3"

18½"

3½"

from experience of being on hanging committees that bad presentation does go against the applicant.

The main British art societies of national repute who exhibit water-colour paintings are as follows:

1 The Royal Academy of Arts (The RA)
 Burlington House
 London
 Founded by Sir Joshua Reynolds 1768. Annual exhibition early May. Open to any non-member. Artist to send in up to three works. Application form obtainable from Secretary in February. Sending-in day in March. Any medium is acceptable and this includes water-colours.

2 The Royal Scottish Academy
 Edinburgh
 Approximately the same conditions at the RA at 1 above.

3 Royal Society of Painters in Water-Colours (The RWS)
 Bankside Galleries
 Hopton Street
 London E3
 Founded in 1804. *Not* open to non-members to exhibit. Have to submit works for election first. Write to Secretary for information about membership and exhibitions.

4 Royal Society of British Artists (The RBA)
 The Mall Galleries
 17 Carlton House Terrace
 London SW1Y 5BD
 Founded 1824. Oil paintings and water-colours accepted. Open to any non-member artist to send in up to three works. Application form from Secretary. Annual Exhibition usually held in July.

5 Royal Institute of Painters in Water-Colours (The RI)
 The Mall Galleries
 17 Carlton House Terrace
 London SW1Y 5BD

Open to any non-member artist to send up to three works. Application form from Secretary. Annual Exhibition usually held in the spring.

There are various other painting societies who have their exhibitions at The Mall Galleries such as The Royal Society of Marine Artists, The Britain in Water-Colours Exhibition, The New English Art Club, The Society of Women Artists, The United Society of Artists, all of whom accept water-colours and a letter to the Secretary General at The Mall Galleries will be answered giving full information.

Having your pictures exhibited at a public exhibition is a very good thing to do. It is a way of comparing your work with that of other painters and testing the standard you have reached, quite apart from the financial gain if you sell your pictures.

I hope this book will have been a help to some of you who are fairly new students to the game of painting in water-colours and also to the more experienced painters. As I said at the beginning of this book we are all of us students, learning something new every time we go out to paint. When I paint landscape from nature I am always observing something fresh, something which is a little bit different from what I have experienced before; perhaps it is a beautiful new effect of light and shadow, or I stumble across a new way of putting on a wash when painting a sky. It is all absorbing and good fun. Don't forget to enjoy painting. Although it is a serious job to be able to paint well don't take it *too* seriously.

So I give one last word to those of you who have young families or young nephews and nieces – paint pictures for *them* just for the fun of it and encourage them at an early age to paint too. We want to carry on the water-colour tradition.

I choose for my last illustration a child's picture; it was for my daughter's sixth birthday (130). This picture is of an old elm tree in the garden where the children played

with their toys. It is rather fun for children to see their own favourite toys come to life in a picture. There is a sort of magic in it for them. Try doing this yourself; I am sure you will enjoy it.

130 Picture for Josephine.
21.5 cm × 31.5 cm
(8½ in. × 12½ in.)

Index